Painting
Watercolour
SNOW SCENES
THE EASY WAY

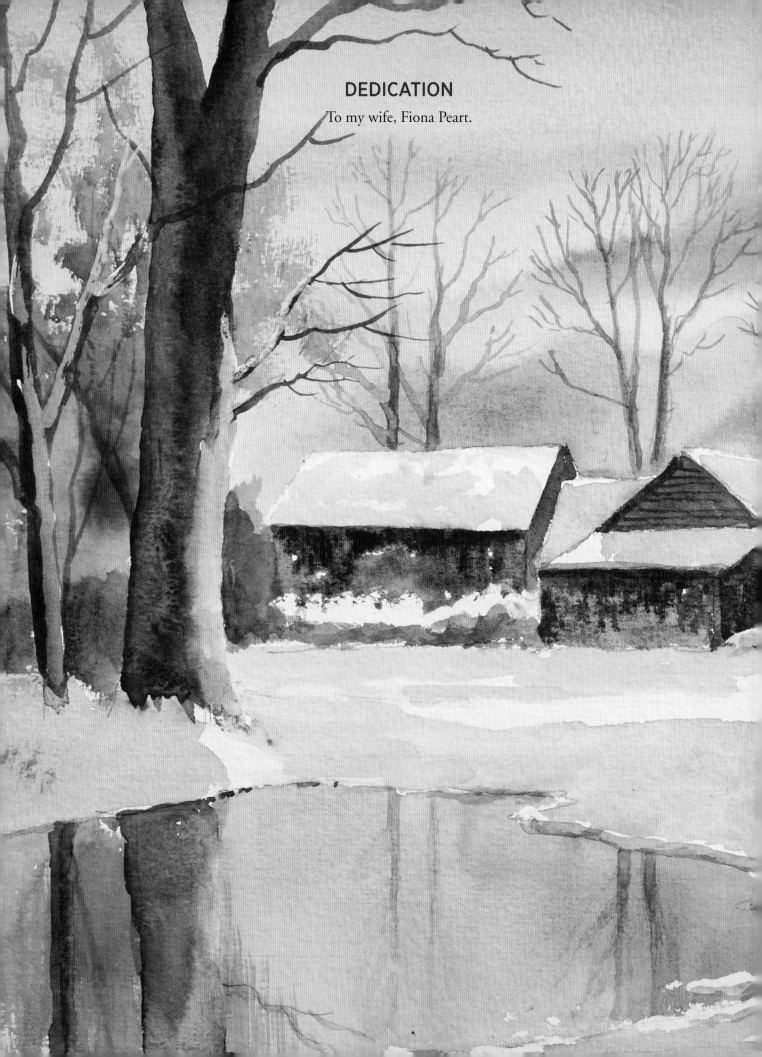

DEDICATION
To my wife, Fiona Peart.

Painting
Watercolour
SNOW SCENES
THE EASY WAY

TERRY HARRISON

SEARCH PRESS

Pages 2–3:

WINTER REFLECTIONS

Long shadows and still water are the main features of this painting. The warmth of the afternoon sky is reflected in the meadow pond and the long, cool, cobalt blue shadows in the foreground remind you that it's still cold out there.

Opposite

WINTER WATERMILL

Here the riverside path leads over the stile and on into the painting. Snow lies on the woodwork of the stile and fence. When painting the watermill, I repeated the same colours in the reflection and used the small detail brush to paint its rippled edges. The golden leaf brush was used to paint the sky and the texture of the trees and undergrowth.

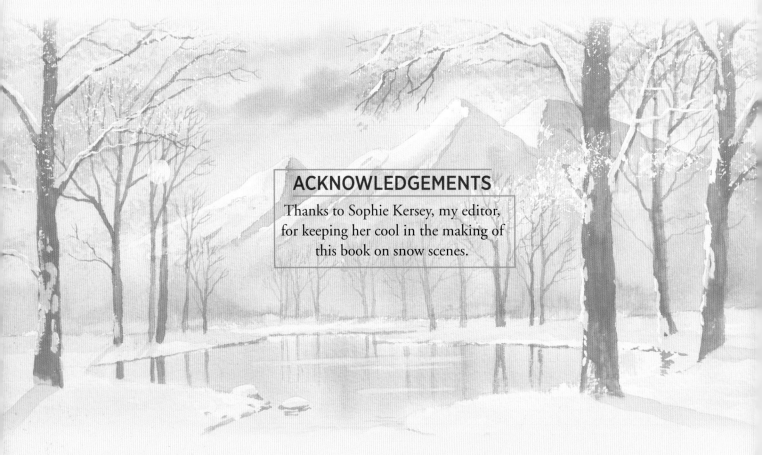

ACKNOWLEDGEMENTS

Thanks to Sophie Kersey, my editor, for keeping her cool in the making of this book on snow scenes.

First published 2017

Search Press Limited
Wellwood, North Farm Road,
Tunbridge Wells, Kent TN2 3DR

Reprinted 2018

Text copyright © Terry Harrison 2017

Photographs by Roddy Paine Photographic Studios
Photographs and design copyright © Search Press Ltd. 2017

ISBN 978 1 78221 325 3

Suppliers
If you have any difficulty obtaining any of the materials and equipment mentioned in this book, please contact Terry Harrison at:

Telephone: +44 (0)1451 820014

Website: www.terryharrison.com

Alternatively, visit the Search Press website:

www.searchpress.com

Publishers' note
All the step-by-step photographs in this book feature the author, Terry Harrison, demonstrating how to paint with watercolours. No models have been used.

Printed in China through Asia Pacific Offset

CONTENTS

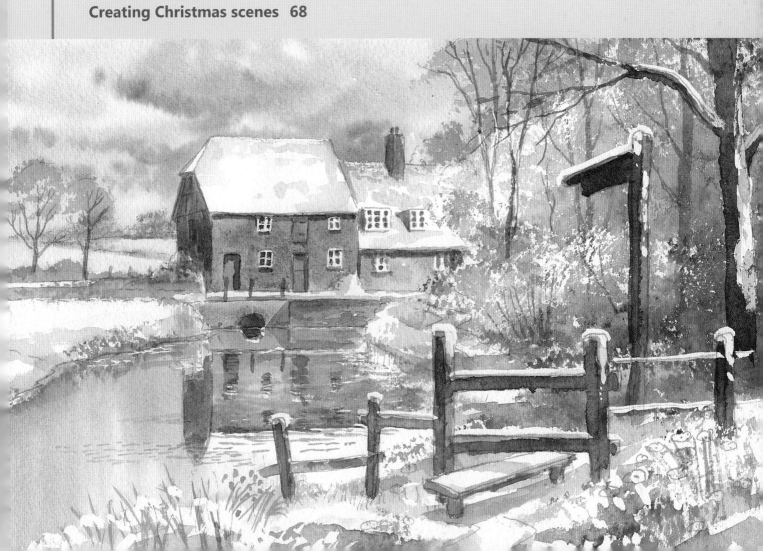

SNOWY HOLLOW

The warm colours of the red barns contrast with the cool tones of the long, blue shadows in the foreground snow. The wheel tracks in the lane lead you into the painting and the shelter of the farm. The light sprinkling of snow in the twigwork and branches of the trees was created using masking fluid.

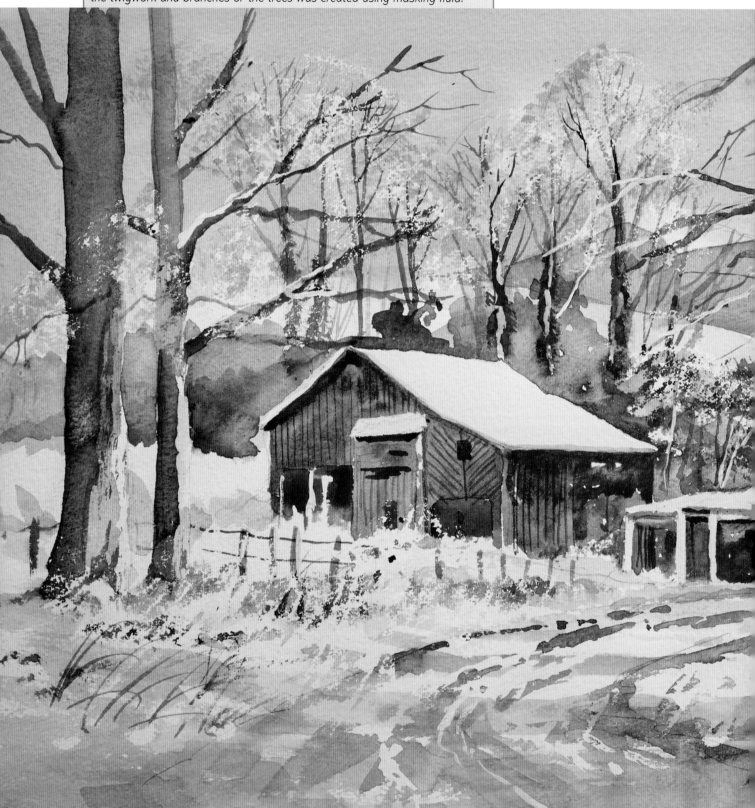

INTRODUCTION

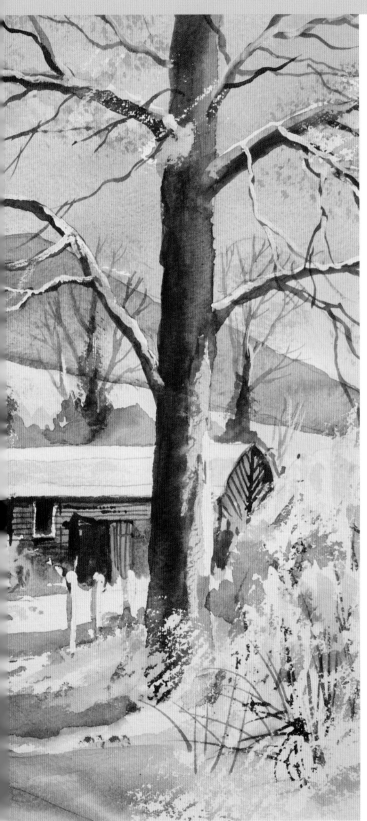

I have always had a passion for painting snow scenes, but I must say I am now more of a fair-weather painter. When I was just starting out painting landscapes, I did paint outside on many occasions in the snow. I remember getting all wrapped up in a woollen hat, scarf, layers of sweaters, two pairs of socks, Wellington boots, thick overcoat and the finishing touch: a pair of fingerless gloves. I must have looked as though I was setting off on a trip to the North Pole.

Lots of effort and dedication went into my winter painting expeditions and I like to think it has paid off over time and has culminated in the writing of this book on snow scenes.

This book will show you how you can paint snow scenes the easy way, without setting foot outside in the cold. You will learn useful colour mixes for snowy landscapes and how to create winter trees and grasses, reflections, snow shadows and the warm glow of a winter sunset. There are new tricks and tools to use with masking fluid which are ideal for snow scenes, and techniques for creating snowdrifts, snow-capped mountains and falling snow. I will show you how I transform a summer landscape into a winter wonderland by following some simple guidelines, and even how to create your own festive greetings card by adding a few seasonal images. I hope all this will stimulate your passion for painting snow scenes.

Terry Harrison

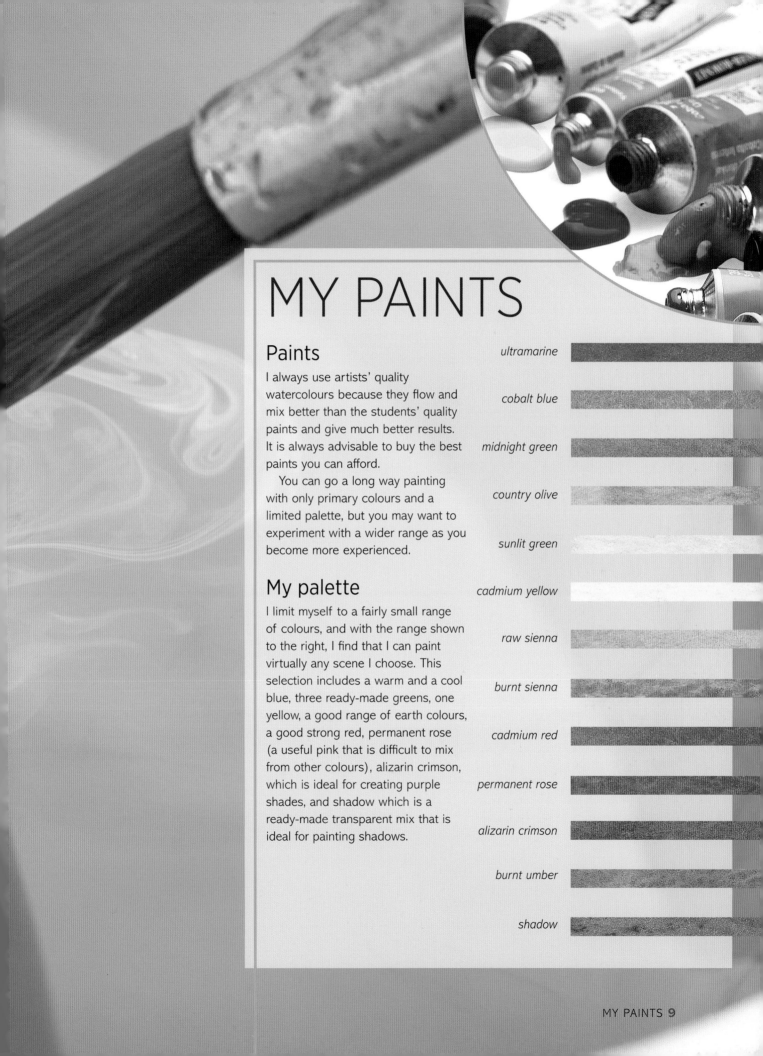

MY PAINTS

Paints

I always use artists' quality watercolours because they flow and mix better than the students' quality paints and give much better results. It is always advisable to buy the best paints you can afford.

You can go a long way painting with only primary colours and a limited palette, but you may want to experiment with a wider range as you become more experienced.

My palette

I limit myself to a fairly small range of colours, and with the range shown to the right, I find that I can paint virtually any scene I choose. This selection includes a warm and a cool blue, three ready-made greens, one yellow, a good range of earth colours, a good strong red, permanent rose (a useful pink that is difficult to mix from other colours), alizarin crimson, which is ideal for creating purple shades, and shadow which is a ready-made transparent mix that is ideal for painting shadows.

ultramarine

cobalt blue

midnight green

country olive

sunlit green

cadmium yellow

raw sienna

burnt sienna

cadmium red

permanent rose

alizarin crimson

burnt umber

shadow

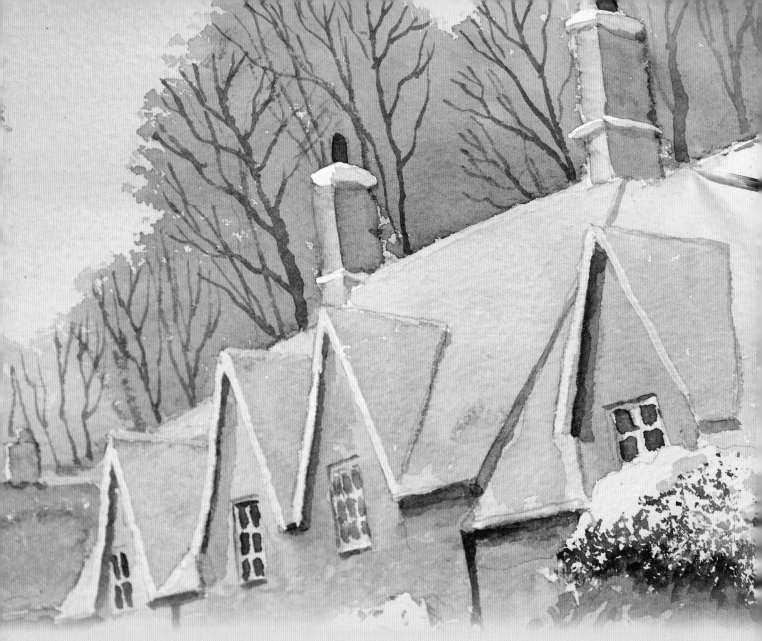

Useful mixes for snow scenes

Painting a snow scene in watercolour on white paper should be easy – after all, snow is just white, isn't it?

Indeed, a single snowflake appears white, but when the flakes fall and cover everything with a blanket of snow, this reflects the light and colour of its surroundings. Bright sunlight on snow looks white and the shadows take on the colour of the sky and appear blue. On an overcast day, the snow will appear to take on shades of grey. When the sun is low in the sky, at sunset but also in the earlier part of a winter day, the snow reflects some of the warm hues of the sky and appears golden, and the shadows can be shades of purple. So you can see that snow scenes are full of possibilities for colour. Here are some good mixes to get you started.

COBALT BLUE

Cobalt blue is a really cool colour, just right for cool shadows on snow. Simply add water to make the blue lighter.

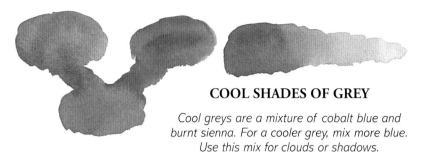

COOL SHADES OF GREY

Cool greys are a mixture of cobalt blue and burnt sienna. For a cooler grey, mix more blue. Use this mix for clouds or shadows.

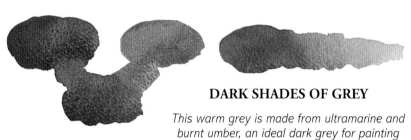

DARK SHADES OF GREY

This warm grey is made from ultramarine and burnt umber, an ideal dark grey for painting buildings and barns as well as winter trees.

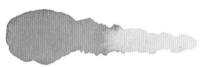

COOL SHADOW

This two-colour mix of shadow with cobalt blue is useful for painting shadows on snow or even cloud formations.

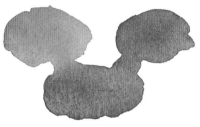
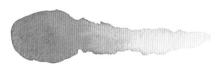

WARM SHADOW

This warm purple colour is ideal for creating warmer shadows. Here it is mixed with permanent rose and cobalt blue.

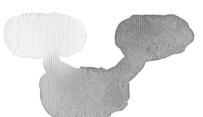

WARM LIGHT

Cadmium yellow and permanent rose mixed together make an ideal colour for sunsets and light glowing through a window.

USING MY BRUSHES

Some artists adapt brushes to suit their personal requirements. I have gone a step further than this and designed my own range of brushes, specially made to make good results easily achievable, and these are used throughout this book. The following pages show how each of these brushes can be used to create a range of effects which you will find useful when painting snow scenes.

My brushes will help you to achieve the best effects with the minimum effort. You can use your own brushes to paint the demonstrations in this book, but look for the qualities outlined over the next few pages to help you choose the right brush for the job.

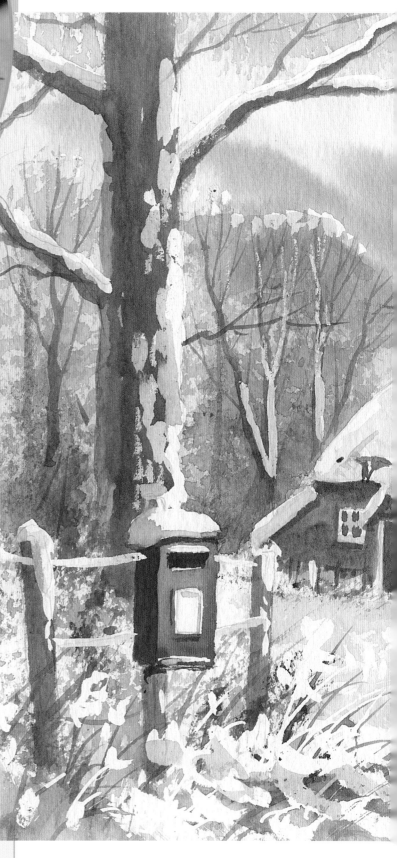

THE LAST POST

The sun is low in the sky behind these snow-covered cottages. This would make a good Christmas scene, especially with the bright red post box ready for Christmas cards. The glow of the sun through the trees creates warmth.

I used a coin wrapped in kitchen paper to lift out the shape of the sun. The golden leaf brush was used for the sky washes and the detail brushes for the winter trees, with the half-rigger to capture the finest branches. I stippled on the texture of the ivy on the tree trunks with the foliage brush and the fan stippler. The masking fluid was applied using an old brush.

TERRY HARRISON

Golden leaf

This is a large wash brush which holds lots of paint and is ideal for painting washes and wet-in-wet winter skies. The golden leaf brush is made from bristle blended with fine, natural hair. When the hair is wet, it curls and keeps the bristles separate.

Use it to drop clouds into a wet wash. This brush is also excellent for stippling large areas of texture.

Painting a sky with the golden leaf brush

This brush is usually the first one I reach for when beginning a new painting, as it holds a lot of water and is excellent for painting skies.

1 Wet the sky area with clean water, then paint on a pale wash of raw sienna from the bottom of the sky.

2 Drop in a wash of permanent rose.

3 Sweep ultramarine across the top of the sky.

4 Drop in a slightly thicker mix of ultramarine and permanent rose to create clouds (see inset). Allow the sky to dry naturally.

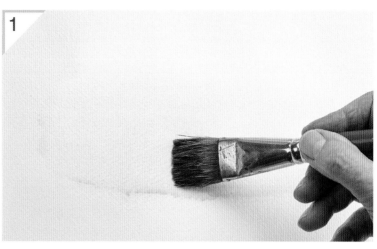

1

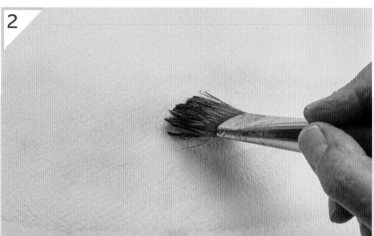

2

3

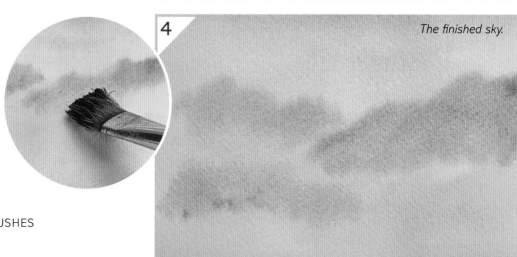

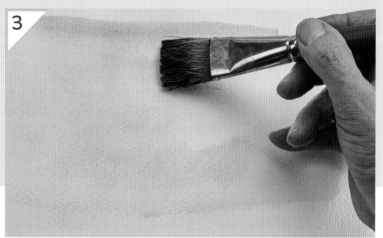

4

The finished sky.

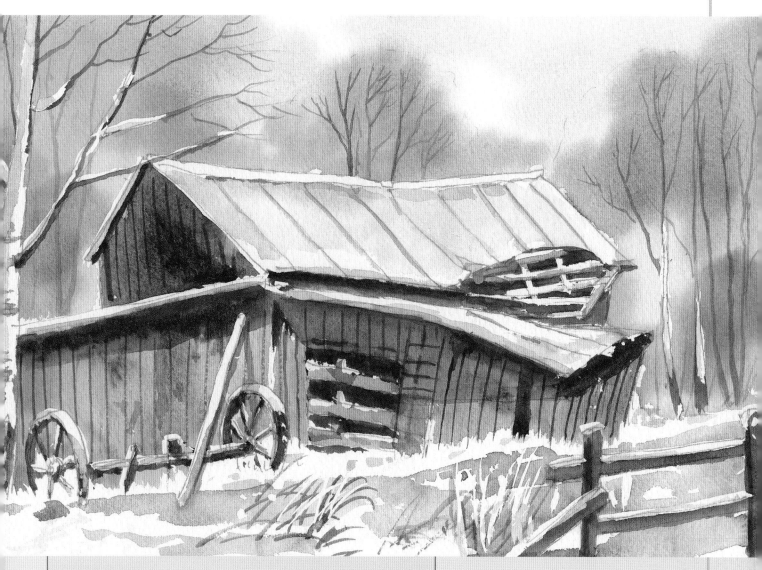

RUINED BARN

In this painting, the sky and the hazy colour for the background trees were painted with the golden leaf brush and wet washes.

Painting a winter tree with the golden leaf brush

The qualities of the golden leaf brush make it ideal for stippling texture. Here it is used to suggest winter foliage and ivy.

Alongside some of my other brushes (detailed later), it makes painting an ivy-covered tree simplicity itself.

1 Use the golden leaf brush to stipple on a mix of burnt sienna and shadow for winter foliage.

2 Stipple on midnight green to create ivy round the trunk. Allow to dry.

3 Use the half-rigger to paint branches with a stronger mix of burnt sienna and shadow.

4 Use the medium detail brush and cobalt blue to paint shadows in the snow beneath the tree.

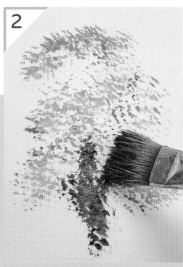

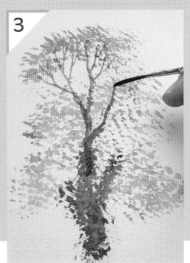

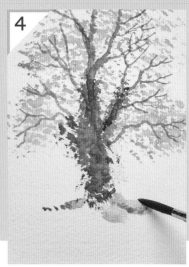

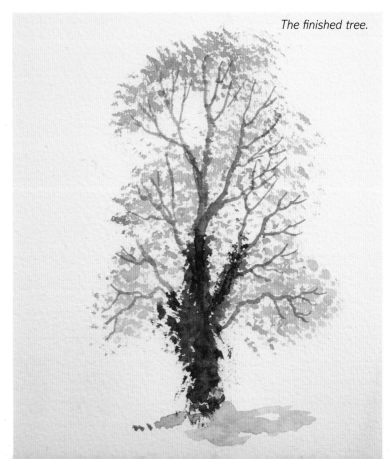

The finished tree.

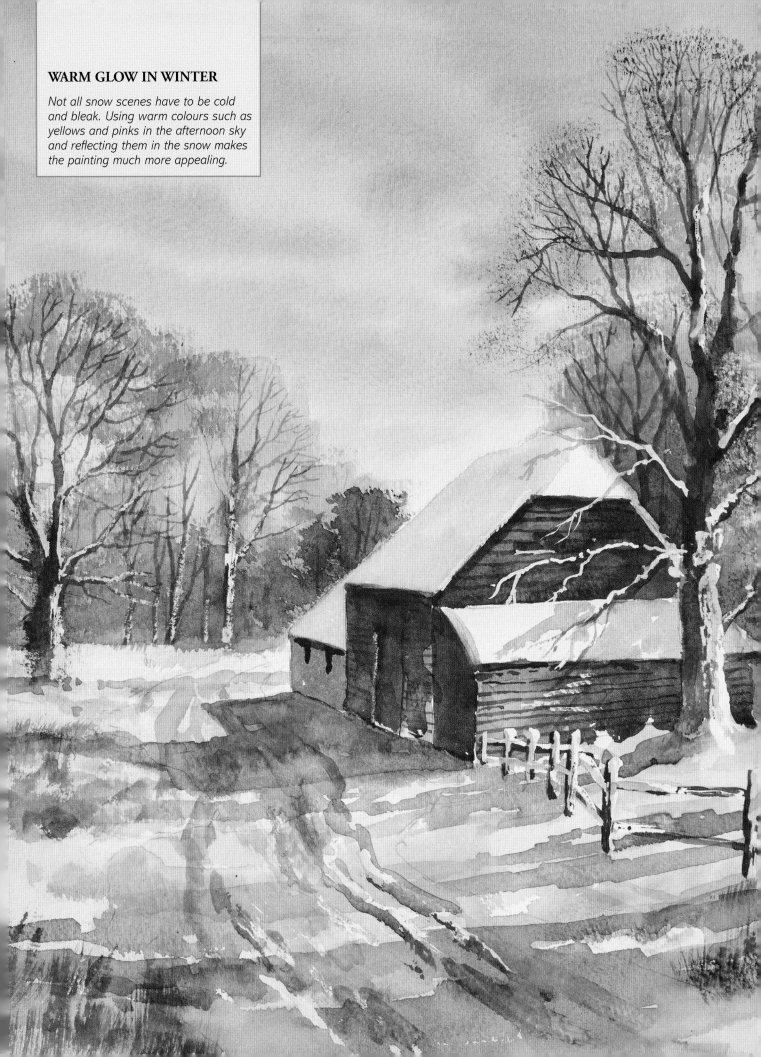

WARM GLOW IN WINTER

Not all snow scenes have to be cold and bleak. Using warm colours such as yellows and pinks in the afternoon sky and reflecting them in the snow makes the painting much more appealing.

Foliage brush

This smaller version of the golden leaf brush is good for painting the dried-out foliage that remains on trees in winter.

Painting distant hedgerows with the foliage brush

Like its bigger brother, the golden leaf, this brush is good for stippling texture for hedgerows, foliage, ivy and winter trees.

1 Make a paper mask from a piece of scrap paper or card and use the foliage brush to stipple a mix of ultramarine and shadow over the edge, to suggest a distant hedgerow with trees and bushes.

2 Change the angle of the mask coming forwards, and continue stippling hedgerows at different angles to suggest a patchwork of distant fields.

3 Stipple the ivy on a foreground tree with midnight green, then use the ultramarine and shadow mix to stipple the winter foliage.

4 Make a stronger mix of ultramarine and shadow and use the half-rigger to paint branches and twigs.

5 Add fenceposts with the same colour, then paint a few shadows on the snow beneath the trees and hedgerows with a pale wash of ultramarine (see inset).

1

2

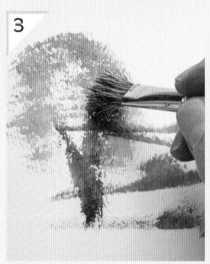

3

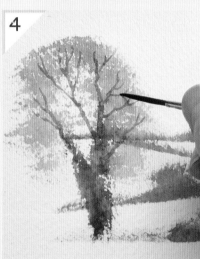

4

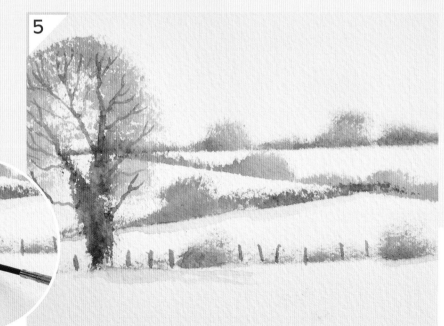

5

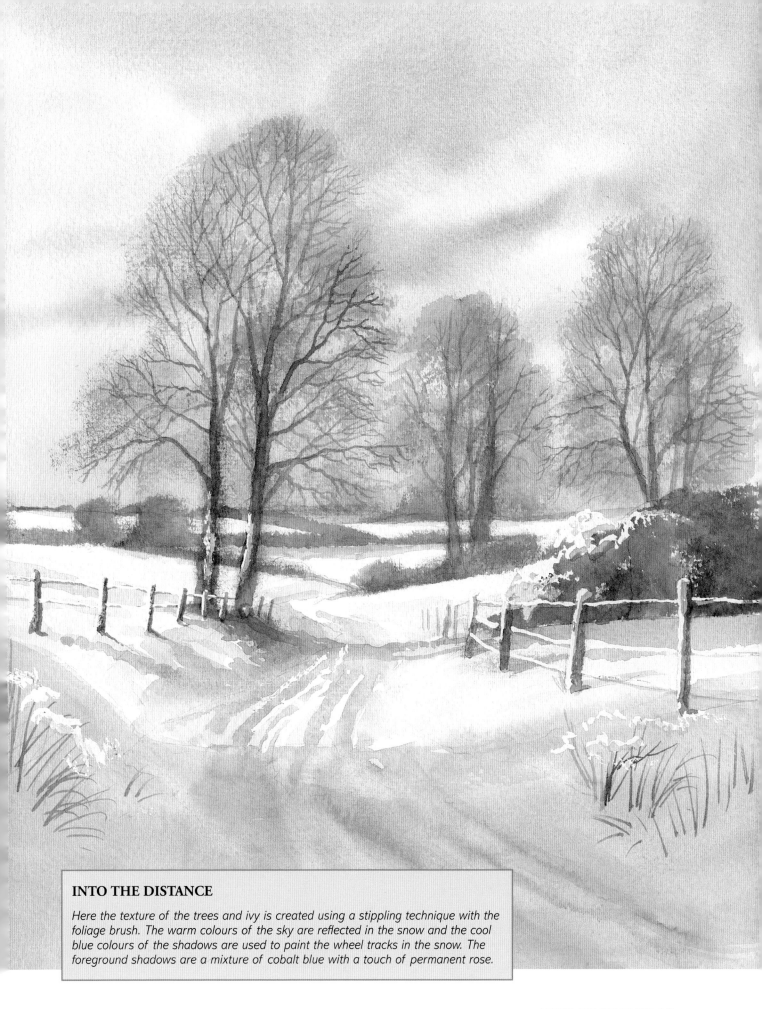

INTO THE DISTANCE

Here the texture of the trees and ivy is created using a stippling technique with the foliage brush. The warm colours of the sky are reflected in the snow and the cool blue colours of the shadows are used to paint the wheel tracks in the snow. The foreground shadows are a mixture of cobalt blue with a touch of permanent rose.

Fan stippler

This is a fan-shaped version of the foliage brush.

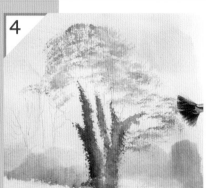

Painting ivy with the fan stippler brush

Ivy is a common sight in woodlands and is a good way to add a bit of green to a winter scene. The fan stippler is ideal for creating its texture and for picking out the shape of tree trunks.

1 Wet the sky area and use the fan stippler to paint raw sienna at the bottom and ultramarine at the top.

2 While this is wet, paint distant bushes on the horizon line with ultramarine and shadow, then paint warmer bushes on the left with burnt sienna. Drop in shadow at the bottom. Allow to dry.

3 Use the end of the fan stippler brush upright to stipple ivy onto the main tree with midnight green. Allow to dry.

4 Mix shadow and burnt sienna and lightly stipple on the winter foliage. Add a little ultramarine to the mix to stipple the more distant trees.

5 Use the half-rigger with a mix of burnt umber and shadow to paint the trunks and branches of the more distant trees.

6 Use the medium detail brush and a pale mix of cobalt blue to paint the track leading into the scene and the shadows on the snow.

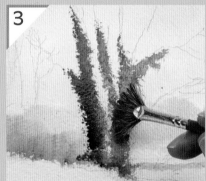

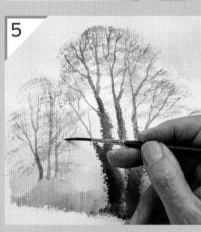

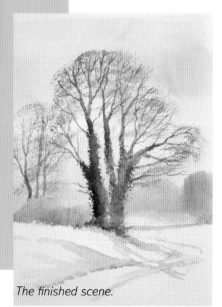

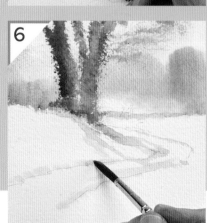

The finished scene.

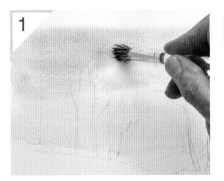

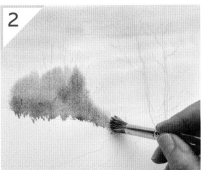

Stippler px

This brush has the same hair combination as the foliage and fan stippler brushes, so it is of course good for stippling texture. It also has a clear resin handle with the end shaped to be used for scraping out paint.

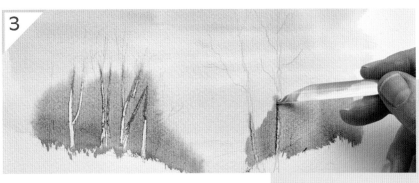

Painting trees with the stippler px

This is another versatile brush that comes into its own for snow scenes. Here it is used to create the shapes of distant trees and then to scrape out the trunks. Finally it is used to stipple on white gouache for snow on the branches.

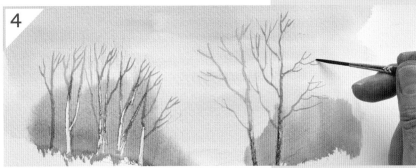

1 Wet the sky area and drop in raw sienna with a touch of permanent rose, using the stippler px. Sweep a mix of ultramarine and a touch of burnt umber across the top of the sky.

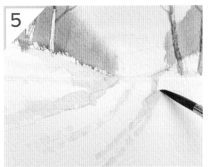

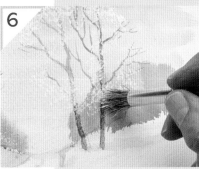

2 While this is wet, make a much browner mix of burnt umber and ultramarine and paint the distant tree area in soft shapes.

3 Paint another distant tree area on the right of the painting in the same way. When the paint is just damp, take the shaped end of the px brush handle and scrape out tree trunks.

4 Use the half-rigger with burnt umber and ultramarine to extend the scraped out trunks and add branches and twigs.

5 Take the medium detail brush and paint snow shadows on the banks and in the ruts in the path with cobalt blue.

6 Dip the stippler px brush in pure white gouache and stipple this on the bare branches to suggest snow.

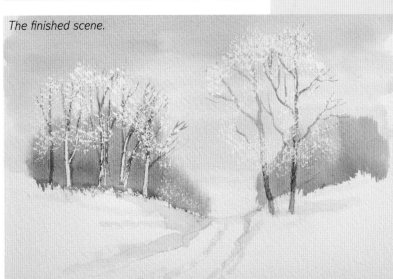

The finished scene.

Wizard

Twenty per cent of the hair in this brush is longer than the rest, which produces some interesting effects.

Painting reflections with the wizard brush

The wizard brush is excellent for painting reflections. Paint a wash on first, then drag the brush down.

1 Wet the painting with the wizard brush and clean water, then paint raw sienna in the lower sky and upper water.

2 Paint ultramarine across the top of the sky and bring it down into the raw sienna, then do the same at the bottom of the water and merge the blue upwards.

3 While this is wet, paint downward strokes of shadow and burnt sienna for distant woodland, then stipple on a tree.

4 Still working wet into wet, paint the reflections, dragging down the same shapes in the water. Allow to dry.

5 Use the half-rigger and a stronger mix of the same colours to paint the tree trunk and branches, and hint at their reflection.

6 Mix burnt umber and shadow and use the wizard to flick up grasses and drag down reflections, then use the half-rigger to paint snow shadows in cobalt blue.

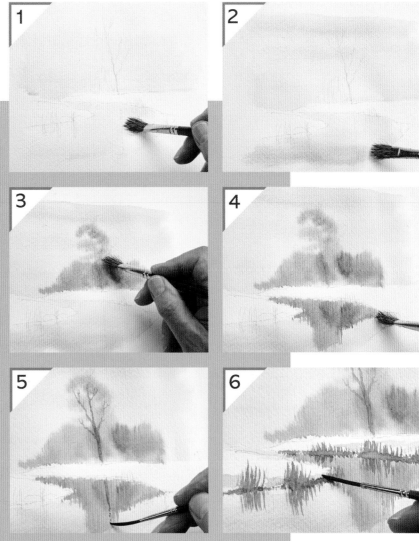

The finished scene.

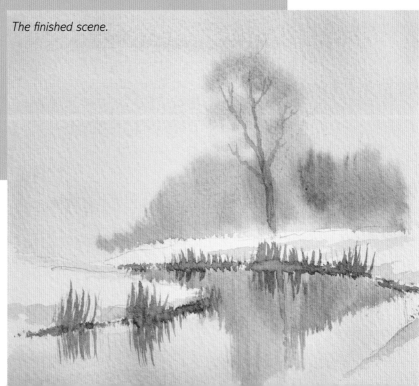

Fan gogh

This thick fan brush is very versatile, able to turn its hand to many aspects of the winter landscape.

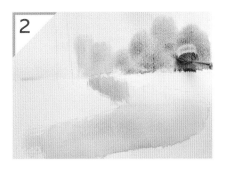

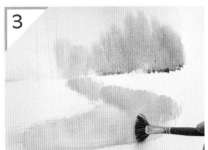

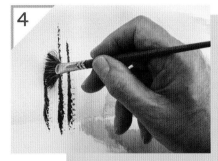

Painting fir trees and grasses with the fan gogh brush

The fan gogh is shown here painting the sky, water and distant trees, as well as the trunks and boughs of fir trees and flicking up grasses.

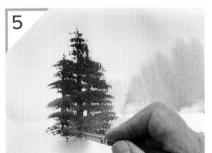

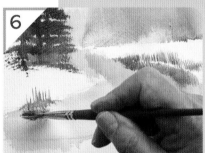

1 Wet the painting with the fan gogh and paint raw sienna at the bottom of the sky and top of the water, then paint ultramarine wet into wet at the top of the sky and bottom of the water.

2 While this is wet, paint distant trees with a mix of cobalt blue and midnight green.

3 Use the fan gogh edge upright to suggest the distant fir tree shapes, then add their reflection.

4 Mix midnight green and ultramarine and use the fan gogh edge upright to paint the fir trunks.

5 Use the brush edge horizontally to paint the branches.

6 Flick up grasses at the water's edge with a paler mix of the same colours. Allow to dry.

7 Use the medium detail brush and cobalt blue to paint shadows in the snow. Change to the 19mm (¾in) flat brush, wet it and squeeze out some of the water to make a thirsty brush. Use the edge of the brush to lift out colour in the water to suggest ripples.

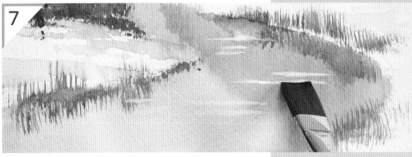

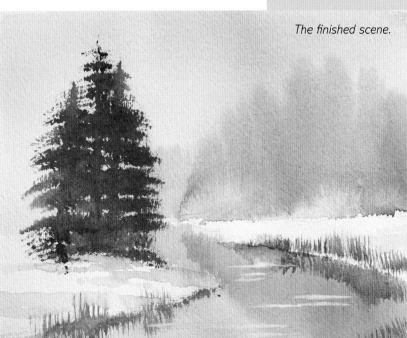

The finished scene.

Detail brushes

These different-sized round brushes are useful for almost every painting, and snow scenes are no exception!

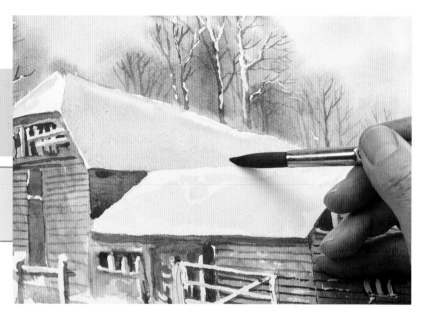

Using the large detail brush

The large detail brush creates large brush strokes, making it good for painting snow shadows in larger areas.

Here I am adding cobalt blue to the snowy roof to give it form. The blue shadow makes the white of the paper sing out, suggesting bright snow.

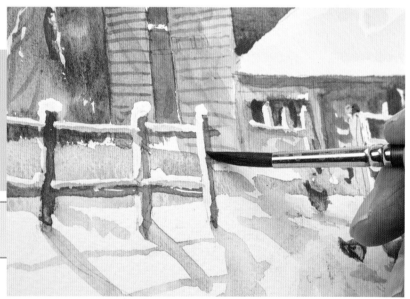

Using the medium detail brush

The medium detail brush, ideal for painting smaller details, is one of the most useful in the range. In this book it is often used to paint snow shadows suggesting the lie of the land under the snow.

Here I am using it to paint fenceposts with a mix of shadow and burnt umber.

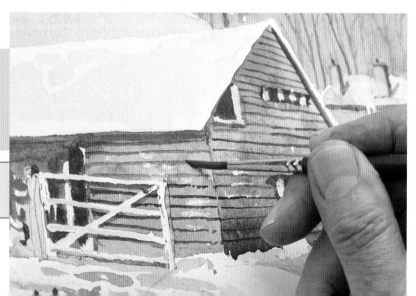

Using the small detail brush

When you need more control to paint fine details, grab this brush. It is most useful towards the end of the painting when you add the smallest details.

Here it is shown suggesting the planking in this building, with a mix of shadow and burnt umber over a dried background.

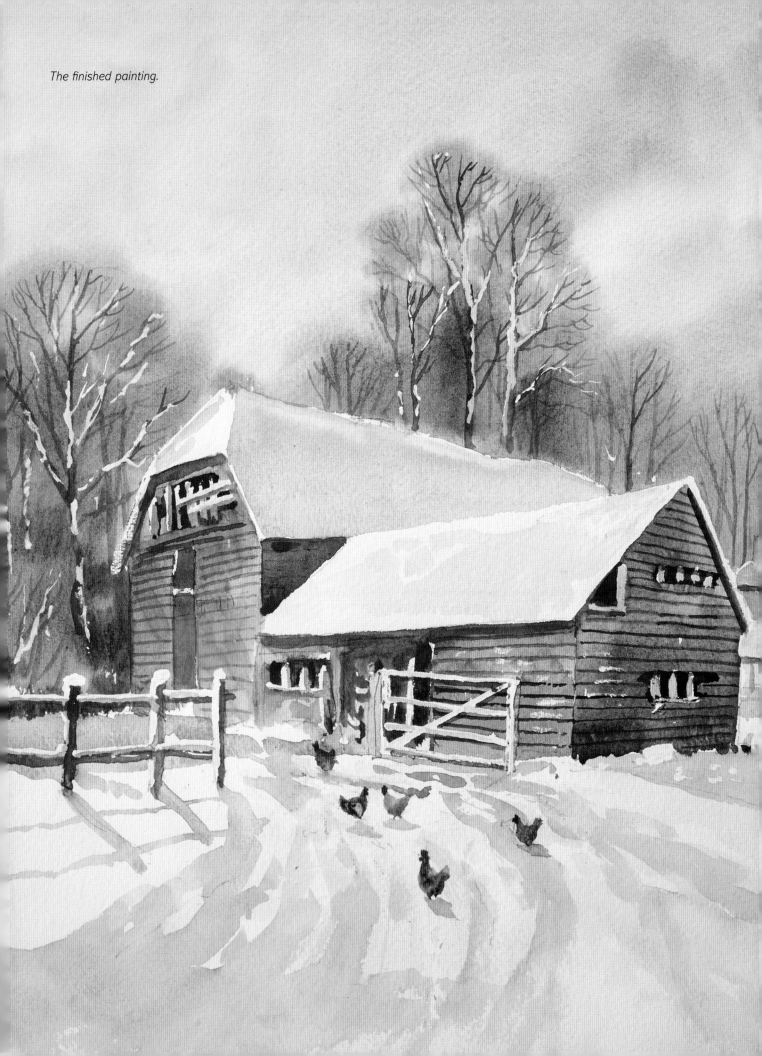

The finished painting.

19mm (¾in) flat

Made mostly from squirrel with a little synthetic hair, this brush combines the water-carrying capacity of the natural hair with the springy, shape-holding advantages of the synthetic.

Painting ripples and lifting out with the 19mm (¾in) brush

Rippled water appears in many winter scenes and the 19mm (¾in) flat brush is ideal for painting this using a side to side motion with the tip of the brush. This brush is also excellent for lifting out colour in a controlled way.

1 Wet the sky and water areas and paint ultramarine in the top of the sky and bottom of the water with the 19mm (¾in) flat brush.

2 Paint the wooded background wet into wet with downwards strokes of the brush and a mix of burnt umber and ultramarine. Paint the reflection in the water, then break it up into ripples with the flat of the brush.

3 Add further ripples with ultramarine, reflecting the sky.

4 Paint the tree trunks with burnt umber and ultramarine on the medium detail brush, using a paler mix for the more distant trees on the right. Add twigs with the half-rigger.

5 Paint broken reflections of the trunks in the water.

6 Wet the 19mm (¾in) flat brush and squeeze it out to create a thirsty brush. Use this to lift out colour from the left-hand sides of all the trees to suggest light coming from the left.

7 Use the thirsty brush to lift out ripples in the water.

8 Paint shadows in the snow with cobalt blue then allow to dry to finish.

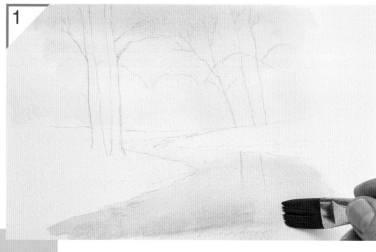

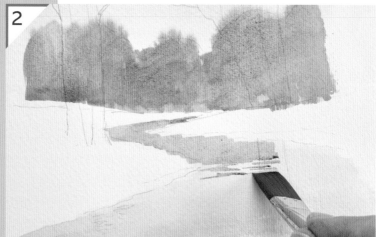

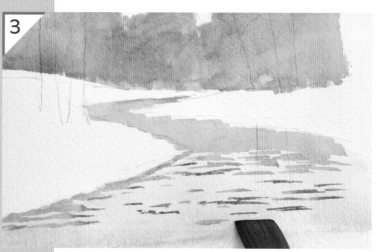

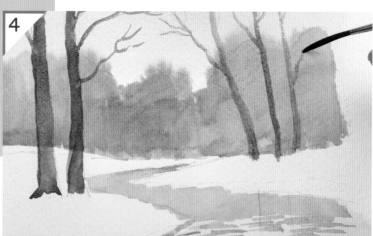

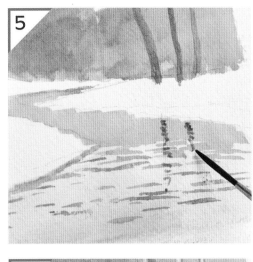

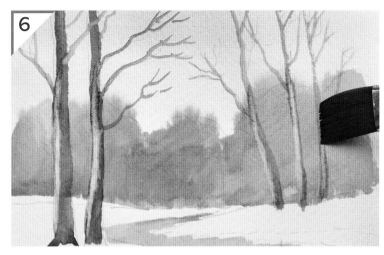

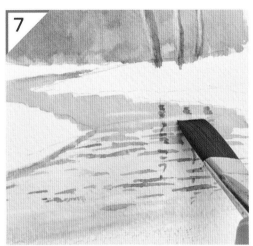

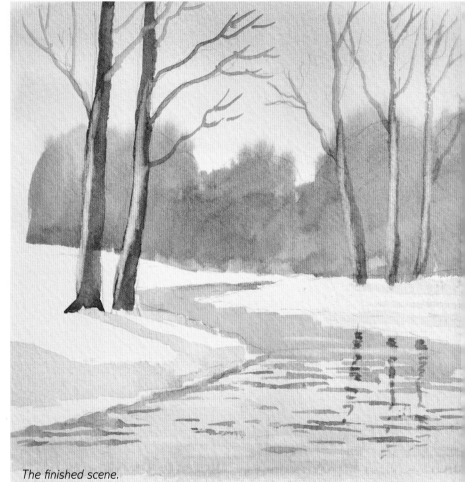

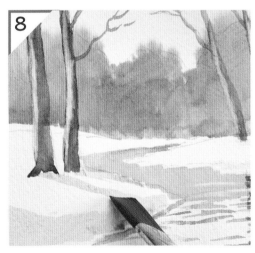

The finished scene.

Half-rigger

The half-rigger has a really fine point but holds a lot of paint. The hair is long, though not as long as a rigger.

Painting grasses with the half-rigger brush

The half-rigger's light touch is ideal for delicate details.

Here the half-rigger is shown painting grasses peeping through the snow.

Painting twigs with the half-rigger brush

This brush is excellent for painting the branches of winter trees. For many of my snow scenes, I use this brush to paint the finest twigwork.

Here I am using the brush to paint the finest twigs at the end of this tree's branches.

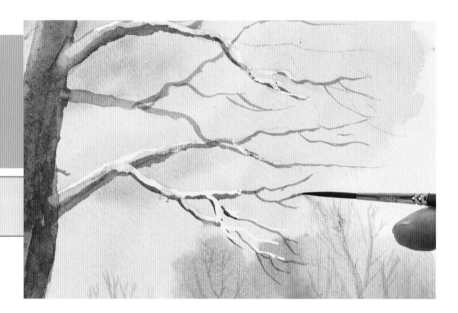

Opposite

COOL WATERS

The half-rigger makes painting fine grasses and branches a pleasure. The 19mm (¾in) flat is an ideal brush to create the movement and ripples of the water in the foreground.

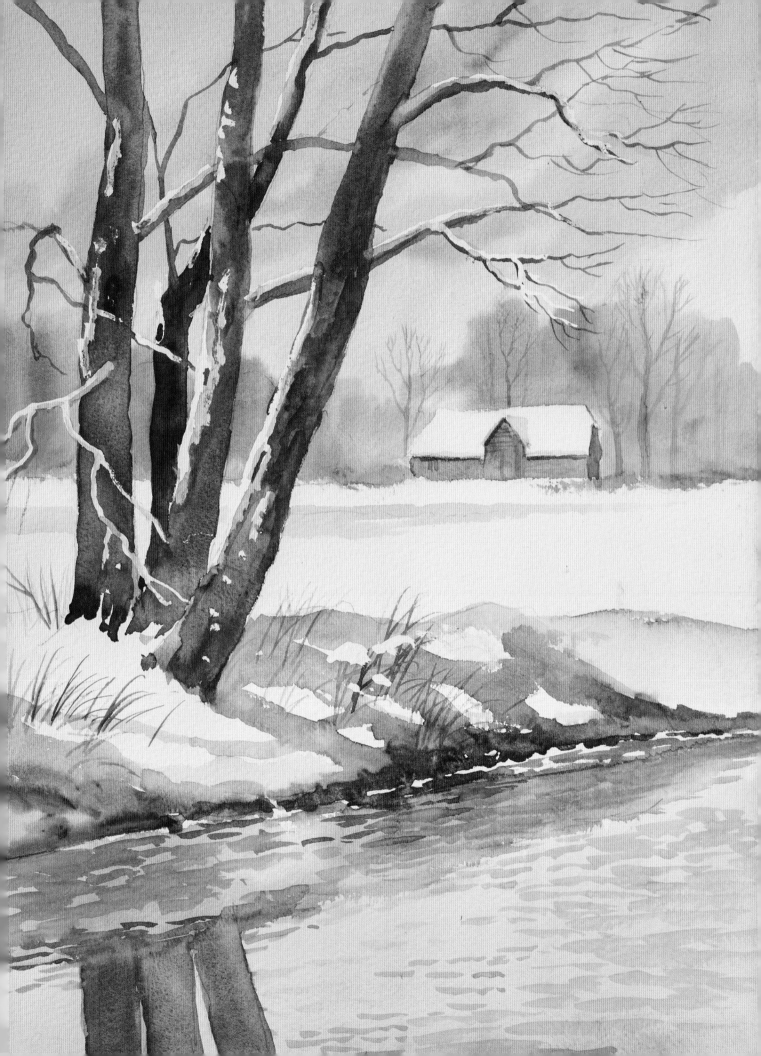

Funky pouncer

This brush, a recent addition to my armoury of brushes, is made from strips of durable leather, bound together with a nickel ferrule. It has a clear acrylic resin handle and a soft, non-slip rubber grip.
It is designed to create texture by stippling (pouncing).

Creating texture with the funky pouncer

Great for creating random, natural-looking texture, here I am using the pouncer with white gouache to add snow clinging to winter branches.

Here I am dabbing the pouncer lightly up and down on the trees to deposit pure white gouache. This creates lots of little dots of paint – a technique called stippling.

The snow clinging to winter branches in this painting was stippled in the same way. This easy technique adds wonderful texture.

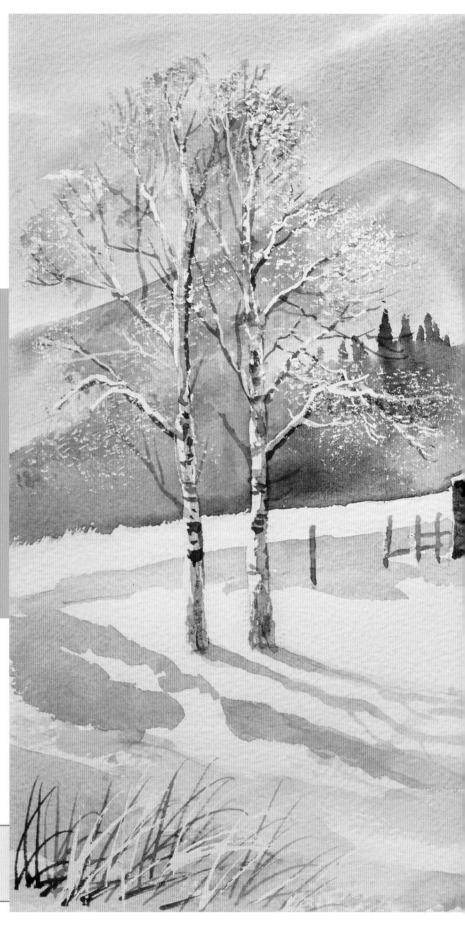

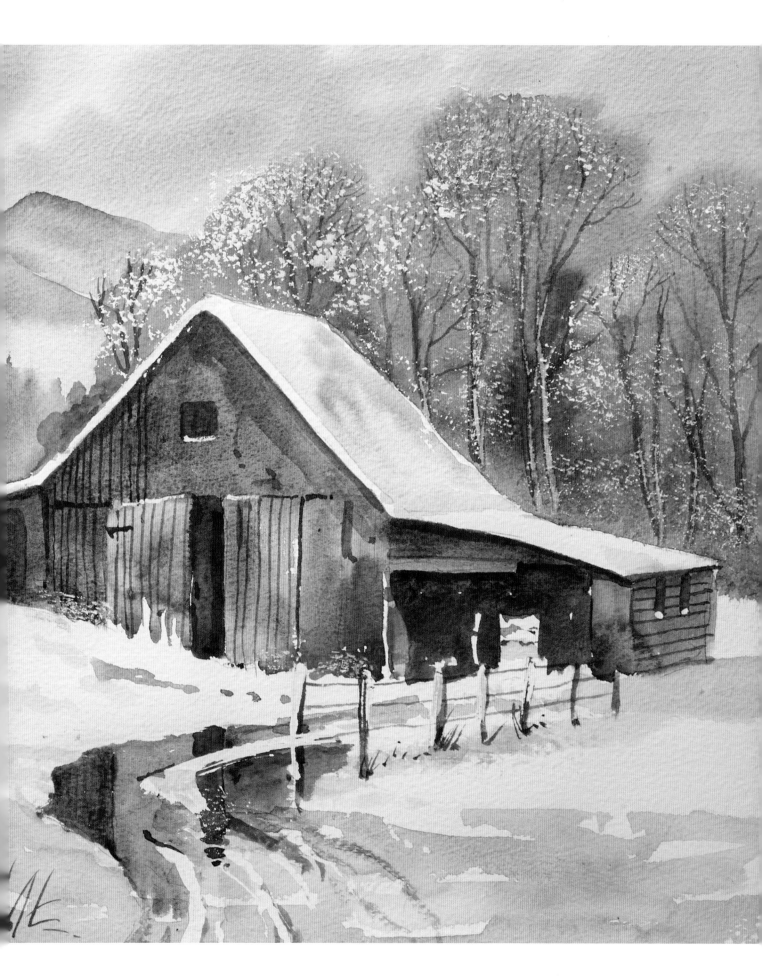

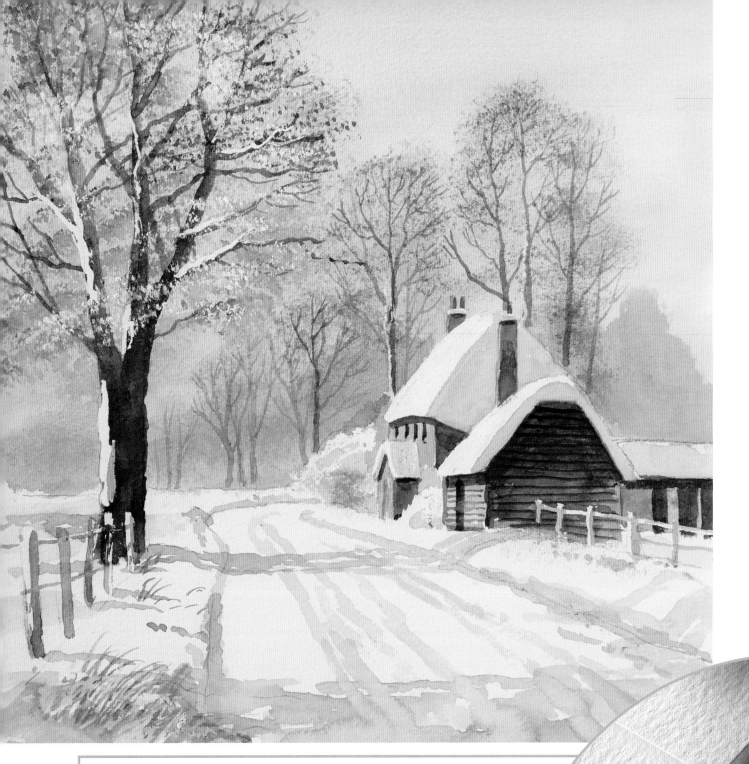

MY PAPER

Watercolour paper comes in different weights and in three surfaces: smooth (called hot-pressed or HP), semi-smooth (called Not) and Rough. I usually use 300gsm (140lb) Rough paper, because the texture is useful for many of my techniques. You can use Not paper of the same weight if you need a smoother surface for detailed work.

I never bother to stretch paper before painting. If a painting cockles as it dries, turn it face down on a smooth, clean surface and wipe the back all over with a damp cloth. Place a drawing board over it and weigh it down. Leave it to dry overnight and the cockling will disappear.

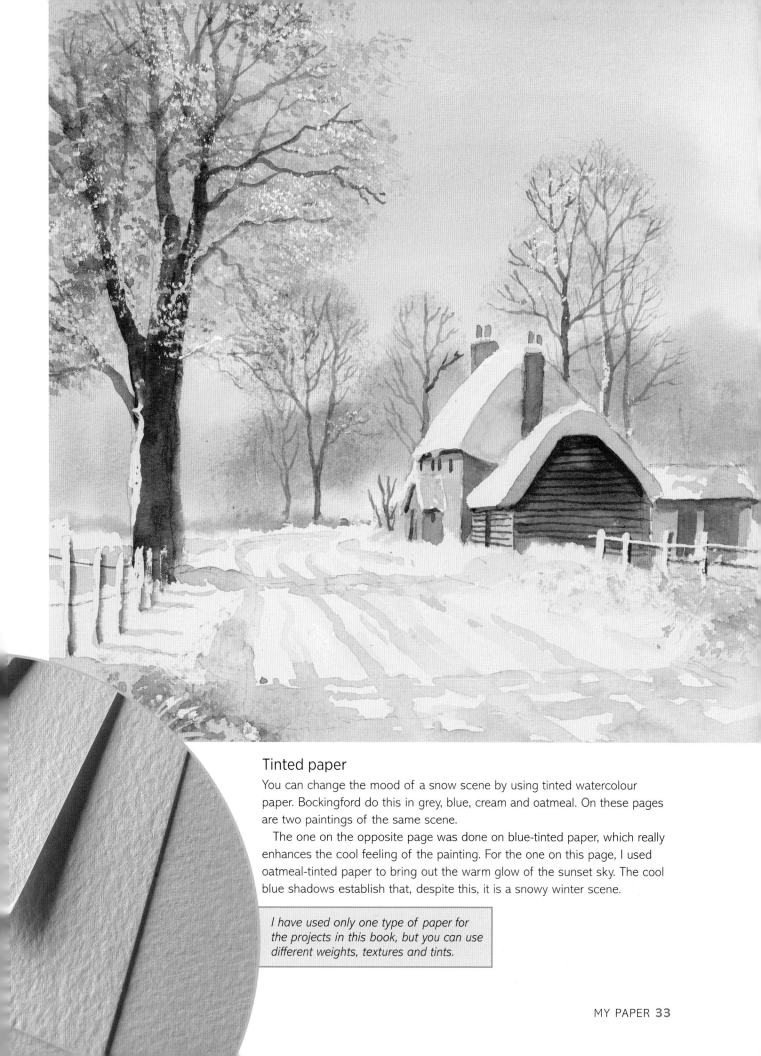

Tinted paper

You can change the mood of a snow scene by using tinted watercolour paper. Bockingford do this in grey, blue, cream and oatmeal. On these pages are two paintings of the same scene.

The one on the opposite page was done on blue-tinted paper, which really enhances the cool feeling of the painting. For the one on this page, I used oatmeal-tinted paper to bring out the warm glow of the sunset sky. The cool blue shadows establish that, despite this, it is a snowy winter scene.

I have used only one type of paper for the projects in this book, but you can use different weights, textures and tints.

OTHER MATERIALS

In addition to the range of brushes, and selection of paints and papers detailed on the previous pages, you will need a few other useful tools and materials, which are explained here.

Hairdryer
This can be used to speed up the drying process if you are short of time.

Masking fluid
This is applied to keep the paper white where you want to achieve effects such as snow on woodwork or branches.

Soap
A bar of soap is useful to protect your brushes from masking fluid. Wet the brush and coat it in soap before dipping it in the masking fluid. When you have finished applying the masking fluid, it washes out of the brush with the soap.

Ruling pen
This can be used with masking fluid to create fine, straight lines.

Masking tape
I use this to tape paintings to my drawing board and to create a straight horizon.

Pencil and sharpener
A 2B pencil is best for sketching and drawing, and you should always keep it sharp.

Eraser
A hard eraser is useful for correcting mistakes and removing masking fluid.

Kitchen paper
This is used to lift out wet paint, for instance when painting clouds and to apply masking fluid for some techniques.

Bucket
Your brushes need to be rinsed regularly. This trusty bucket goes with me on the painting demonstration circuit so that I am never short of water.

SHORTCUT TO THE FARM

Masking fluid was applied with a ruling pen on the fence wires and the grasses in the foreground, and with a brush on the fencepost and stile.

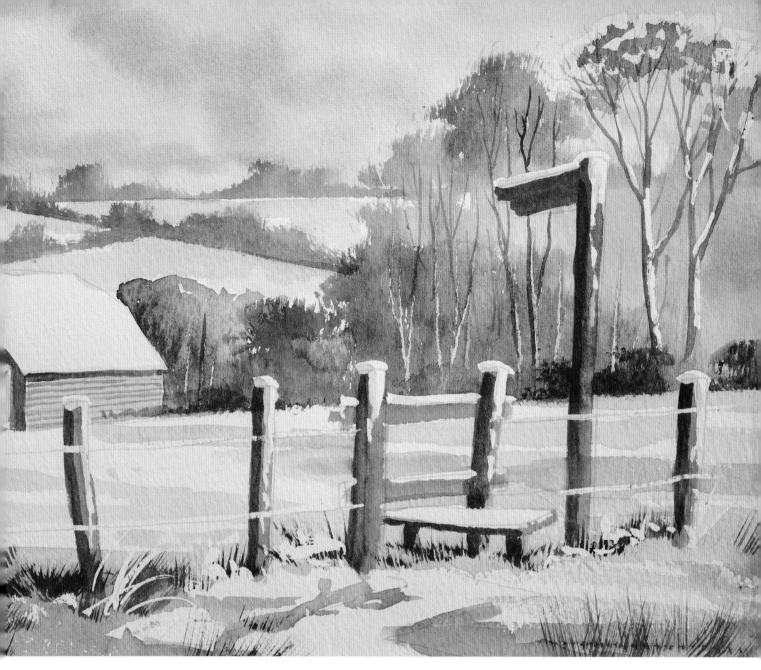

Easel

This is my ancient box easel. You can stand at it, as I do, or fold the legs away and use it on a table top. There is a slide-out shelf that holds your palette. This particular one collapsed shortly after we photographed it, after twenty years' service, but I have used the good bits, together with another easel, to rebuild it.

Wipe-away tool

This new addition to my painting kit is great for applying masking fluid and is therefore ideal for snow paintings.

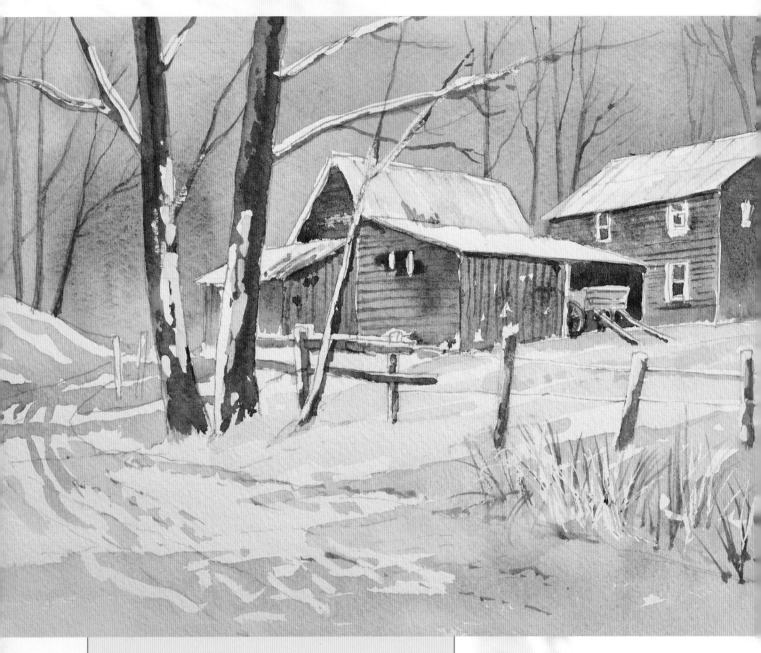

THE FARM IN SNOW

A variety of brushes were used to paint this attractive farmhouse. In particular, the half-rigger was used to paint the foreground grasses and the finer details of the woodwork in this painting.

Opposite

WINTER LANE

In this painting, the two pheasants crossing the lane make the perfect finishing touch. They are a focal point, drawing the eye into the painting and their warm, bright colours contrast with the cool tones in the snow shadows.

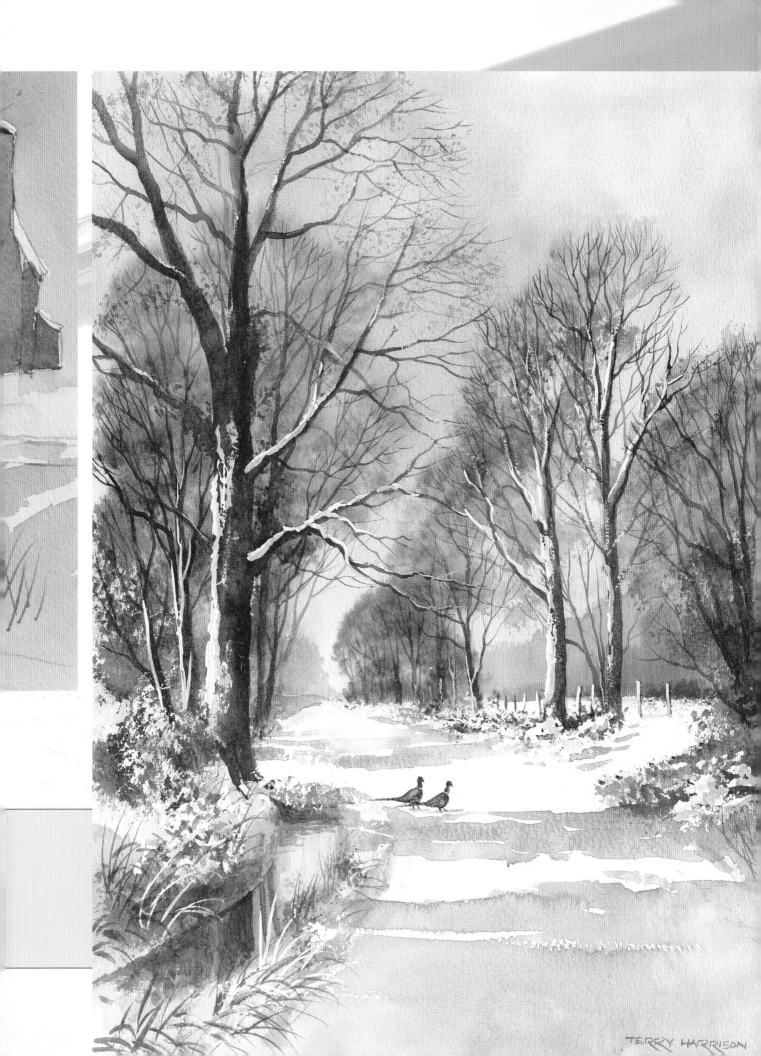

TERRY HARRISON

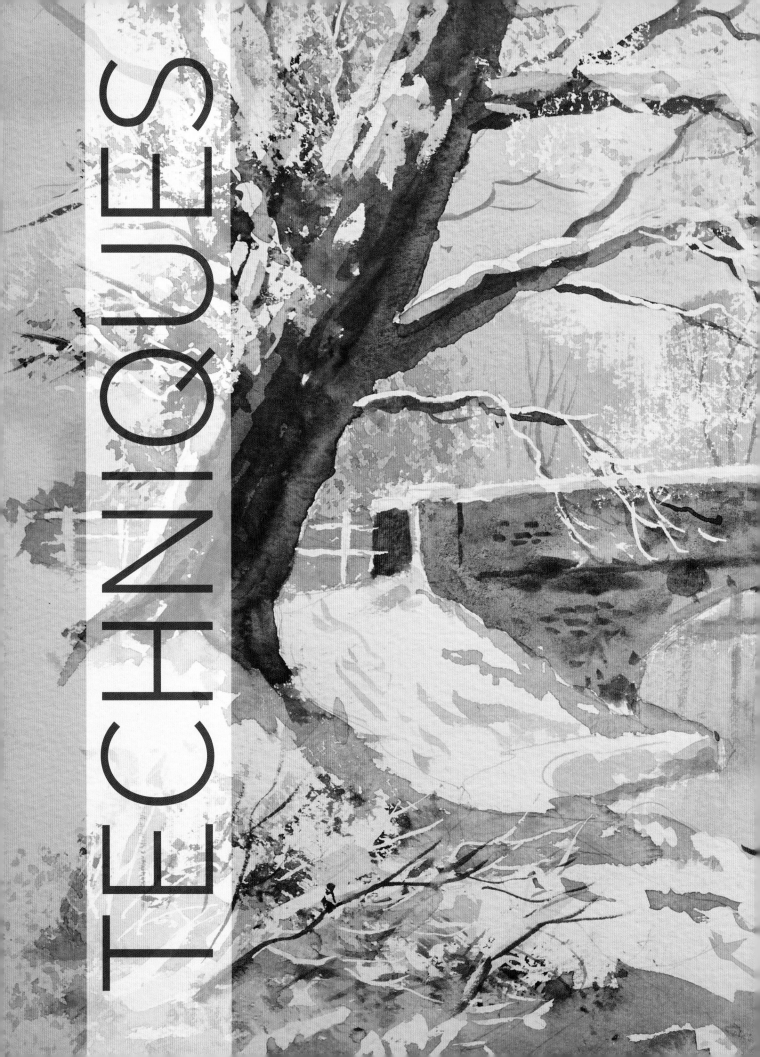

TECHNIQUES

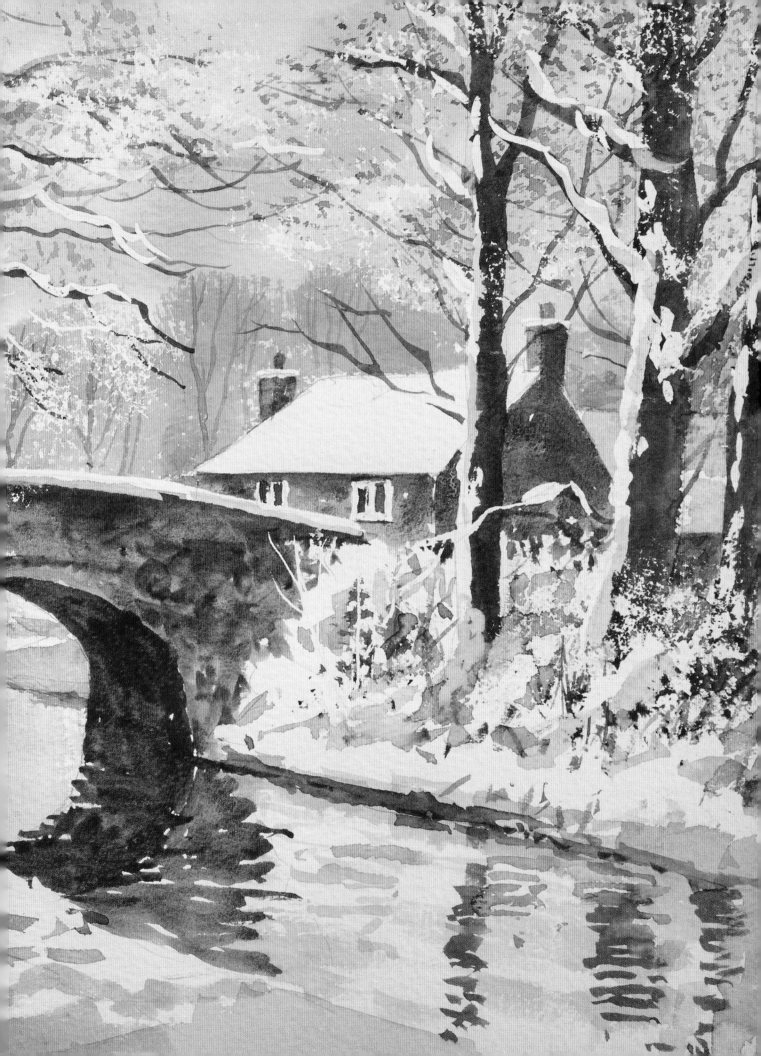

Snow scenes need not be cold or colourless. Here I show you how to capture the warm glow of the low winter sun shining through trees, using wet into wet techniques to create the sunset sky.

1 Mask out the sun with the small detail brush and masking fluid. Wet the sky area with the golden leaf and paint a band of cadmium yellow across the sun, then paint a mix of cadmium yellow and permanent rose at the top and bottom of the painting while this is wet.

2 Paint cobalt blue with a little permanent rose at the top of the scene.

3 Still painting wet into wet, use the fan gogh to paint a mix of burnt sienna and shadow to create the background trees. Allow to dry.

4 Use the golden leaf brush to stipple foliage with shadow and burnt sienna.

5 Lift out some colour around the sun with kitchen paper.

6 Use the half-rigger with shadow and burnt umber to paint the trunks and branches.

7 Remove the masking fluid with a clean finger and use the half-rigger to paint a mix of cadmium red and cadmium yellow to show the branches going over the sun. Lift out a little colour with kitchen paper to soften the effect.

8 Soften the edges of the sun a little with white gouache.

9 Use the large detail brush and a mix of cobalt blue and permanent rose to paint shadows on the snow.

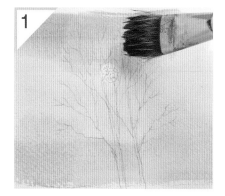

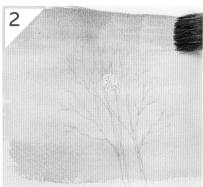

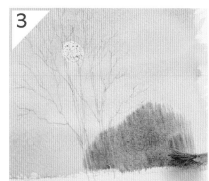

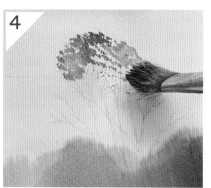

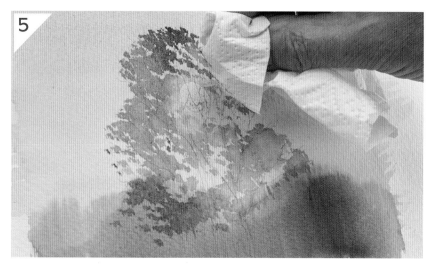

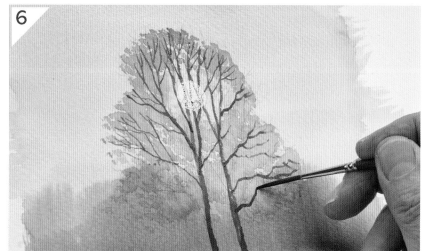

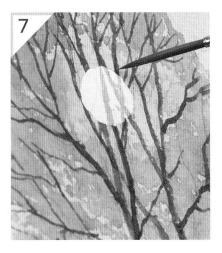

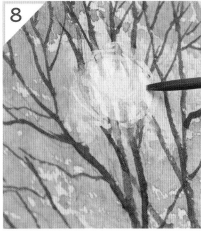

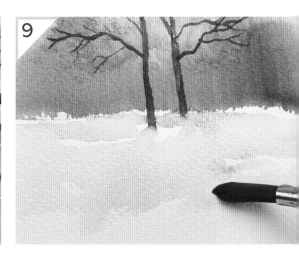

The finished painting.

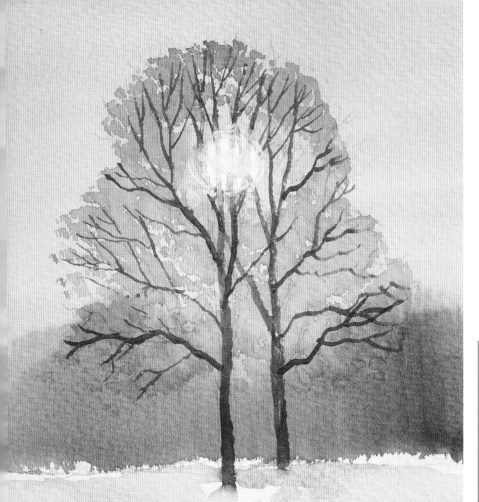

Overleaf

THE SUN THROUGH
THE TREES

The late afternoon sun glows through the trees and warms the sky with yellows and crimsons. The foreground snow has a hint of warmth just below the sun while the rest of the snow keeps its cool. The long, snow-covered branches of the tree in the foreground link one side of the painting with the other. Masking fluid, placed on top of the horizontal branches, becomes snow when rubbed off. The texture of the undergrowth was created by applying masking fluid using a metal kitchen scourer (see page 46).

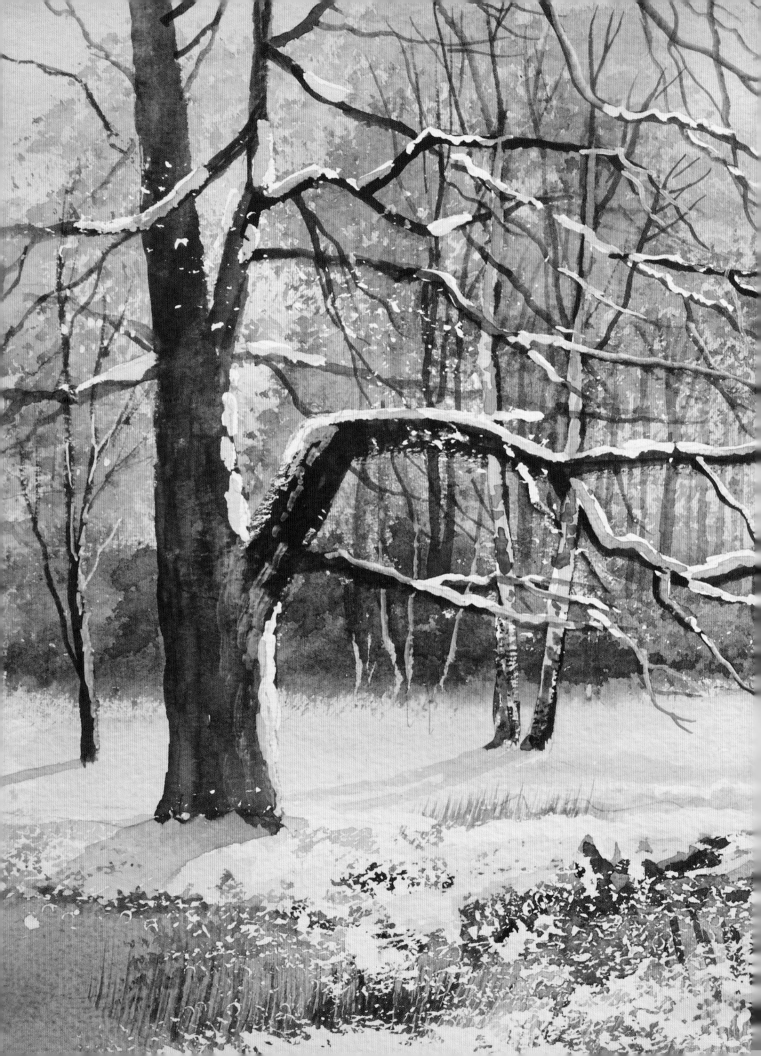

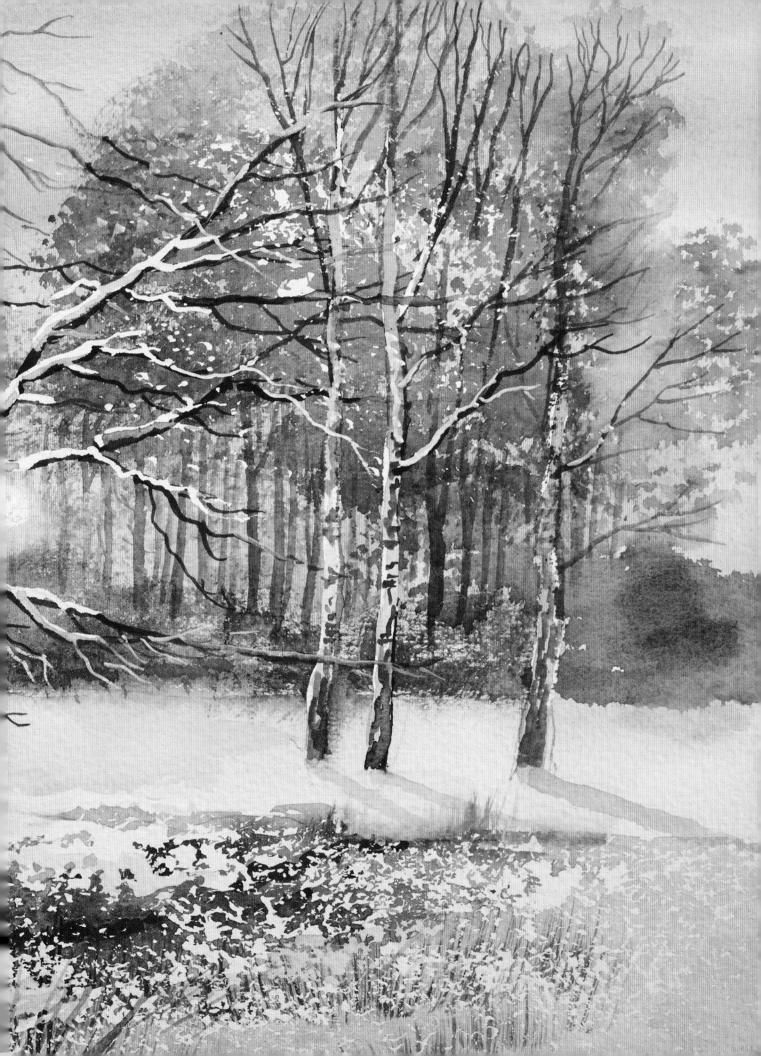

Using kitchen paper

This is an effective way of creating the texture of snow clinging to winter branches.

1 Pour a little masking fluid into a saucer and dab a piece of kitchen paper into it.

2 Use this to dab masking fluid onto your tree. Allow to dry.

3 Use the fan gogh to wet the whole area and paint on ultramarine, then a mix of ultramarine and burnt umber, wet into wet. Allow to dry.

4 Use the half-rigger with a dark mix of ultramarine and burnt umber to paint the trunk and branches. Allow to dry, then rub off the masking fluid with a clean finger to reveal the white of the paper, suggesting snow.

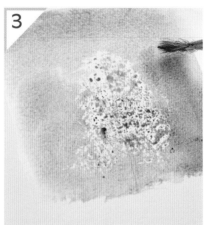

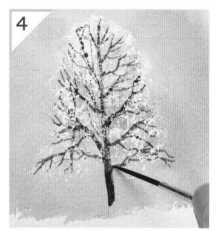

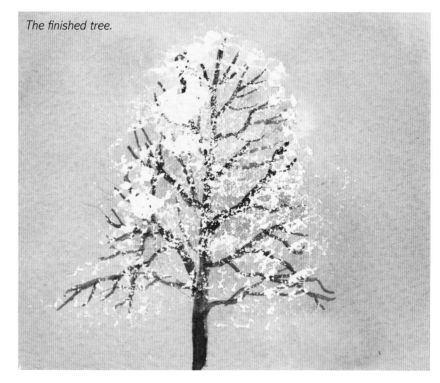

The finished tree.

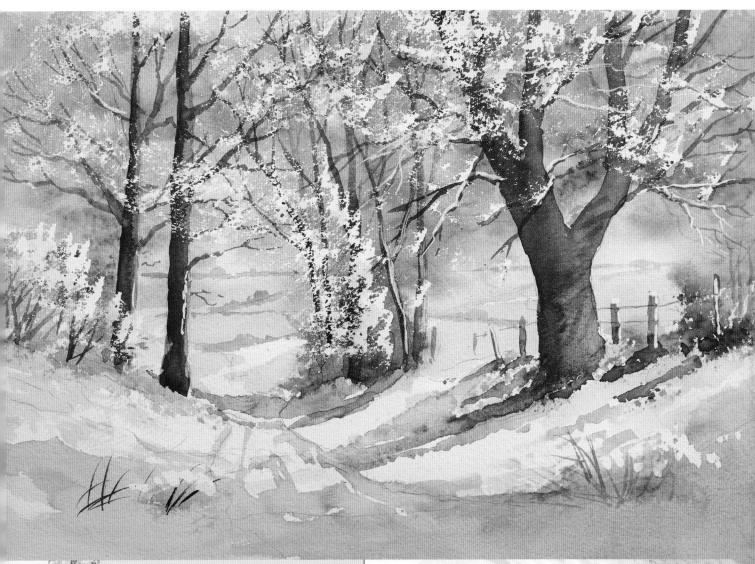

A HEAVY FALL OF SNOW

The masking fluid for the snow clinging to the branches was applied using kitchen paper.

MASKING FLUID TREES

Using a wipe-away tool and scourer

The wipe-away tool allows you to apply masking fluid in a more controlled way, and an ordinary kitchen scourer like the one shown is ideal for creating texture.

1 Draw the winter tree. Use the wipe-away tool to apply masking fluid to the left-hand side of the trunk and the top edges of the branches to suggest snow that has fallen quite thickly and clung on. Allow to dry.

2 Dip a kitchen scourer in masking fluid. This one is wire wool and has a good, random texture – you don't want to create a regular pattern. Apply the masking fluid to the tree, suggesting snow in the twigwork. Allow to dry.

3 Wet the whole painting area with the fan gogh brush and then paint on a wash of ultramarine. Allow to dry.

4 Use the half-rigger to paint a dark mix of ultramarine and burnt umber on the undersides of the branches topped with masking fluid. Paint in the same way down the left-hand side of the trunk. Allow to dry and rub off the masking fluid with clean fingers.

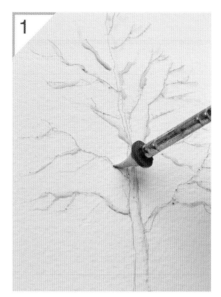

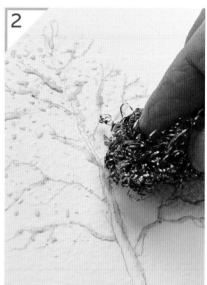

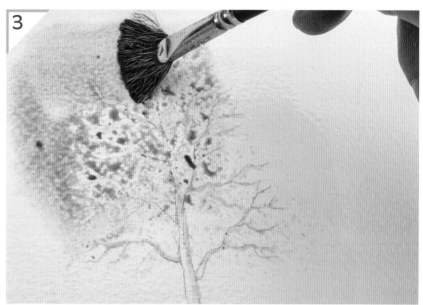

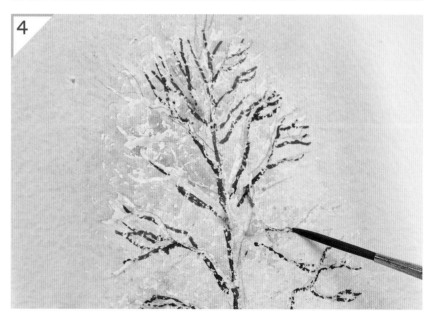

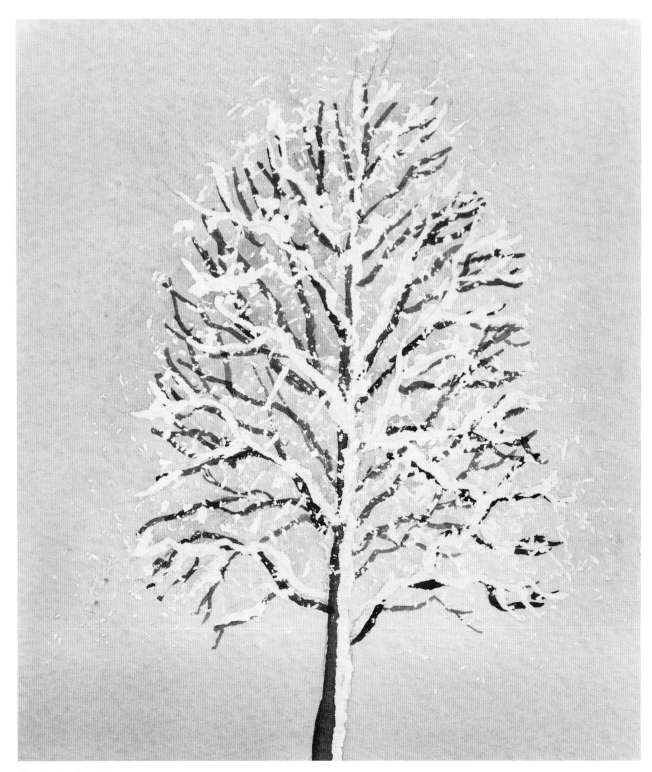

The finished painting.

Using a brush: Snow on fir trees

Here a brush is used to apply masking fluid to create clumps of snow on fir tree branches, both near and far.

1 Apply masking fluid to the branches of the fir tree with a brush to suggest clumps of snow. Also mask out the two more distant trees on the right. Allow to dry.

2 Use the golden leaf brush to wet the sky, then paint a wash of raw sienna across the middle of the painting.

3 Paint ultramarine at the top and bottom of the sky, working wet into wet. Before this dries, use the fan gogh to drop a slightly thicker mix of ultramarine into the background, suggesting distant fir trees.

4 Drop a little midnight green into the background fir trees.

5 Paint the fir tree with midnight green. Allow to dry.

6 Rub off the masking fluid with a clean finger. Use the small detail brush to paint shadow on the clumps of snow with cobalt blue.

7 Paint shdows in the snow beneath the fir tree with the same brush and colour.

8 Finally, paint shadows on the two more distant fir trees in the same way.

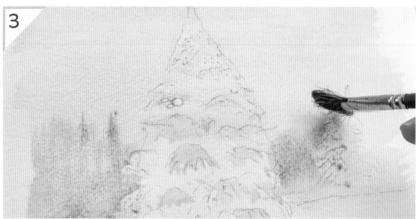

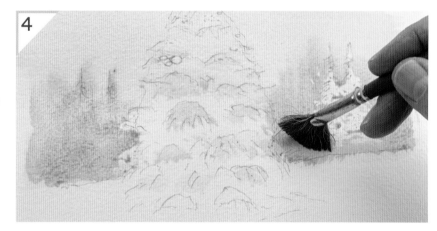

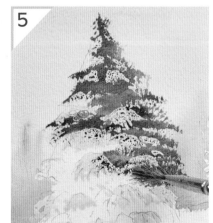

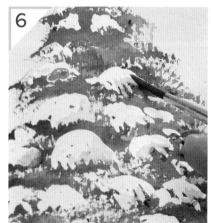

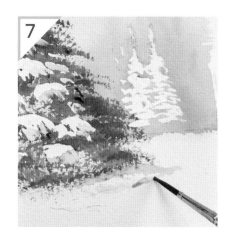

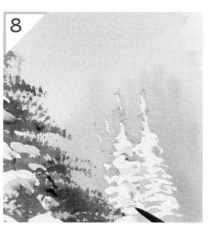

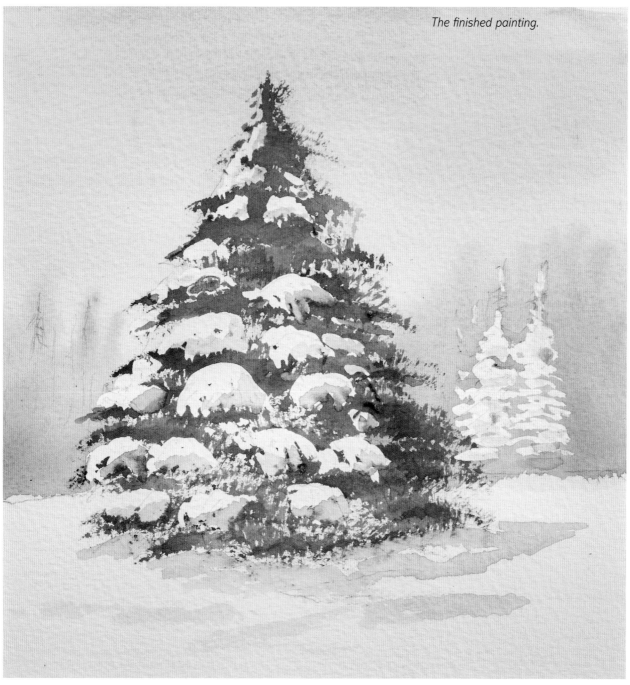

The finished painting.

DRY BRUSHWORK TRACKS

You will need to use Rough surface watercolour paper to create the texture of the tracks with this technique.

1 Apply masking fluid to the tracks, fenceposts, trunks and branches using the wipe-away tool. Allow to dry, then pour a little masking fluid into a saucer and use a kitchen scourer to apply it to the twigwork of the trees.

2 Wet the sky area and paint on raw sienna in the lower sky with the golden leaf brush. Paint ultramarine at the top of the sky, coming down into the yellow, wet into wet.

3 Still working wet into wet, paint on clouds, going over the tree area with a mix of shadow and ultramarine.

4 Use this same mix to paint shadows along the tracks in the snow. Allow the painting to dry.

5 Take the large detail brush and paint the background hill with a mix of cobalt blue and shadow. Paint the field in front of this with a wash of raw sienna.

6 Drop shadow into the lower part of the field wet into wet.

7 Paint cobalt blue shadows on the snow either side of the track, and allow the painting to dry.

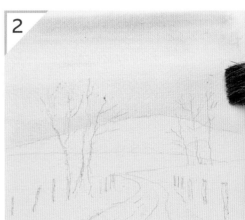

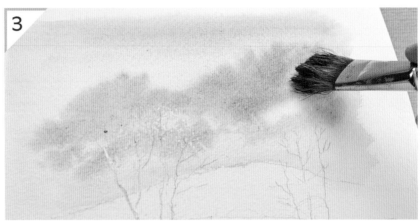

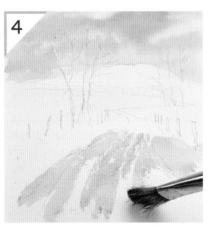

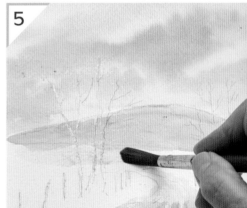

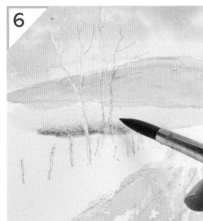

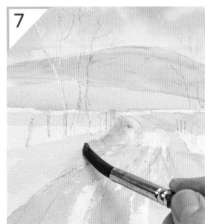

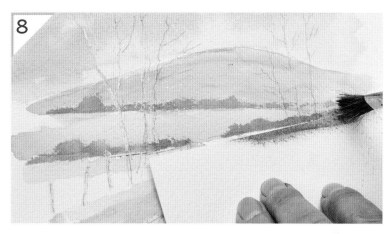

8 Use a paper mask to mask the area below the hill. Using the foliage brush, stipple on a distant hedgerow with a mix of cobalt blue and shadow. Add burnt sienna to the mix and bring the paper mask forwards at an angle as shown. Stipple on another hedgerow.

9 Stipple foliage on the trees with the foliage brush and a mix of shadow and burnt sienna.

10 Use the half-rigger and a mix of shadow and burnt sienna to paint the trunks, branches and fenceposts. Allow the painting to dry. Mix burnt umber and ultramarine to paint the fence wire with the same brush.

11 Take the medium detail brush and blot off any excess moisture using kitchen paper, then pick up a fairly dry mix of burnt umber and ultramarine. Drag the dry brush over the surface of the paper to create the texture of the ruts in the snow receding down the track into the distance.

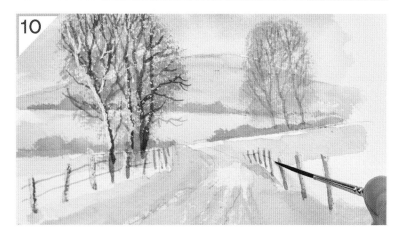

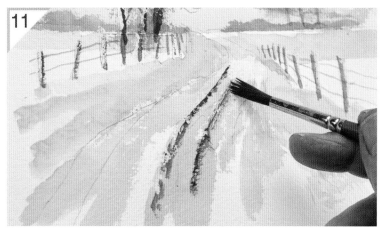

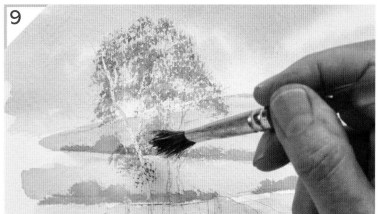

OVERLEAF

The finished painting.

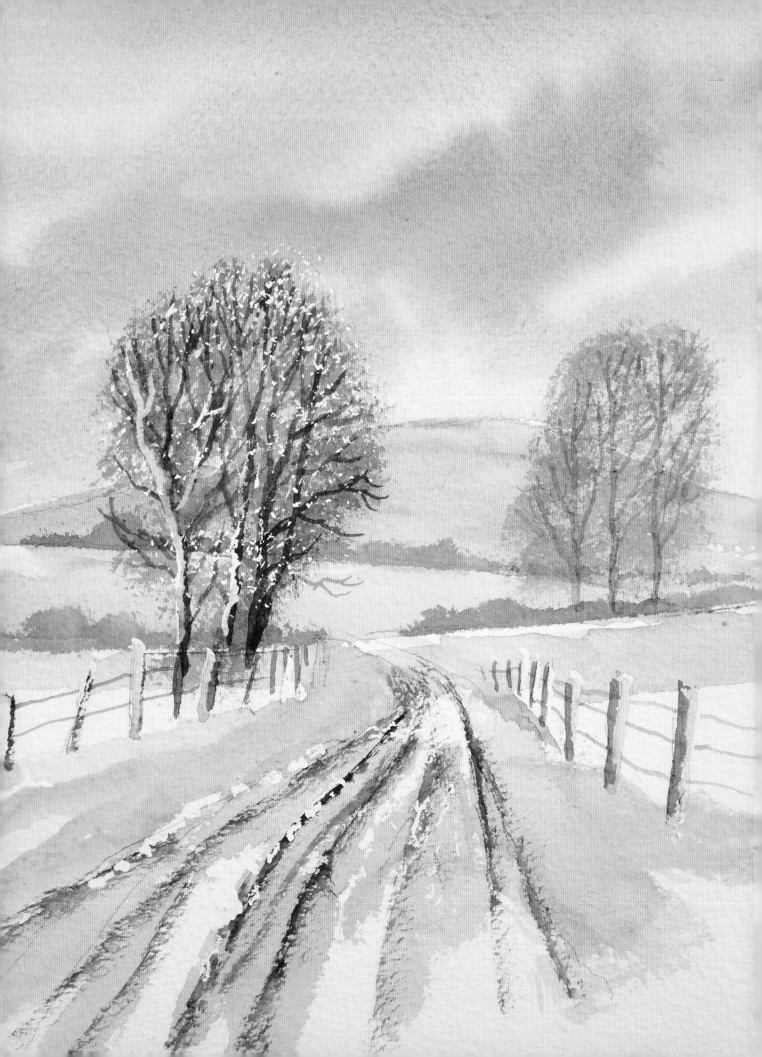

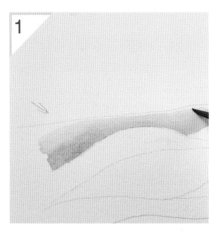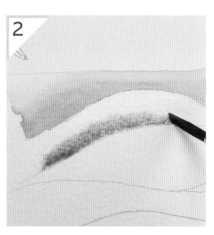

1 Draw an arrow to remind yourself of the direction of the light, which in this scene is coming from above left. Use the medium detail brush and cobalt blue to paint the shadow behind the top snowdrifts. Use a brush dampened with clean water to fade off the top while it is wet.

2 Leave a dry gap beneath this first shadow, then wet the area below this. Drop cobalt blue into the wet shape.

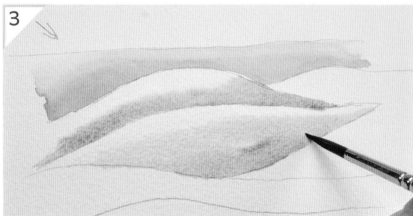

3 Continue in this way, leaving dry white paper for the lit snowdrifts and painting cobalt blue into the wet background for shadow.

4 Complete the shapes as shown.

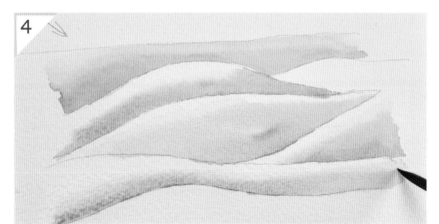

The finished snowdrifts.

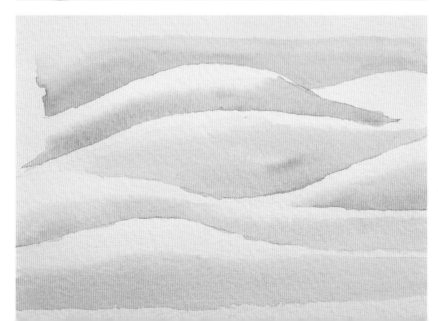

1 Paint the snow on the rocks and the ripples in the water with masking fluid and a small brush. Allow to dry.

2 Use the medium detail brush and ultramarine to paint the sky.

3 Mix ultramarine and burnt umber and paint the rocks beneath their snowy caps. Vary the mix to create a natural look.

4 Change to the 19mm (¾in) flat brush and use the straight edge to paint ripples in the water with ultramarine and burnt umber. Again, vary the mix. Allow to dry.

5 Rub off the masking fluid with a clean finger. Wet the white paper left for snow, leaving a dry gap at the top, which will suggest bright highlights. Drop in cobalt blue for shadows on the snow with the small detail brush.

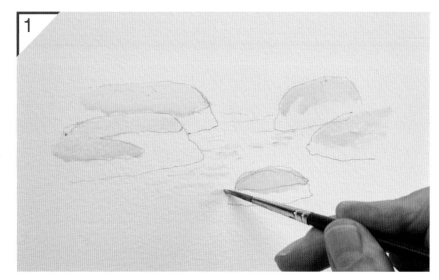

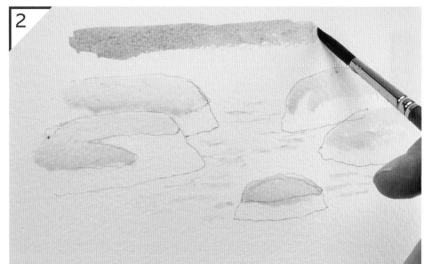

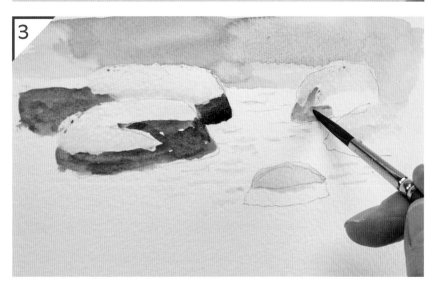

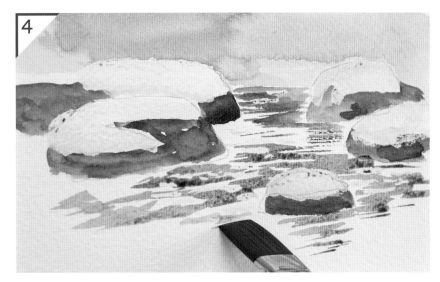

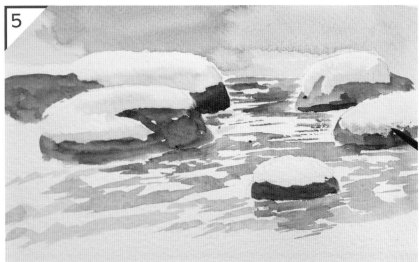

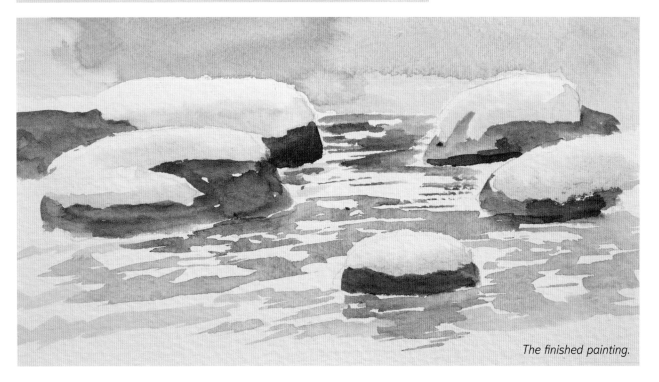

The finished painting.

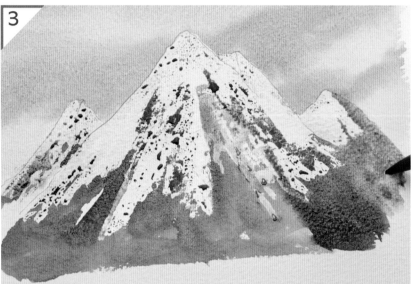

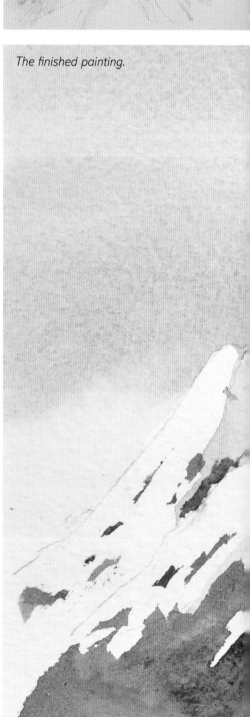

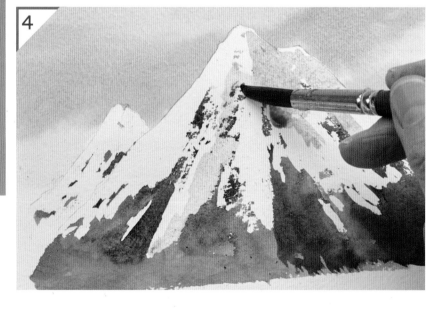

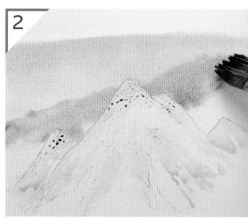

The finished painting.

1 Apply masking fluid to the areas you want to be snowy, using a brush. Allow to dry.

2 Wet the whole painting with the golden leaf brush and paint ultramarine over the sky area, then drop in a thicker mix of ultramarine and burnt umber to suggest clouds.

3 Use the large detail brush with a darker mix of ultramarine and burnt umber to paint the lower, rocky parts of the mountains. Vary the mix and allow to dry. Rub off the masking fluid.

4 Paint the shaded parts of the snow with the large detail brush and cobalt blue.

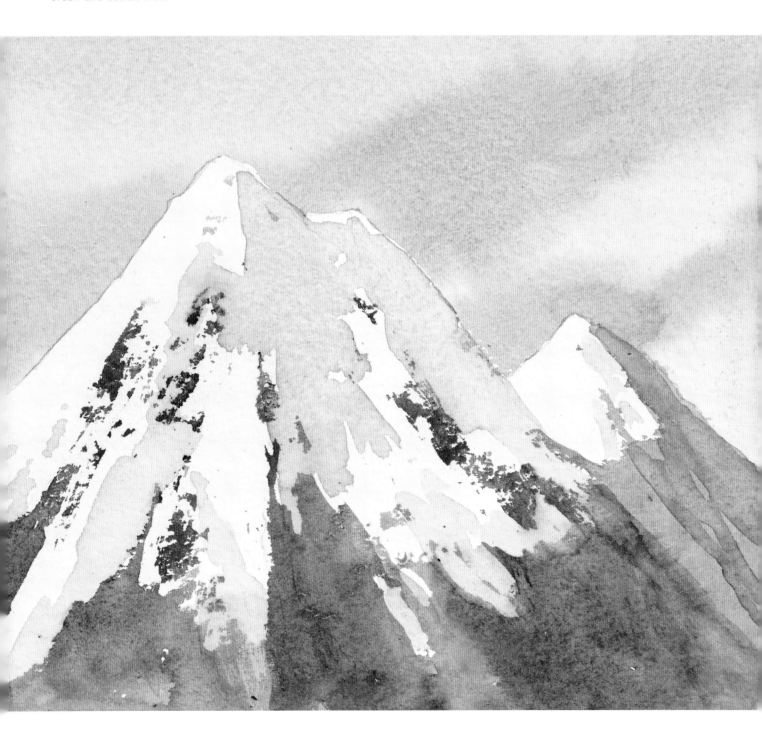

SILVER BIRCHES

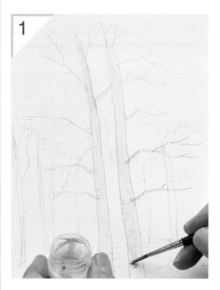

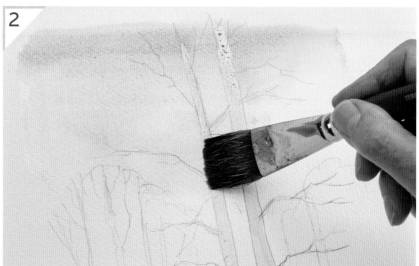

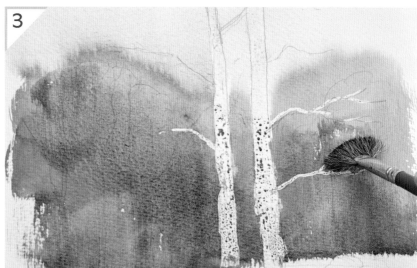

1 Apply masking fluid to the tree trunks and branches, using a brush. Allow to dry.

2 Wet the sky area with the golden leaf brush and paint the sky with a wash of ultramarine.

3 While this is wet, use the fan gogh to paint the background wooded area with a mix of ultramarine and burnt umber. Make this darker lower down.

4 When this area is just damp, use the shaped end of the stippler px brush to scratch out the trunks and branches of more distant trees.

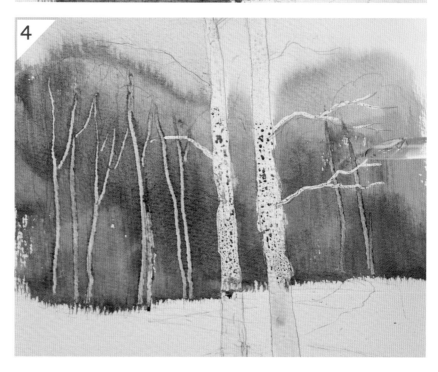

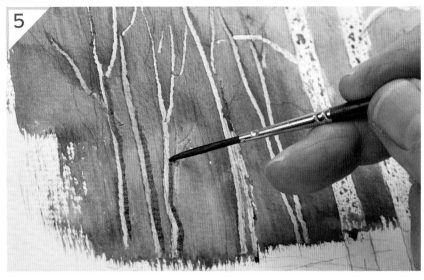

5 Use the half-rigger to paint the shaded right-hand sides of the scratched-out trunks with ultramarine and burnt umber.

6 Add branches and twigwork to the distant trees using the same brush and mix.

7 Take the large detail brush and paint shadows on the foreground snow with cobalt blue. Allow to dry, then rub off the masking fluid.

8 Use the small detail brush with ultramarine and burnt umber to paint the shapes of the broken bark on the lower trunks.

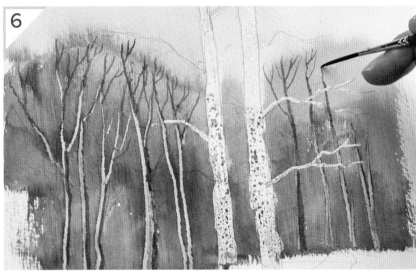

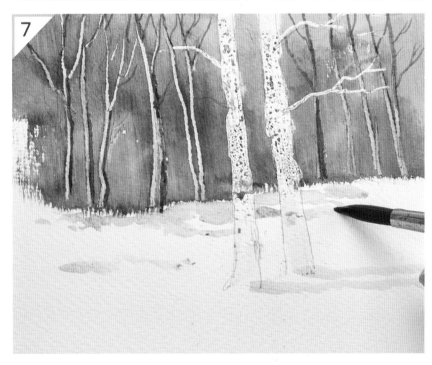

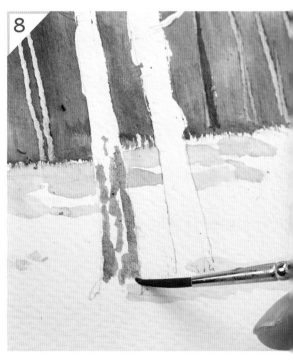

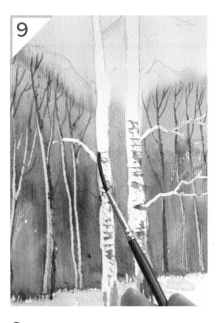

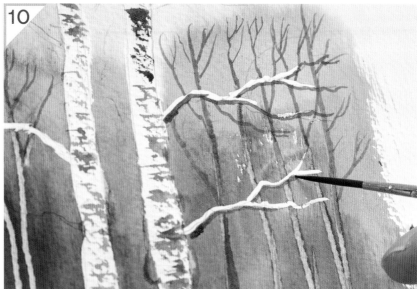

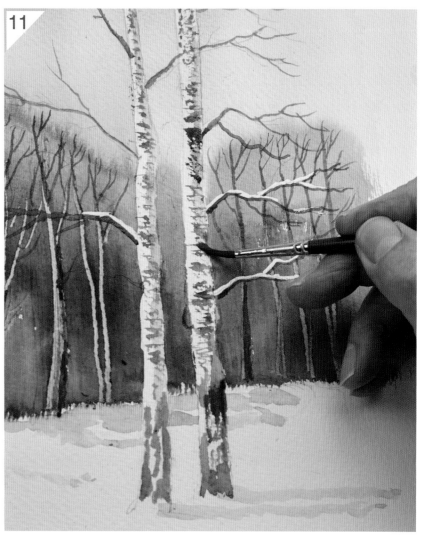

9 Change to the half-rigger and use a dry mix of the same colours to paint the texture of the bark higher up with dry brushwork. Hold the brush almost flat on the paper and drag it sideways.

10 Paint the shade under the snow-capped branches which were masked out with the same brush and mix.

11 Paint the shaded sides of the trunks with the small detail brush and cobalt blue.

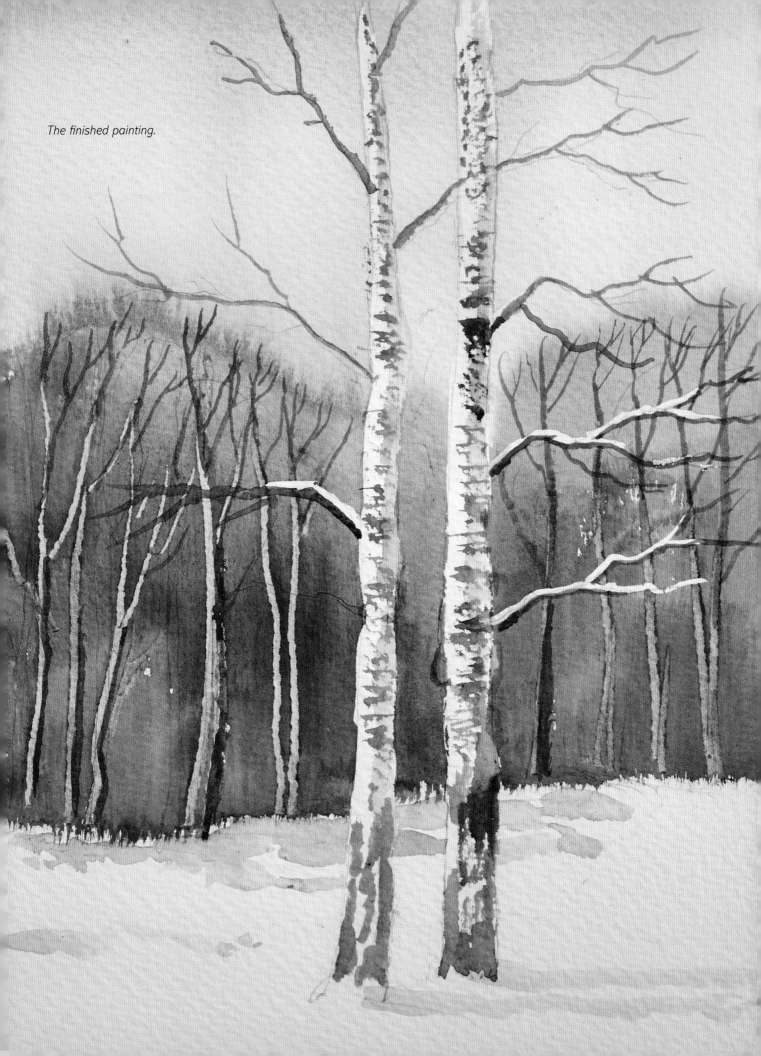

The finished painting.

It is very rare to find yourself in the right place at the right time to photograph that perfect snow scene. However, there is nothing to stop you working from scenes without snow, and adding the wintry touch in your painting, as in the following examples.

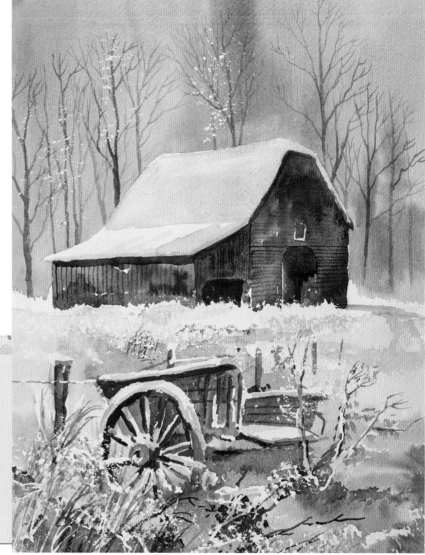

BARN AND WAGON IN SNOW

Old carts and tractors are ideal for adding interest and detail to the foreground. In the painting, I have given this old wagon a coating of snow, which has settled on the top of the woodwork and also the wagon wheels and spokes.

This painting is also shown on page 98, at a larger size.

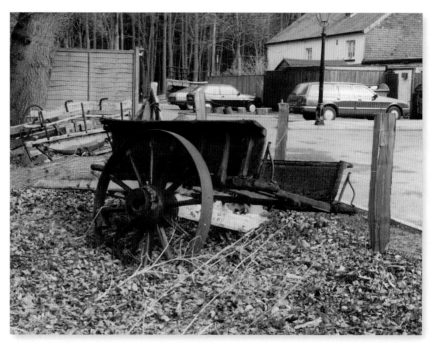

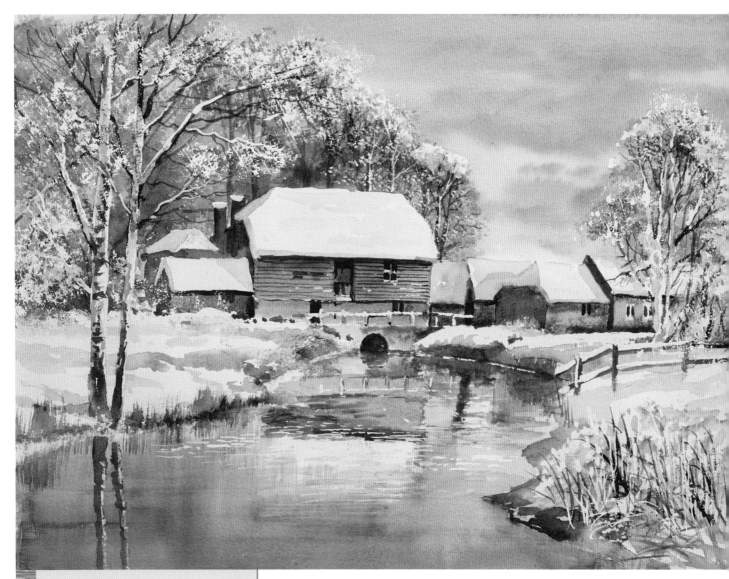

THE OLD MILL

In this snowy rendition of the scene, I took the mill and outbuildings from the reference photograph, but with a few changes: the tree in front was moved to the left so that the mill remains in sight, and some dark trees were added behind the mill to help it stand out more.

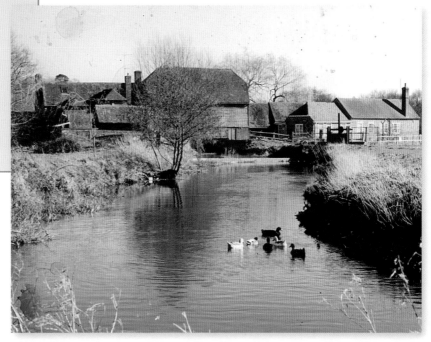

Combining photographs

Here you can see a set of photographs taken at the same location at various times, some in different seasons of the year. I used all these as reference, but added snow, creating a painting with quite a different mood.

The photograph below gave me the basic structure of the buildings and bridge, though I took a little information from all of the other photographs as well, in order to help build up a more complete picture. Using some artistic licence, I added snow to the horizontal surfaces such as the rooftops, branches, window ledges and the ground.

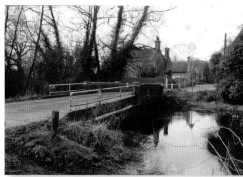

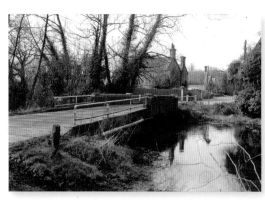

Another scene, painted from the same photographs, is shown below. The bridge leads the eye over the river to the buildings, where the lit windows add a warm, welcoming touch.

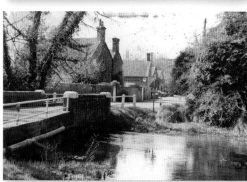

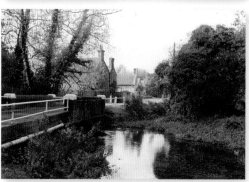

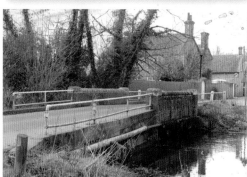

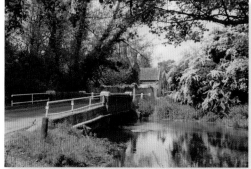

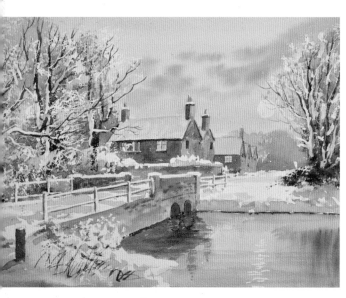

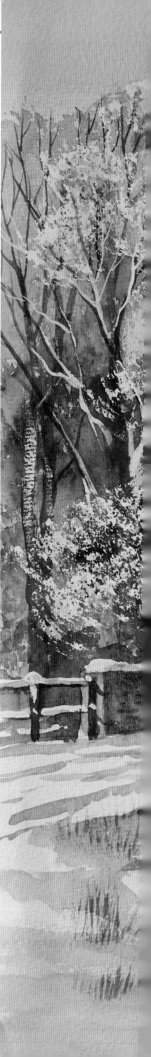

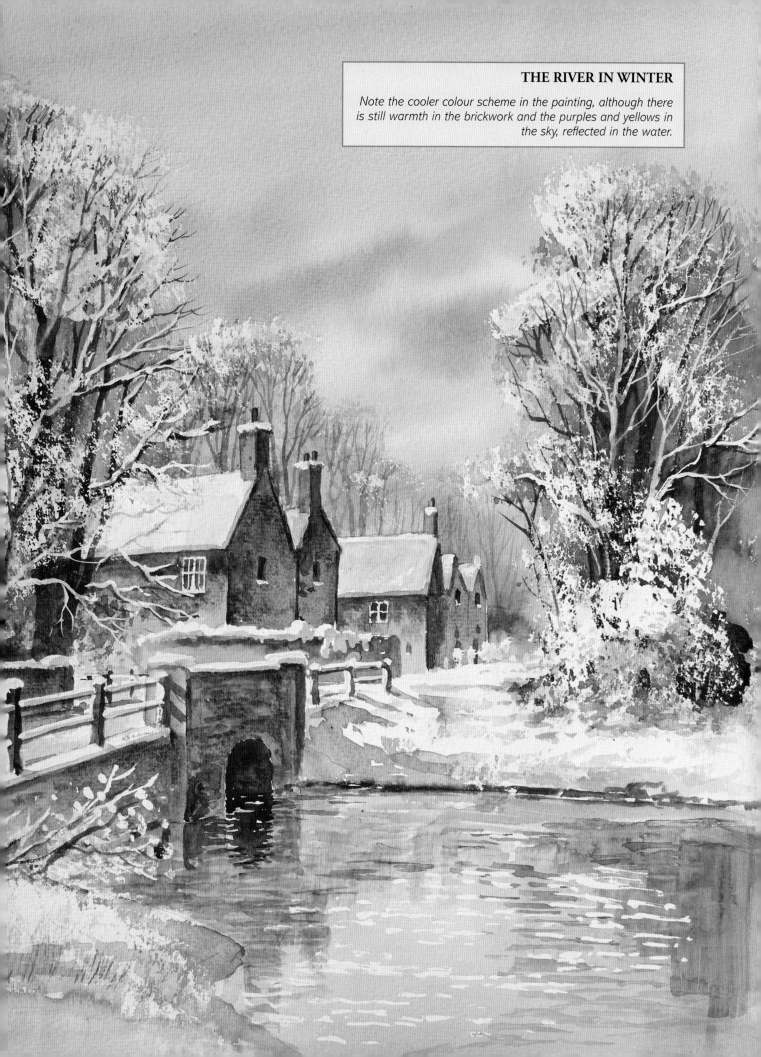

THE RIVER IN WINTER

Note the cooler colour scheme in the painting, although there is still warmth in the brickwork and the purples and yellows in the sky, reflected in the water.

Just as you can use photographs taken throughout the year as reference for your winter scenes, you can use a summer painting and use it to create a more wintry version.

First draw the view using the summer painting as your reference for the bridge, cottage and other buildings. You can then transform the season to winter. The summer foliage is replaced with winter trees. The walls of the inn change from white-painted to brick, to make the snow on the roof stand out against the building. The white fence changes to a dark wood colour so the snow can be seen on top of the railings. The cottage roof is left white, then blue shadows are painted on it. The same shadow colours are washed over the riverbank and foreground snow.

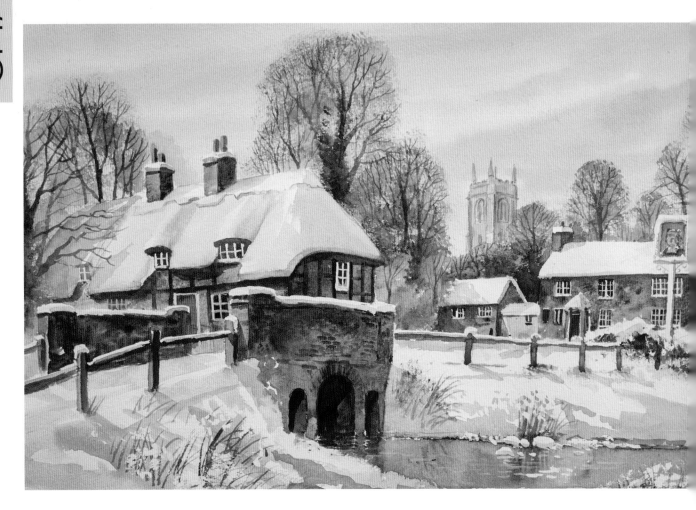

Figures and postboxes are an ideal way to add a hint of hot colour to draw the viewer's eye to the focal point of your painting, and offer a contrast to the cool blues of winter.

This page shows some example finishing touches you can add to your snow scene. Animals also work well – page 37 shows a brace of pheasants acting as an eye-catching focus to *Winter Lane*.

CREATING CHRISTMAS SCENES

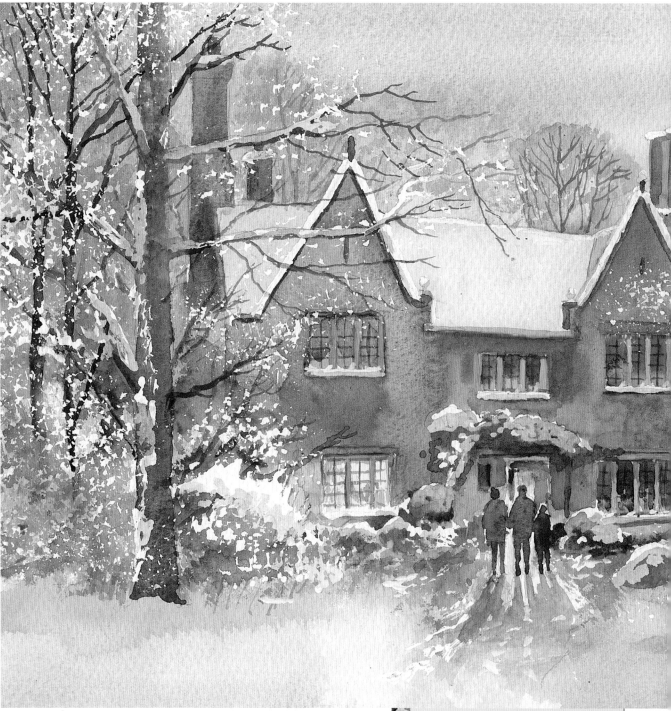

Call me sentimental, but I love a traditional Christmas scene. It could be any snowy landscape, but by adding something festive such as carol singers, children playing in the snow or someone posting cards, you can make everyone nostalgic about Christmas.

CHRISTMAS VISITORS

Here the warm glow in the winter sky is matched by the light coming from the window and open door. This contrasts with the bluish tones of the snow, making it look very chilly for the visitors.

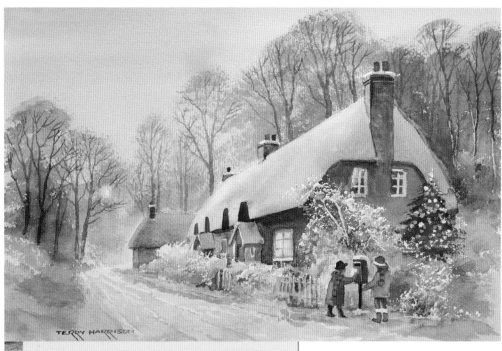

CATCHING THE CHRISTMAS POST

This snow scene with its row of cottages in the light of a winter sunset was crying out to be a Christmas scene. I added the Christmas tree and the children at the post box to complete the effect.

Making a Christmas card

When you have created your festive snow scene, why not turn your painting into a personalised Christmas card? With the help of the internet, you could have a small print run of your own card with envelopes within days. All you need is a good digital photograph of your painting. Search online for a card print company and follow the instructions.

This is the Christmas card I had made from the Catching the Christmas Post *painting. You can add a seasonal greeting too if you wish.*

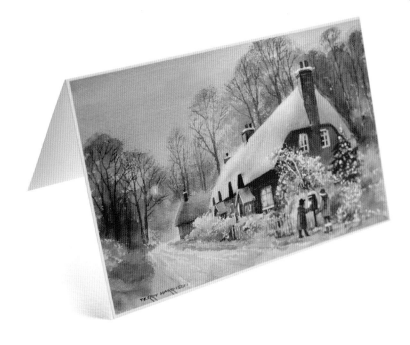

PROJECTS

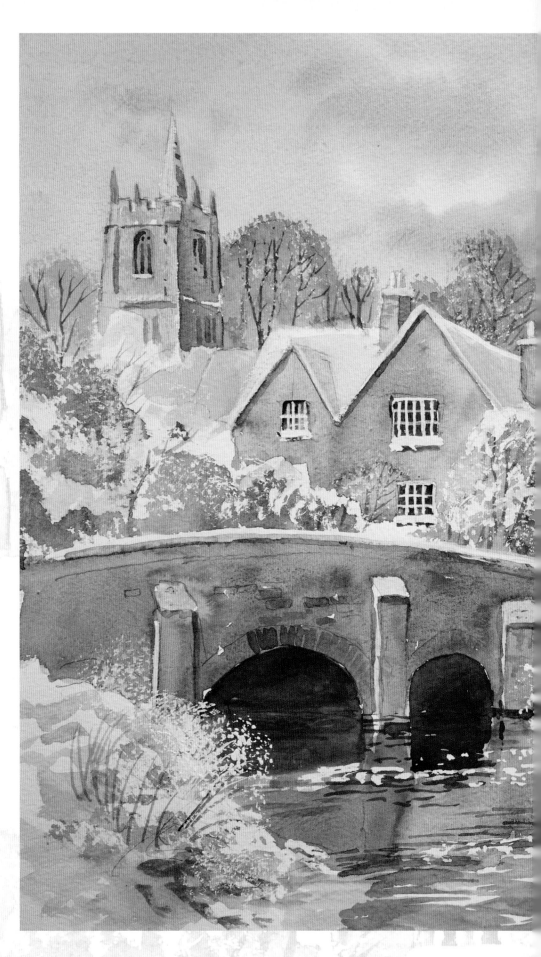

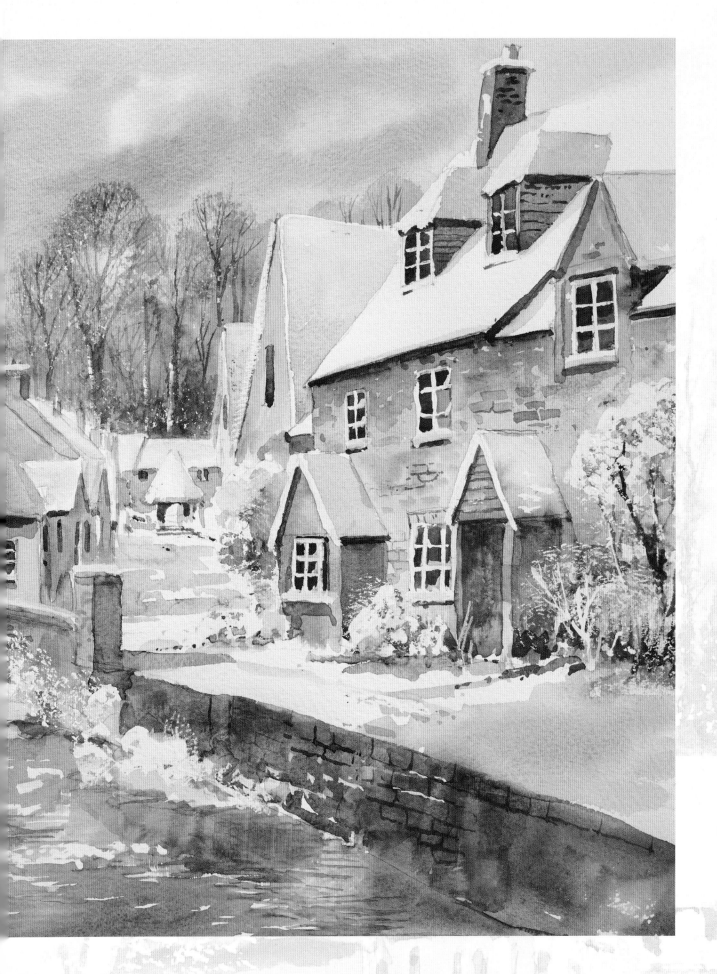

SNOWY AVENUE

This tree-lined avenue has long been a favourite subject of mine. Over the years I have painted it many times and in all seasons.

A point to bear in mind is that the tree trunks and branches are really quite dark, and this helps to draw you down the lane and into the painting. The two lines of trees are linked together by the overhanging branches and the long horizontal shadows which fall across the lane at the bottom of the painting. Using masking fluid with a scourer creates a lively texture, suggesting snow in the twigs and winter foliage.

1 Draw the scene and use a brush with masking fluid to suggest snow on the fences, tree trunks and branches and across the lane.

2 Use a scourer to apply masking fluid to the foliage. Allow to dry.

3 Use the golden leaf brush to stipple a mix of cobalt blue and shadow over the foliage area. While this is wet, stipple burnt sienna on top. Continue, applying the two mixes in the same way.

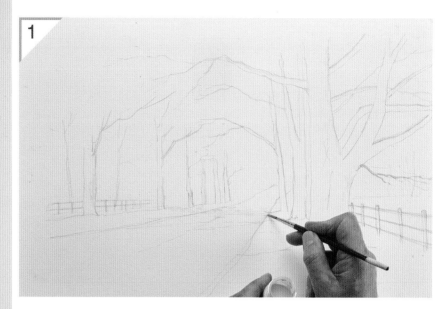

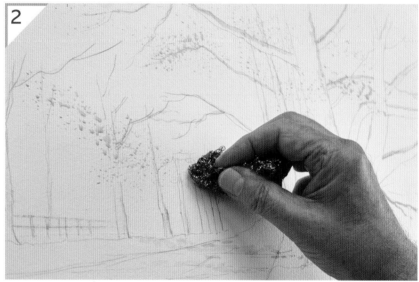

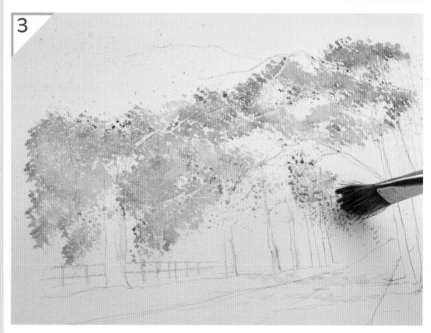

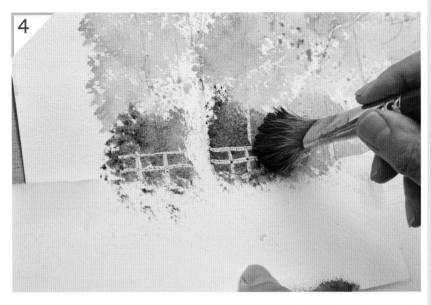

4 Place a paper mask over the ground and stipple a darker mix of burnt umber and shadow above it. Allow to dry.

5 Mix ultramarine, burnt umber and country green and paint the main tree trunk with the large detail brush.

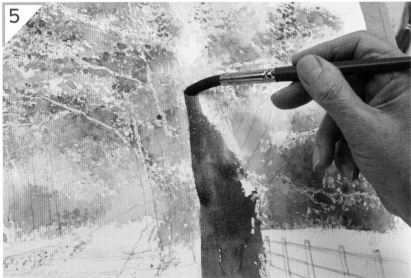

6 Change to the medium detail brush to paint the smaller tree trunks and branches with the same mix.

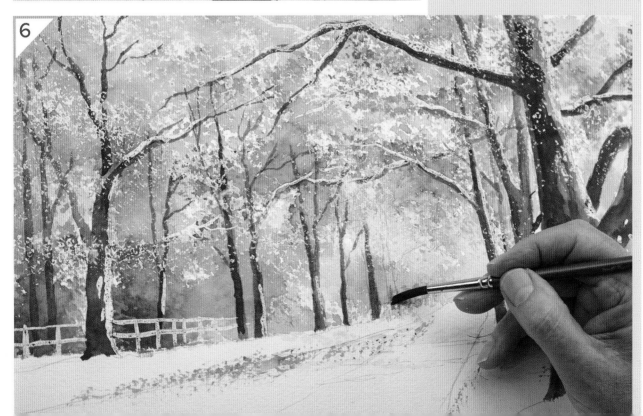

7 Use the half-rigger and the same mix to paint smaller branches and twigs throughout the painting.

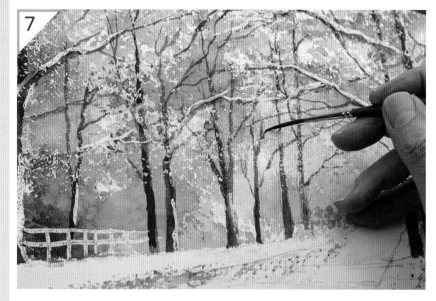

8 Paint pale shadows in the snow with the large detail brush and cobalt blue, creating a dappled effect with horizontal strokes.

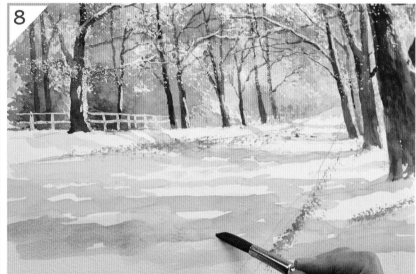

9 Continue painting snow shadows over the masked-out fence, and allow to dry. Use the medium detail brush and a dark mix of ultramarine and burnt umber to paint in the fence, going over the dried snow shadows. Allow to dry.

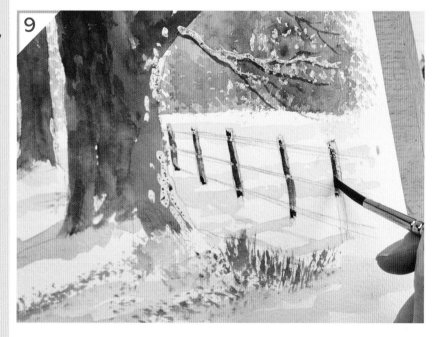

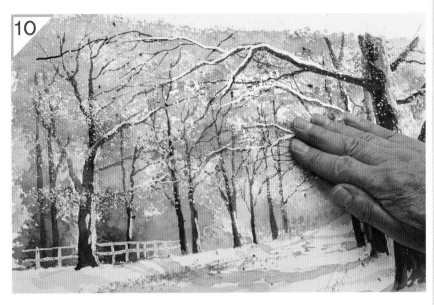

10 Rub off all the masking fluid with clean fingers to reveal the snow.

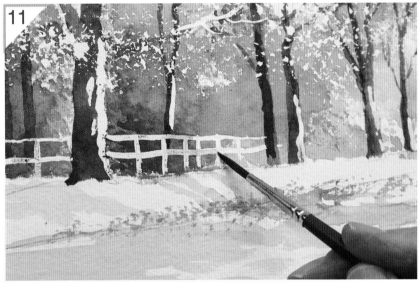

11 Tone down some of the white areas exposed after the removal of the masking fluid by painting snow shadows with the small detail brush and cobalt blue. Add shade to the snow on the fence.

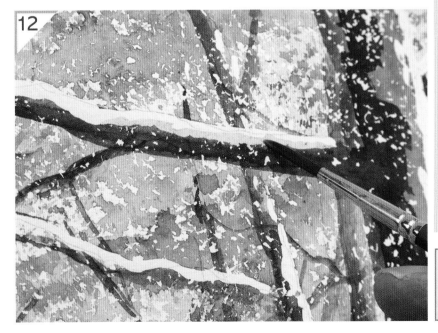

12 In the same way, add shade to the snow on some of the branches.

OVERLEAF

The finished painting.

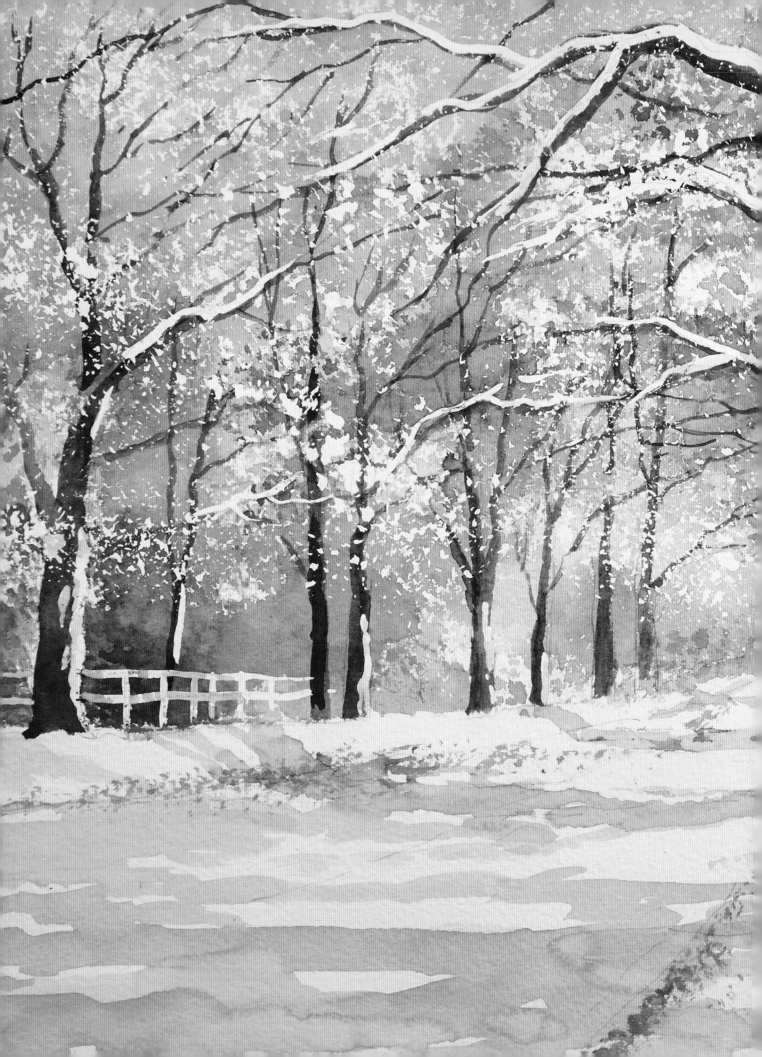

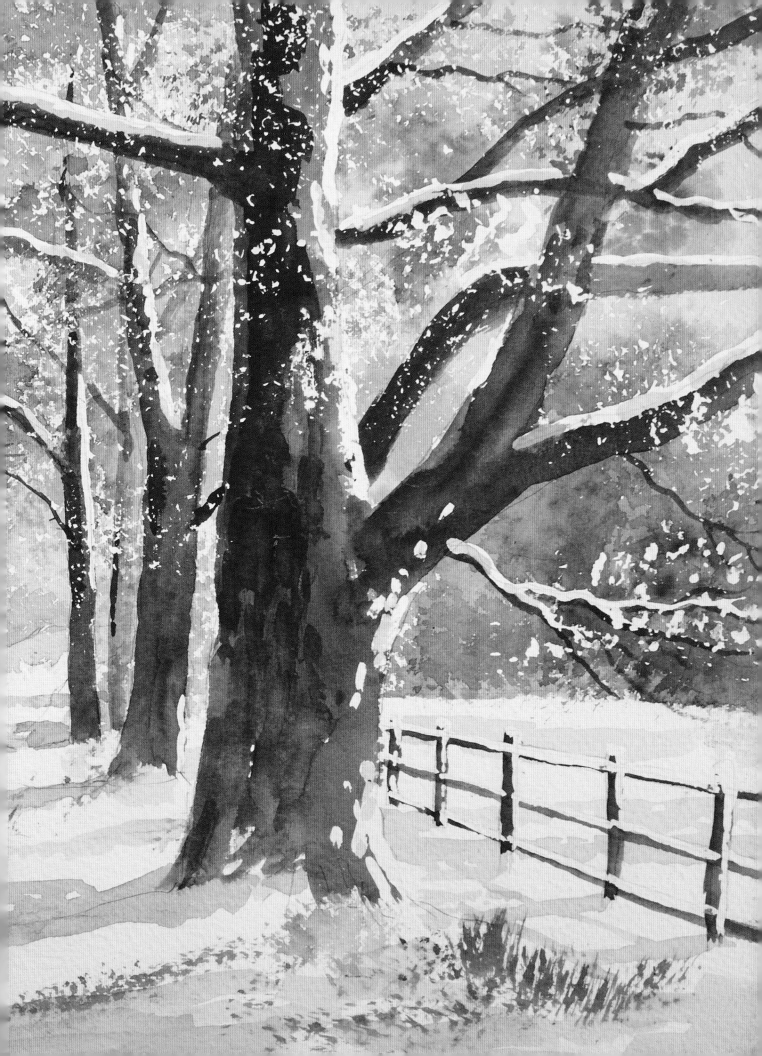

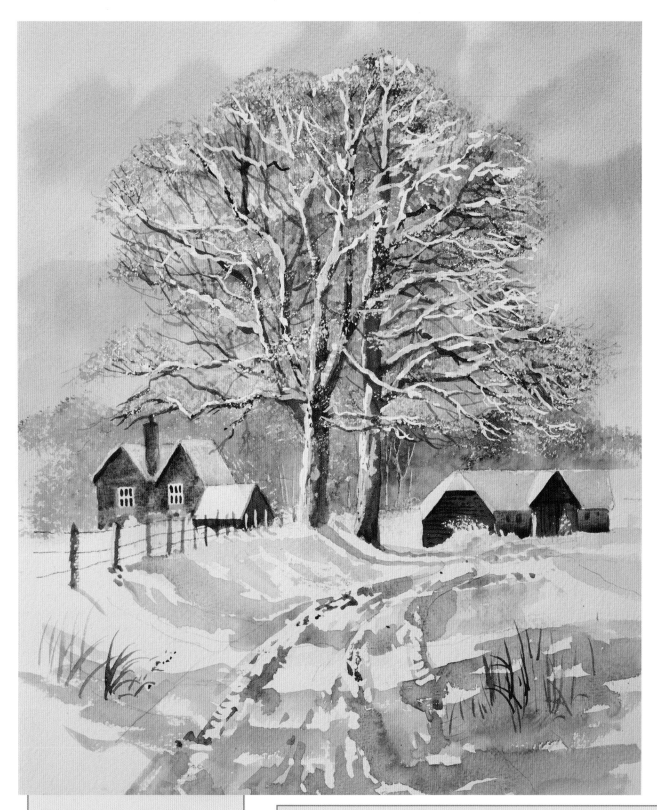

SNOWY FARM LANE

Slush and mud form the tracks in the snow leading you down the lane and into the painting. The shadows fall down the slope of the bank and then horizontally across the lane.

Opposite

THE THAW

As the snow melts, the tracks fill with water, which gives you a chance to add some reflections in the puddles. Colours such as raw sienna and burnt sienna add a touch of warmth to the painting; this coppery glow shines through the trees and is reflected in the water.

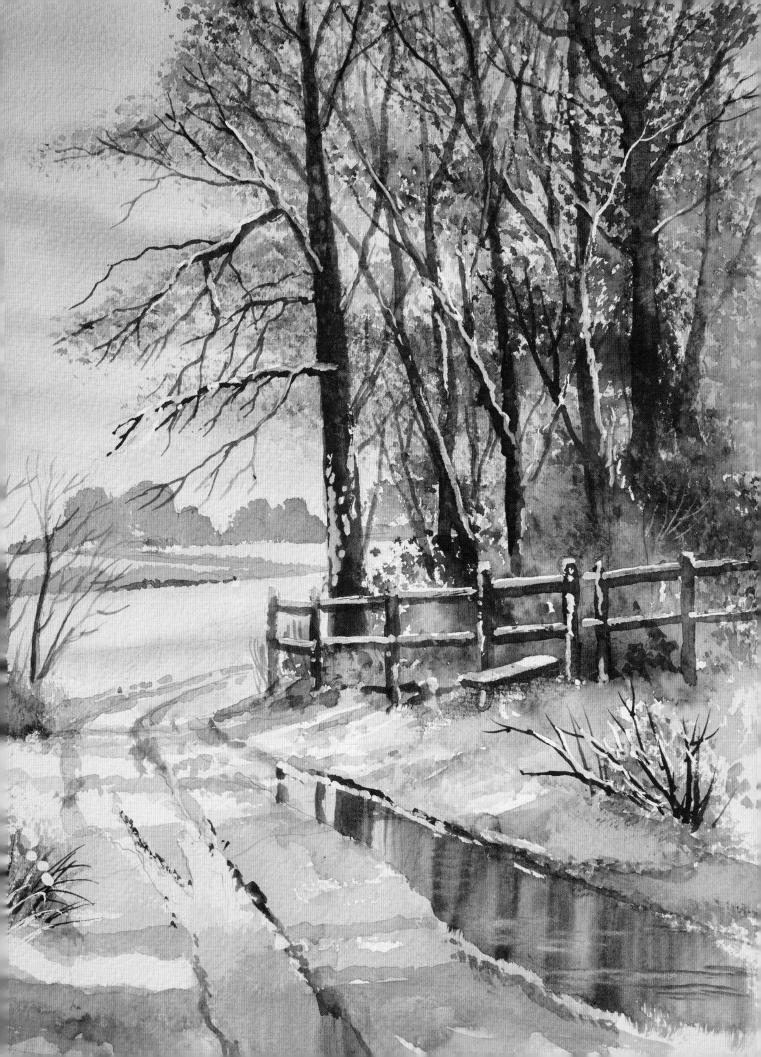

CHRISTMAS COTTAGE

This painting has a traditionally festive mood. The warm glow of the setting sun filtering through the trees and the inviting light in the cottage window create a real feel-good factor. A snow-covered post box always reminds me of Christmas. The greenery around the windows is a welcome touch in a winter scene, which can be lacking in green. There is plenty of practice here if you want to master winter trees.

1 Draw the scene, then use a brush to apply masking fluid to the tops of the windows, the fenceposts and chimneys, a circle for the sun, the one lit window and snow on the tracks.

2 Use a scourer to apply masking fluid to the foliage of the hedge and tree in the foreground. Allow to dry.

3 Use the golden leaf brush to paint the sky area with clean water, down to the building edges, then paint cadmium yellow and permanent rose round the sun. Paint more permanent rose at the top and round the buildings while the paint is wet.

4 Still working wet into wet, paint cobalt blue at the top of the sky, then more permanent rose. Allow to dry.

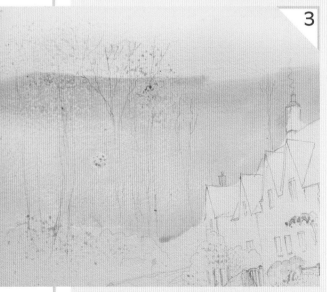

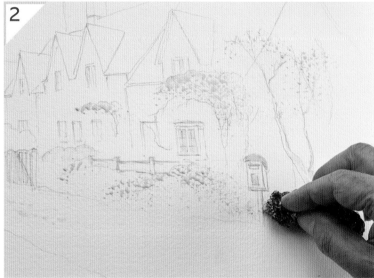

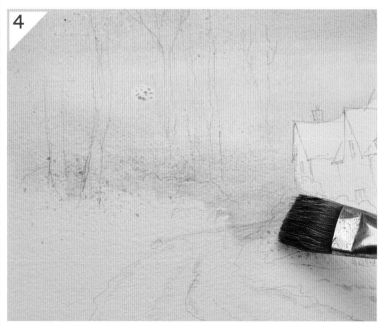

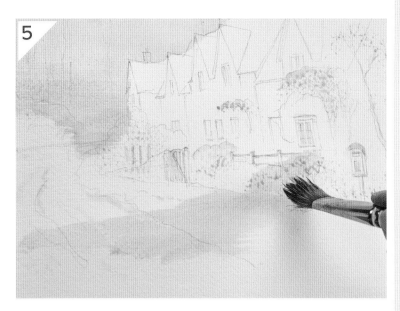

5 With the golden leaf, paint light spilling across the snow from the cottage with cadmium yellow and permanent rose.

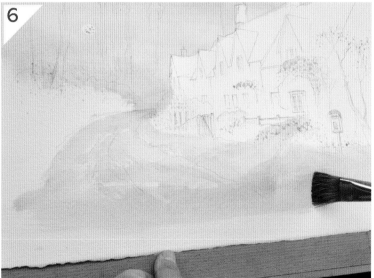

6 Paint shadows on the track and in the foreground with cobalt blue and permanent rose.

7 Mask the building edges with paper and stipple a mix of burnt sienna and shadow over them for foliage, continuing over all the trees. Stipple a darker mix round the sun to make its light stand out.

8 Stipple undergrowth round the bottom of the cottage with a mix of cobalt blue and shadow.

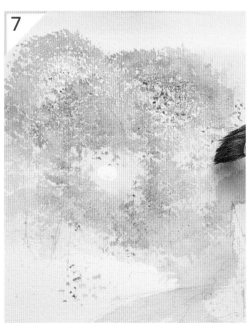

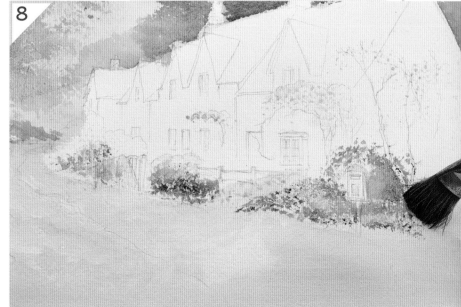

9 Mix raw sienna and shadow and use the large detail brush to paint the cottage walls and chimneys.

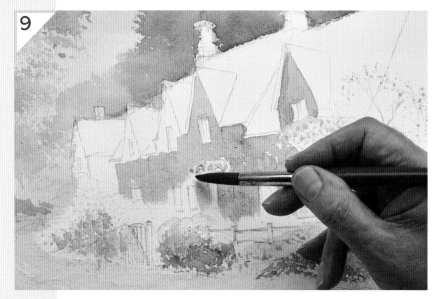

10 With the small detail brush and shadow and burnt sienna, paint the shaded parts of the cottage and the texture of the stone.

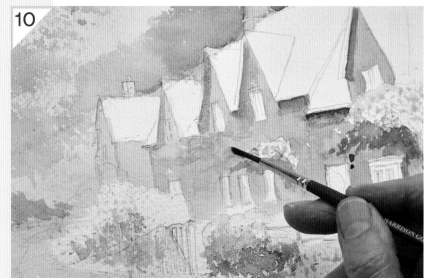

11 Paint the front door with midnight green. Change to the large detail brush and paint the gable end with raw sienna and shadow. Paint burnt sienna and shadow over this wet into wet, and fade out with clean water lower down.

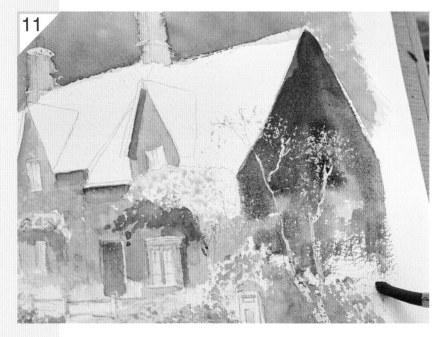

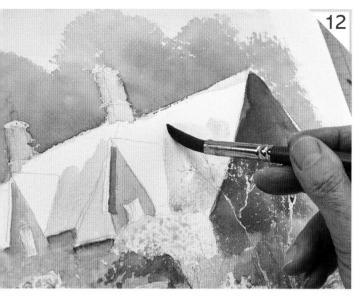

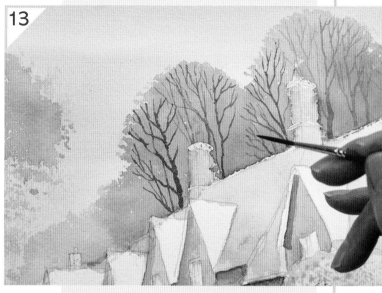

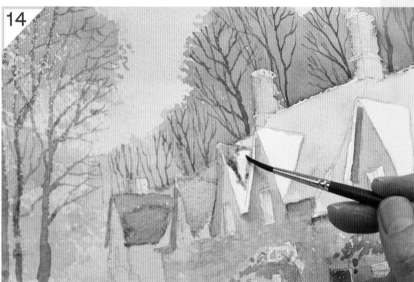

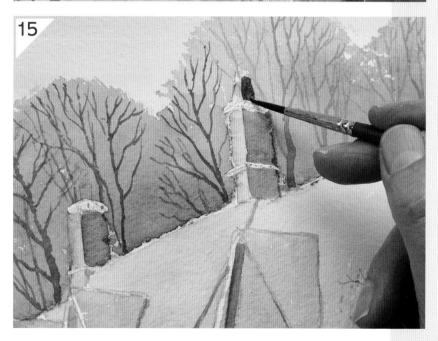

12 Paint the roof with cobalt blue and shadow to suggest shade on the snow. Allow to dry.

13 Mix shadow and burnt sienna and use the half-rigger to paint the tree trunks and branches behind the cottage and on the left.

14 Use shadow and cobalt blue to paint the more shaded parts of the roof with the small detail brush.

15 Paint the shaded parts of the chimneys with shadow and burnt sienna, and add more burnt sienna to paint the chimney pots.

16 Paint the window darks with the small detail brush and burnt umber. Stipple greenery round the door and over the windows with the foliage brush and midnight green.

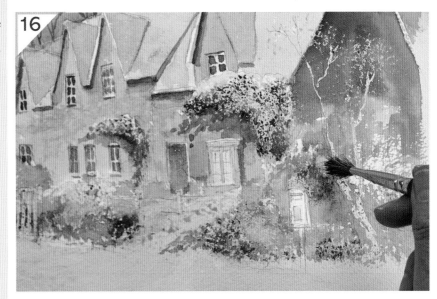

17 Use the half-rigger and burnt umber and ultramarine to paint the bare parts of the foreground tree and the fence.

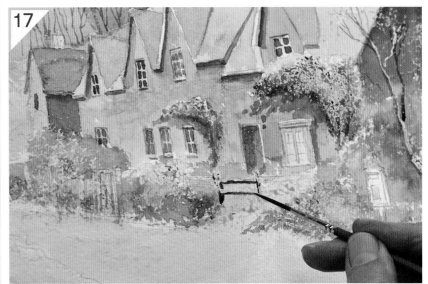

18 Paint the post box in cadmium red with the small detail brush, then add the dark details with burnt umber and ultramarine.

19 Add dark details such as drain pipes to the house front with the same brush and mix.

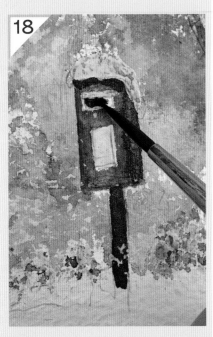

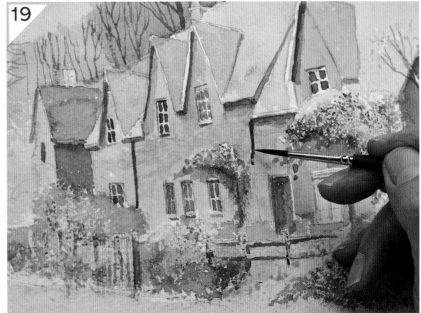

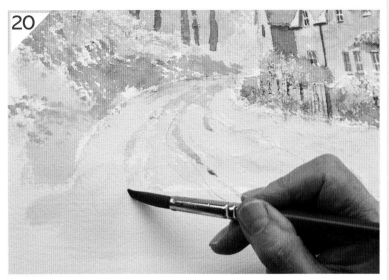

20

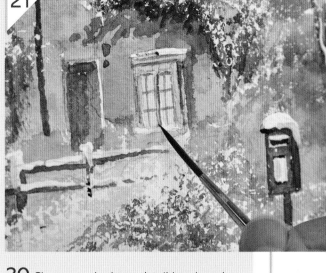

21

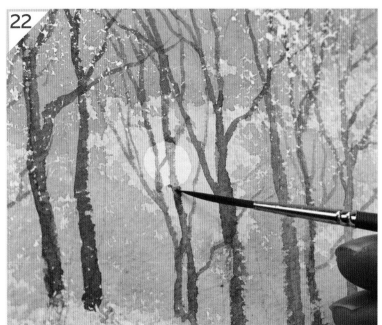

22

20 Change to the large detail brush and paint car tracks in the snow with cobalt blue. Allow to dry and remove all the masking fluid.

21 Paint the lit window with the small detail brush and cadmium yellow. Allow to dry, then use the half-rigger with burnt sienna to paint the frame.

22 Paint the tree trunks going over the sun with a pale mix of burnt sienna, then blot this with kitchen paper to lighten it if necessary.

23 Finally, restore the highlights to the snow on the roof with white gouache on the small detail brush.

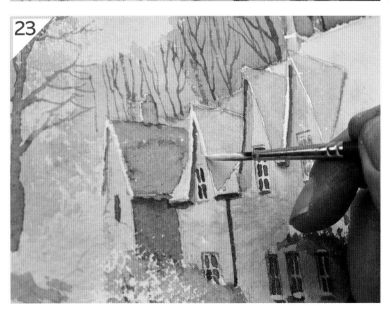

23

OVERLEAF

The finished painting.

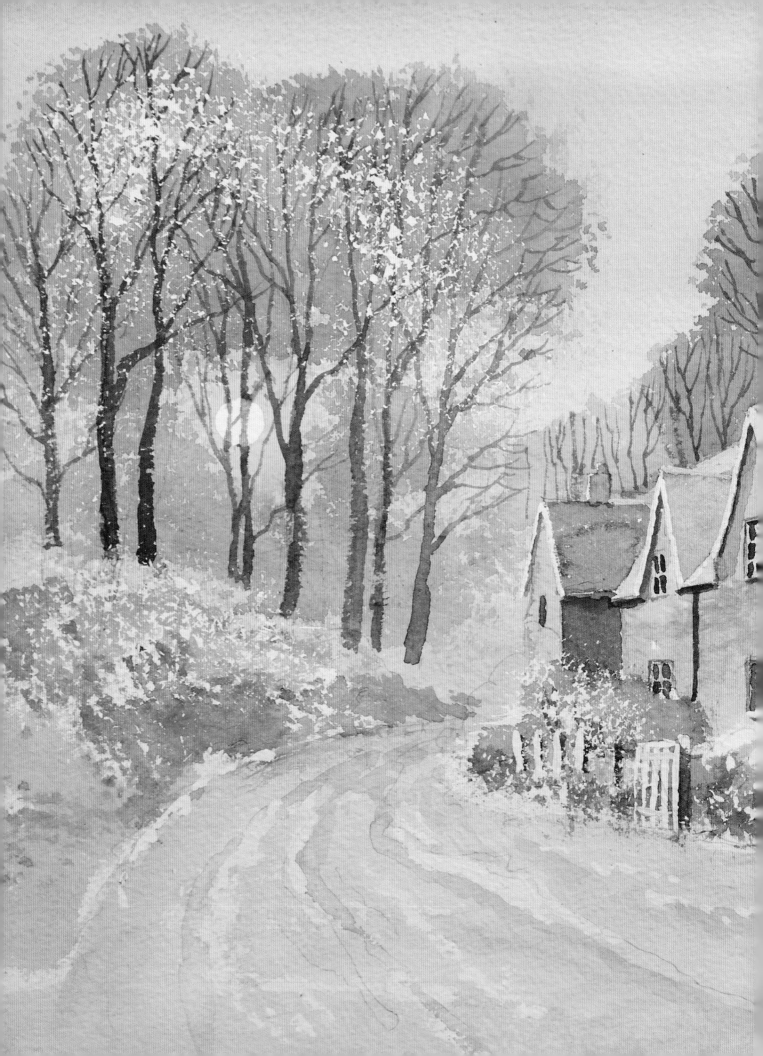

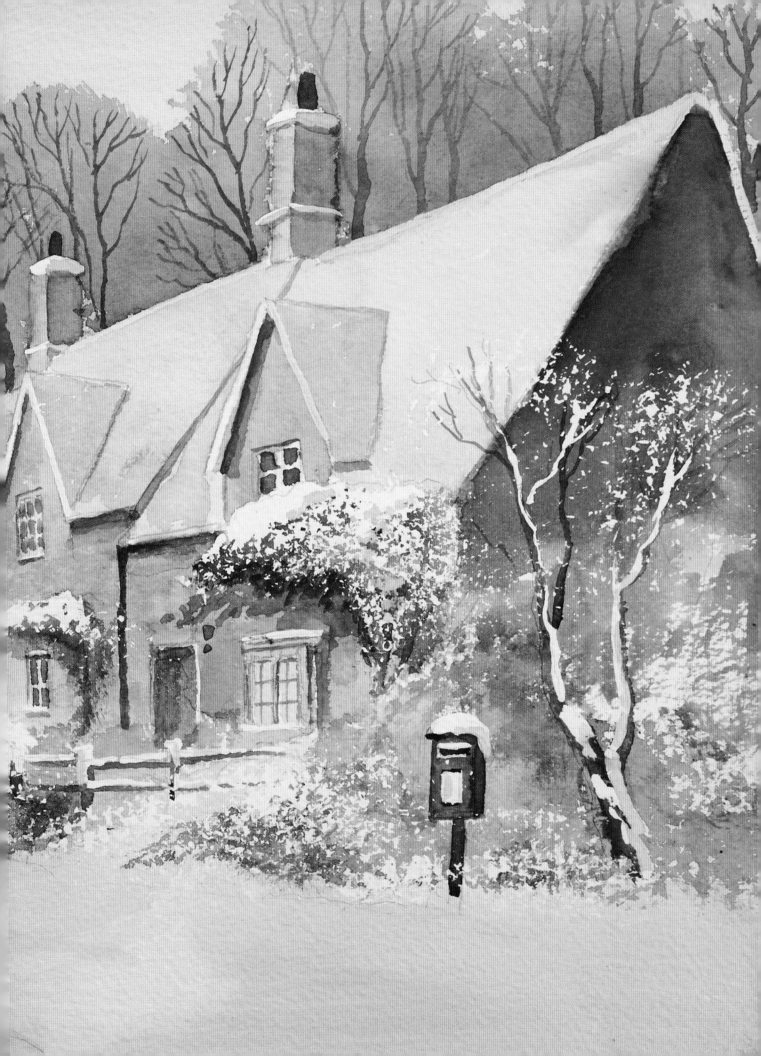

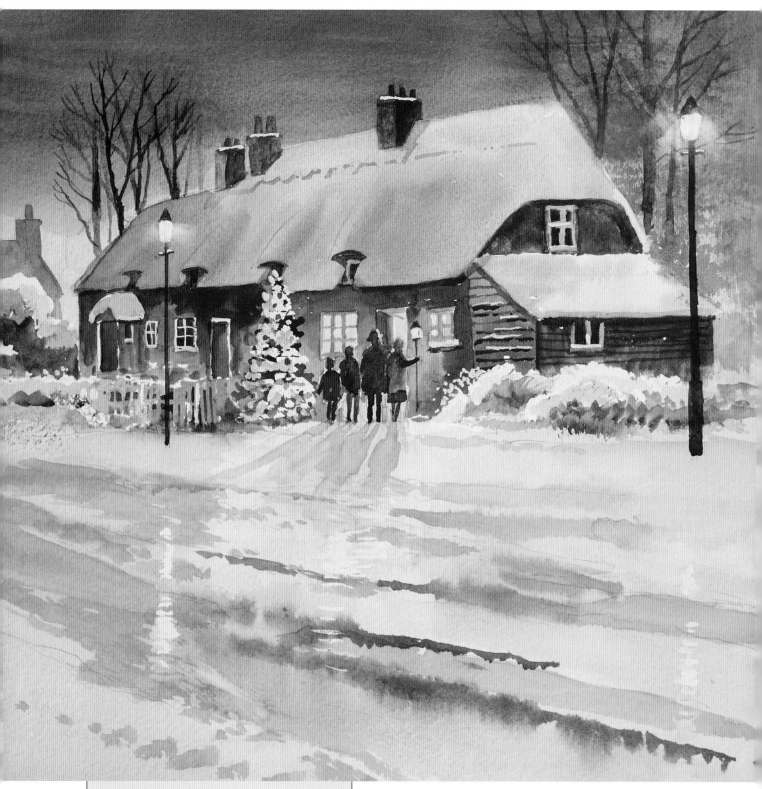

CAROL SINGERS

The snow-covered cottage has all the makings of a festive scene with its Christmas tree and lights, carol singers silhouetted against the warm light of the window and the welcoming open door. The dark sky makes the light in the windows appear brighter.

Opposite

MAKING A NEW FRIEND

You would expect a snow scene to be cold and wintry, but by adding warm colours, you can transform the painting into an inviting haven. Adding the children making a snowman introduces a touch of nostalgia.

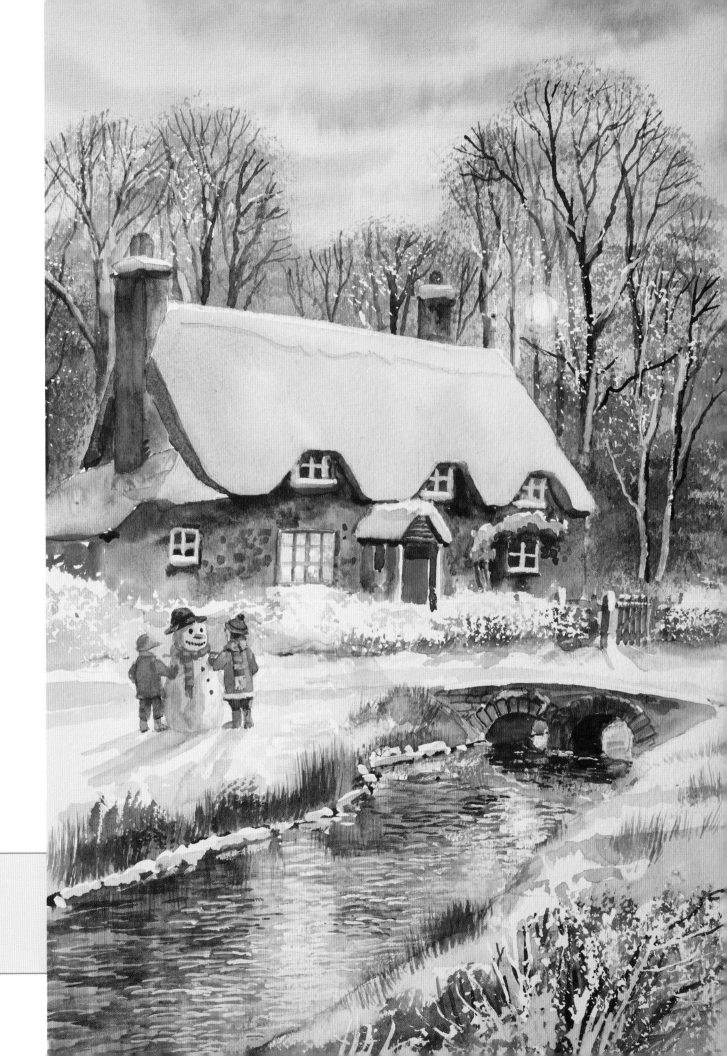

AMERICAN BARN

Old timber barns are a joy to paint. Here I used lots of wet into wet paint with plenty of warm rich colours for the old woodwork, contrasting with the cool colours of the snow. Time spent carefully applying masking fluid to the detail of the barn and snow-capped mountains will pay dividends in the end.

1 Draw the scene and use a brush to apply masking fluid to the snow-covered mountain tops, the edge of the barn roof and some of its snow-covered horizontal details, the fences, tracks and cart as shown. Use a scourer to mask the foliage and undergrowth.

2 Wet the sky area and paint the lower part with the golden leaf brush and raw sienna, then paint ultramarine in horizontal strokes at the top, wet into wet.

3 While this is wet, dab in clouds with a mix of ultramarine and burnt umber. Allow to dry.

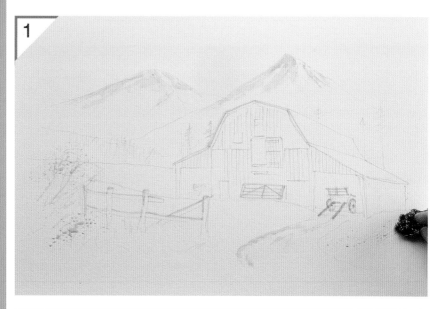

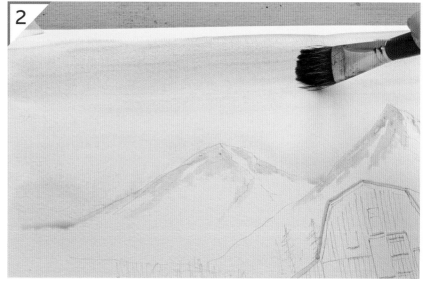

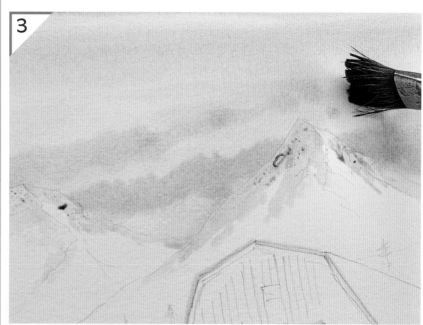

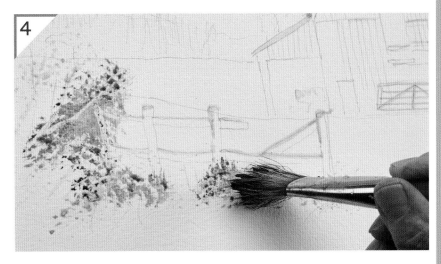

4 Mix burnt umber and shadow and stipple over the bushes.

5 With the large detail brush, paint over the masked parts of the mountains with ultramarine and a touch of shadow. Shade the darker sides of the mountains with burnt umber and shadow.

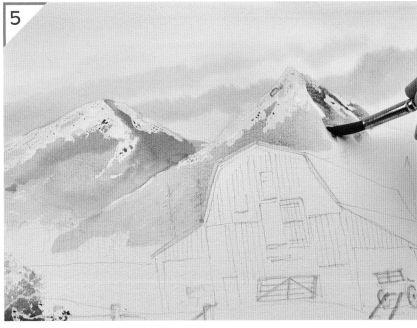

6 Paint distant trees with the fan gogh, creating the shapes and texture with vertical strokes of the brush.

7 Hold the flat edge of the brush upright to put in the shapes of fir trees with a mix of ultramarine and midnight green.

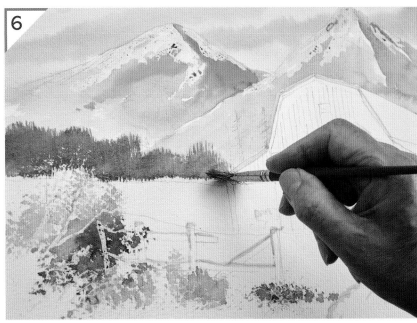

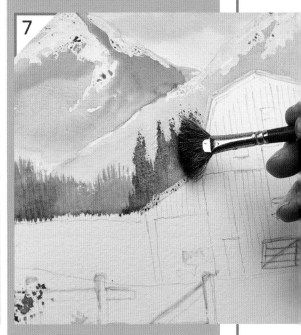

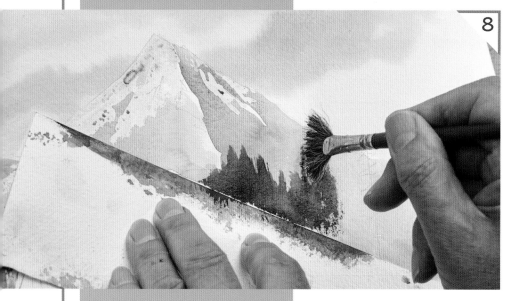

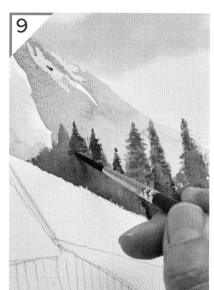

8 Use a paper mask to mask the barn roof while you continue painting fir trees on the other side.

9 Change to the small detail brush and add detail and texture to the trees with midnight green.

10 Begin to paint the barn under the masked roof with the large detail brush and a mix of ultramarine and burnt umber. Working wet into wet, add raw sienna lower down, then burnt sienna, to create a rough, weathered look.

11 Paint a dark mix of ultramarine and burnt umber behind the masked gate and the shaded part under the eaves on the right.

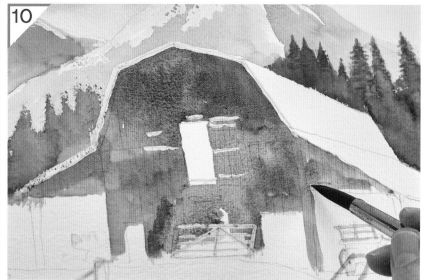

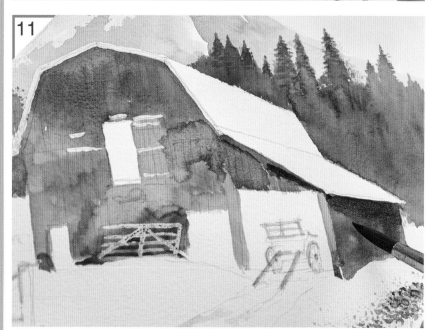

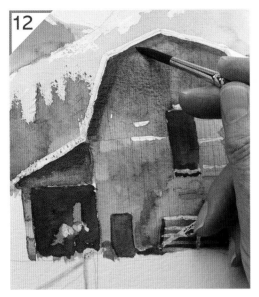

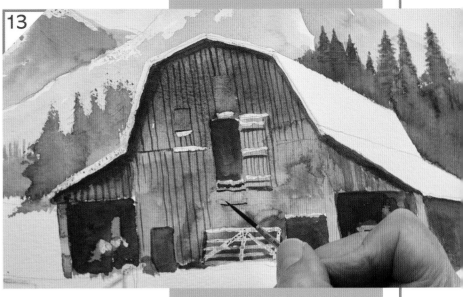

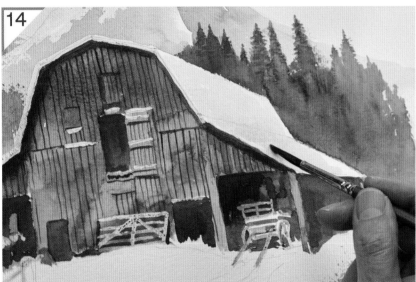

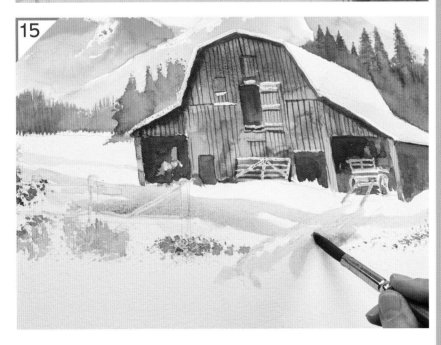

12 Use the same brush and mix to paint the darkness in the doors and windows, and under the eaves on the left and in the middle.

13 Paint the finer details and the planking with the same mix and the half-rigger.

14 Change to the medium detail brush to paint a little shade on the snow on the roof with cobalt blue.

15 Use the large detail brush to paint snow shadows across the foreground with cobalt blue. Go over the masked areas so that they will stand out when the masking fluid is removed. Allow to dry.

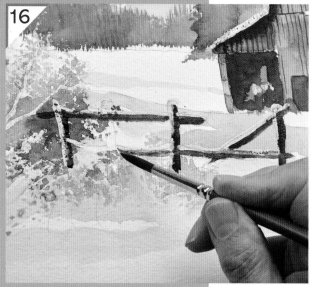

16 With the medium detail brush and ultramarine and burnt umber, paint the parts of the fence not covered by snow.

17 Change to the half-rigger to paint the branches where they are not covered with snow, and the grasses. Allow to dry, then remove all the masking fluid by rubbing with a clean finger.

18 Using the large detail brush, paint cobalt blue onto the right-hand, shaded sides of the mountains.

19 Add shade to the snow on the barn roof in the same way, leaving the lower, flatter part light.

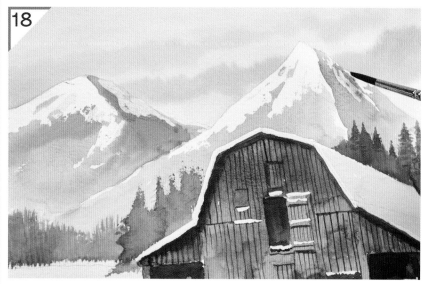

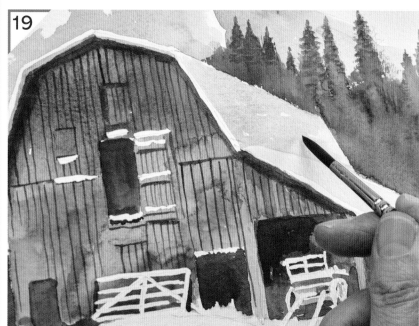

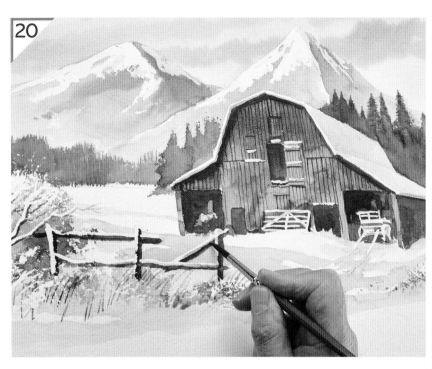

20 Use the medium detail brush and cobalt blue to add shade to the underside of the snow on the barn front, fence and gate and on the cart.

21 Paint the final details of the cart with burnt umber. Complete the painting by adding details in ultramarine and burnt umber with the half-rigger.

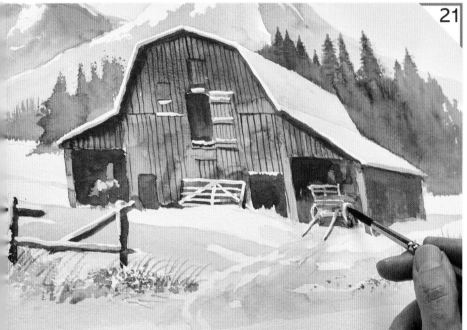

OVERLEAF

The finished painting.

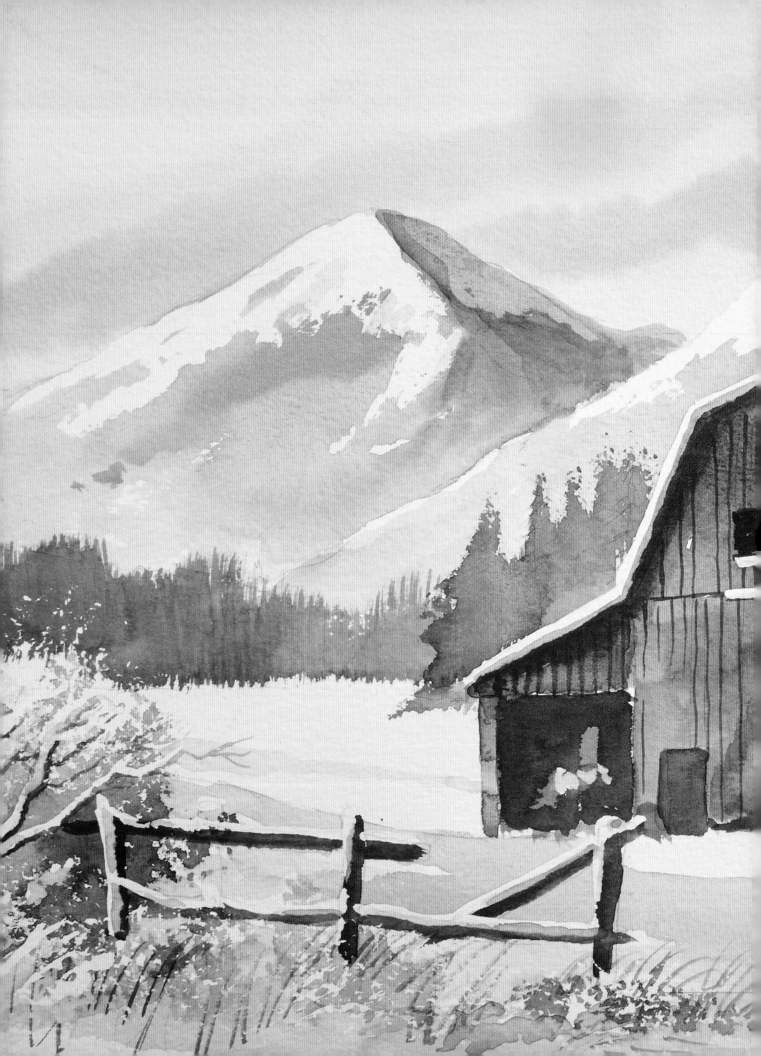

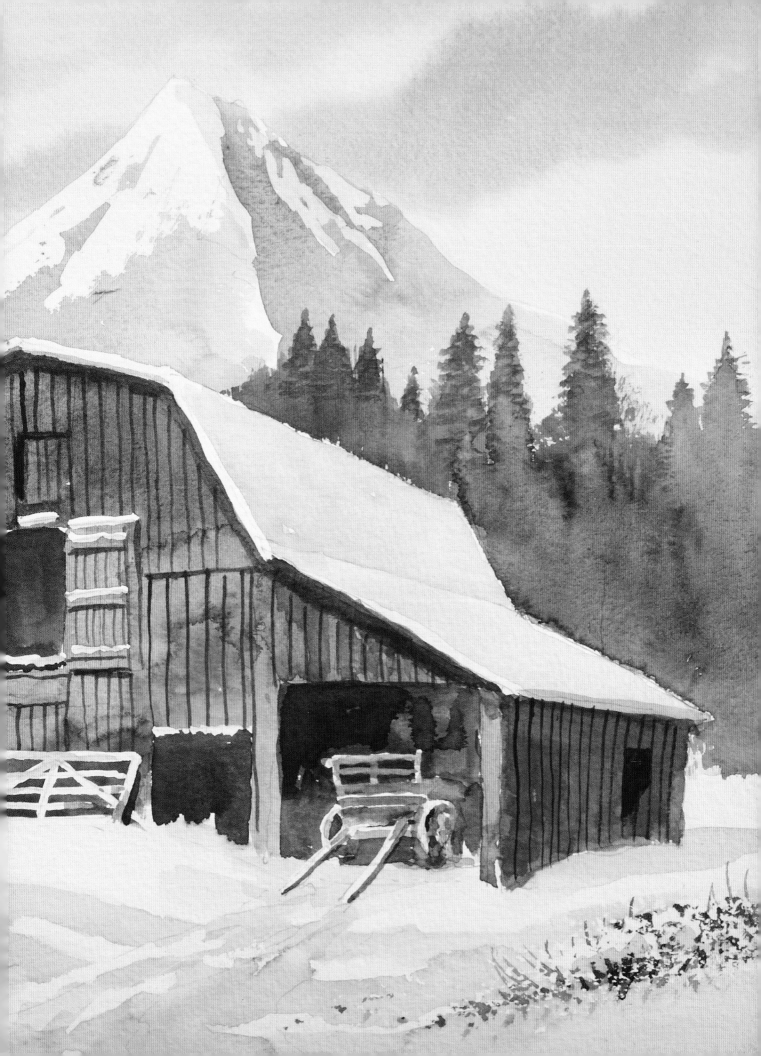

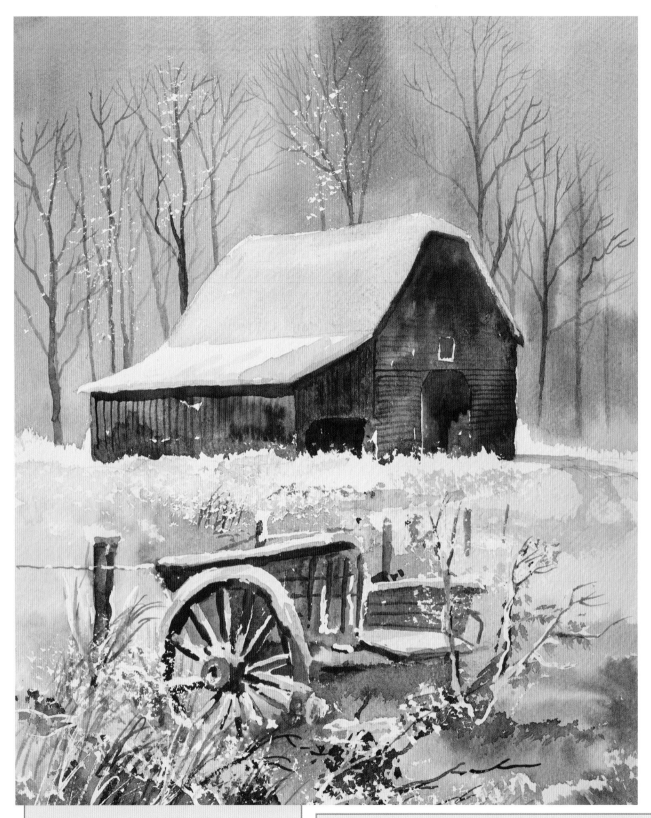

BARN AND WAGON IN SNOW

*The cart adds detail and interest to the foreground.
The dark tones of the barn and background trees
make the snow-covered roof stand out.*

Opposite

THE SHACK BY THE STREAM

*Snow-capped rocks in the icy stream create movement
and drama in the foreground. The stream leads the eye
into the painting and up to the focal point of the old shack.*

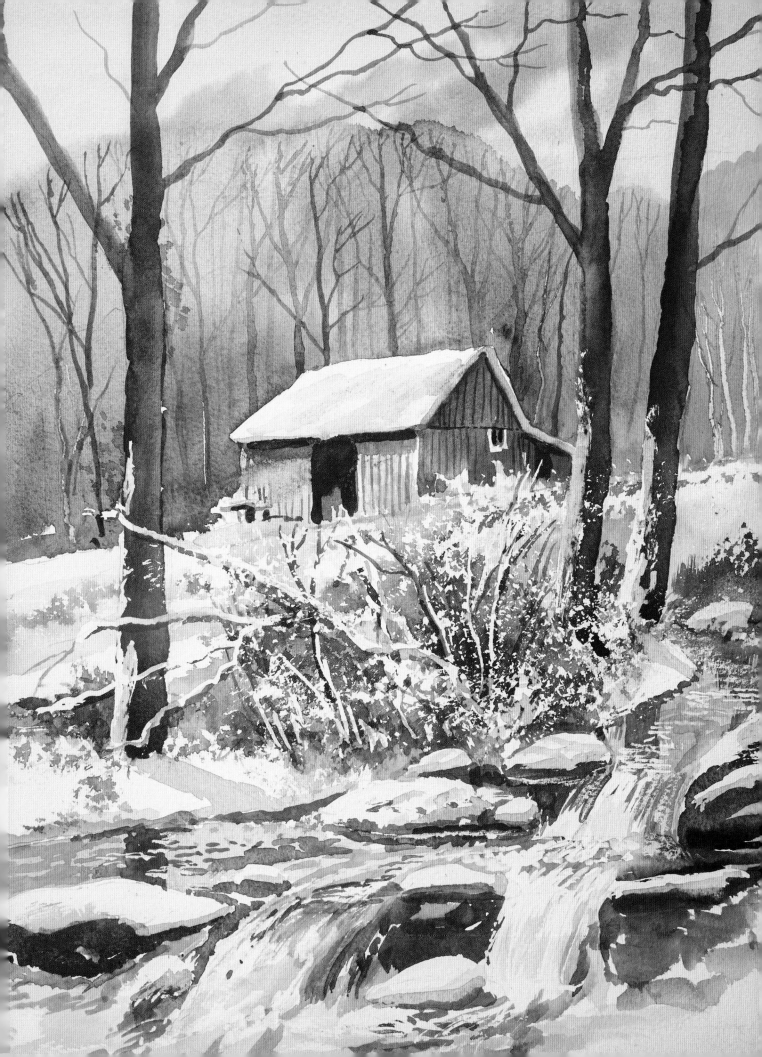

PACKHORSE BRIDGE

The dominant feature of this project is the bridge, which draws the viewer into the painting as well as providing a focal point. The cottages beyond are much paler and cooler in tone than the stonework of the bridge, making them look more distant. Stippling winter foliage over masking fluid applied with a scourer really makes a snow scene sparkle.

1 Draw the scene. Apply masking fluid to the settled snow with a brush, then to the foliage with a scourer.

2 Wet the sky area with the golden leaf and clean water. Paint on raw sienna lower down, then ultramarine higher up.

3 Paint the buildings with the medium detail brush and raw sienna. Drop in a little cobalt blue wet in wet, then burnt sienna.

4 Still working wet into wet, paint a mix of burnt sienna and shadow beneath the eaves.

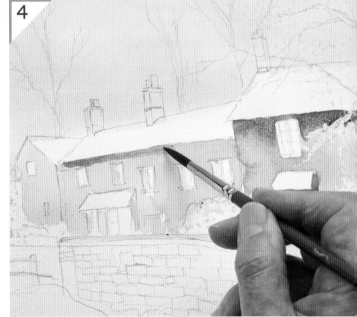

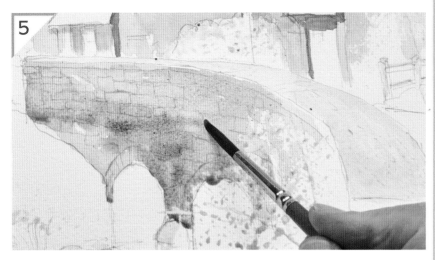

5 Paint the bridge with raw sienna, then drop in cobalt blue wet into wet. Drop in burnt sienna and then shadow in the same way to create a mottled, weathered stone look. Make sure the colours are deeper and warmer than in the background buildings.

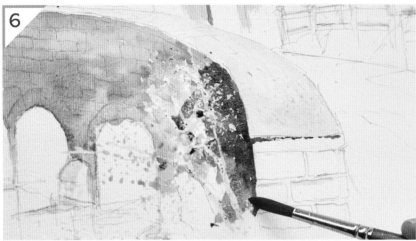

6 Make a dark mix of shadow and burnt umber and use this to paint the right-hand side of the bridge.

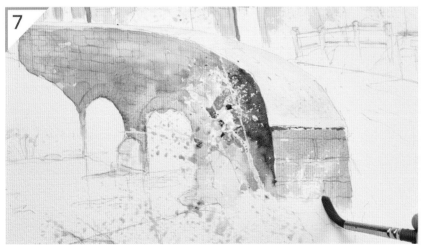

7 Paint the upright of the bridge with raw sienna and drop in a little shadow wet into wet.

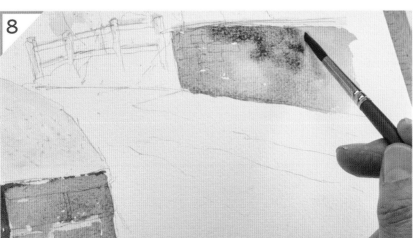

8 Paint the far wall of the bridge with raw sienna and drop in burnt sienna, then shadow, wet into wet.

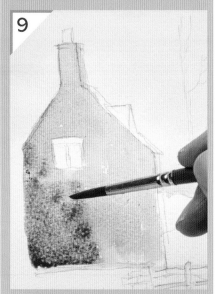

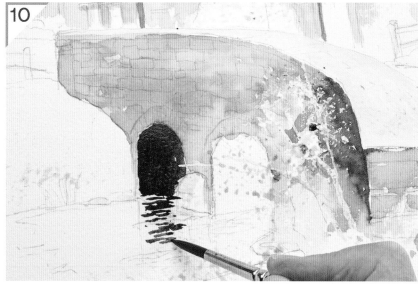

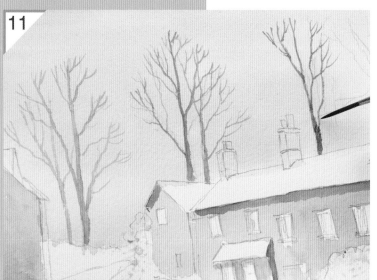

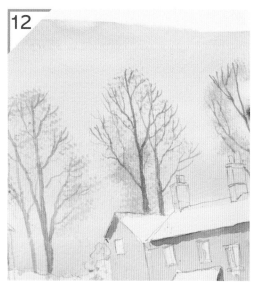

9 Paint the house on the left with raw sienna and drop in shadow wet into wet.

10 Make a very dark mix of burnt umber and ultramarine and paint the dark arches of the bridge and their rippled reflections.

11 Use the half-rigger to paint the background trees with a paler mix of ultramarine and burnt umber.

12 Stipple on winter foliage with the foliage brush and the same mix.

13 Paint the chimneys with raw sienna and the small detail brush. Use a paper mask to mask the far wall of the bridge and stipple foliage above it with the golden leaf brush and burnt umber and ultramarine.

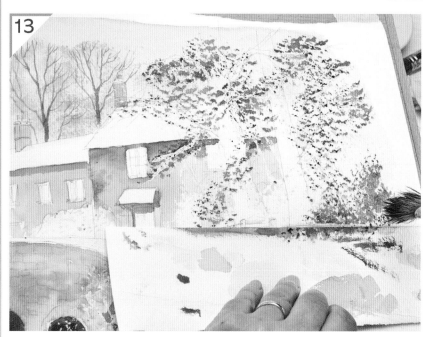

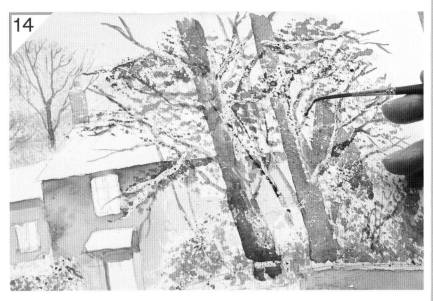

14 Suggest the dark gable end of the building on the right-hand side of the painting with the medium detail brush and ultramarine and burnt umber, going over the masking fluid. Paint the near tree trunks and branches with the same mix, then change to the half-rigger to paint twigs.

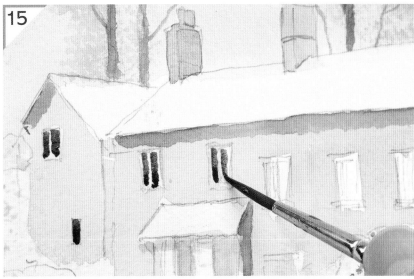

15 Black in the windows with the small detail brush and a dark mix of ultramarine and burnt umber, leaving a vertical line for each central bar.

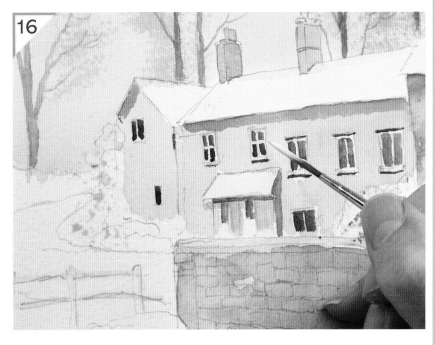

16 Continue painting architectural details with the same brush and mix. Allow to dry, then wash the brush and pick up white gouache to paint in the horizontal window bars.

17 Use the golden leaf brush and a mix of burnt umber and shadow to stipple and flick up undergrowth and grasses on either side of the river.

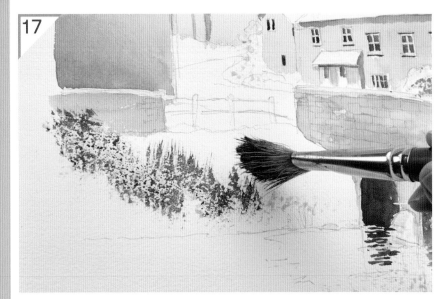

18 Paint the bridge's brickwork with the half-rigger and a mix of ultramarine and burnt umber.

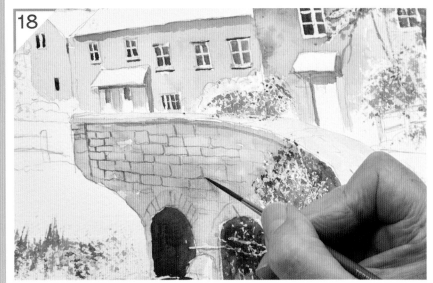

19 Mix cobalt blue with shadow and paint ripples in the river with the tip of the 19mm (¾in) flat brush. Add darker ripples on top with a stronger mix of the same colours.

20 Use the large detail brush with a pale mix of cobalt blue to paint tracks and shadows in the snow.

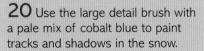

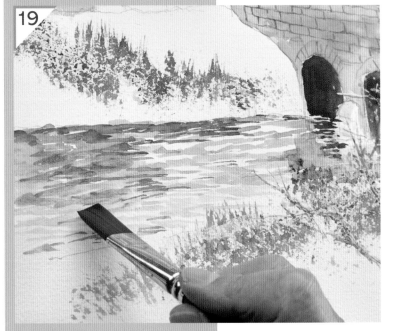

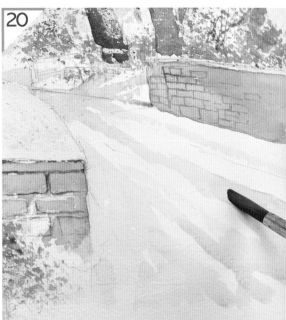

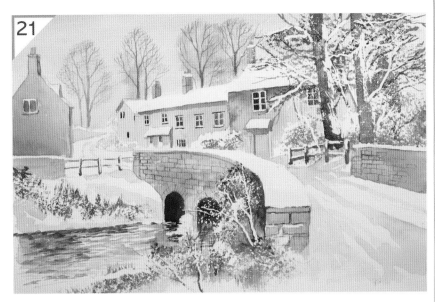

21 Use the small detail brush with a dark mix of burnt umber and ultramarine to paint the details on the house on the left, the shadows on the chimneys and the fences. Allow to dry. Remove all the masking fluid with clean fingers.

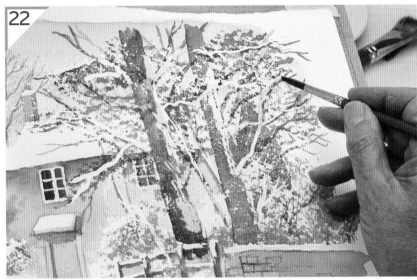

22 With the large detail brush, paint cobalt blue shadows in the snow on the trees.

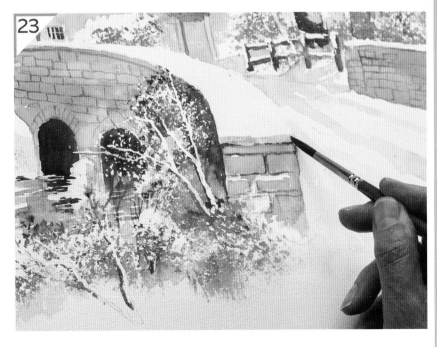

23 Continue in the same way, adding shade to the snow on the bridge and on the roofs.

OVERLEAF

The finished painting.

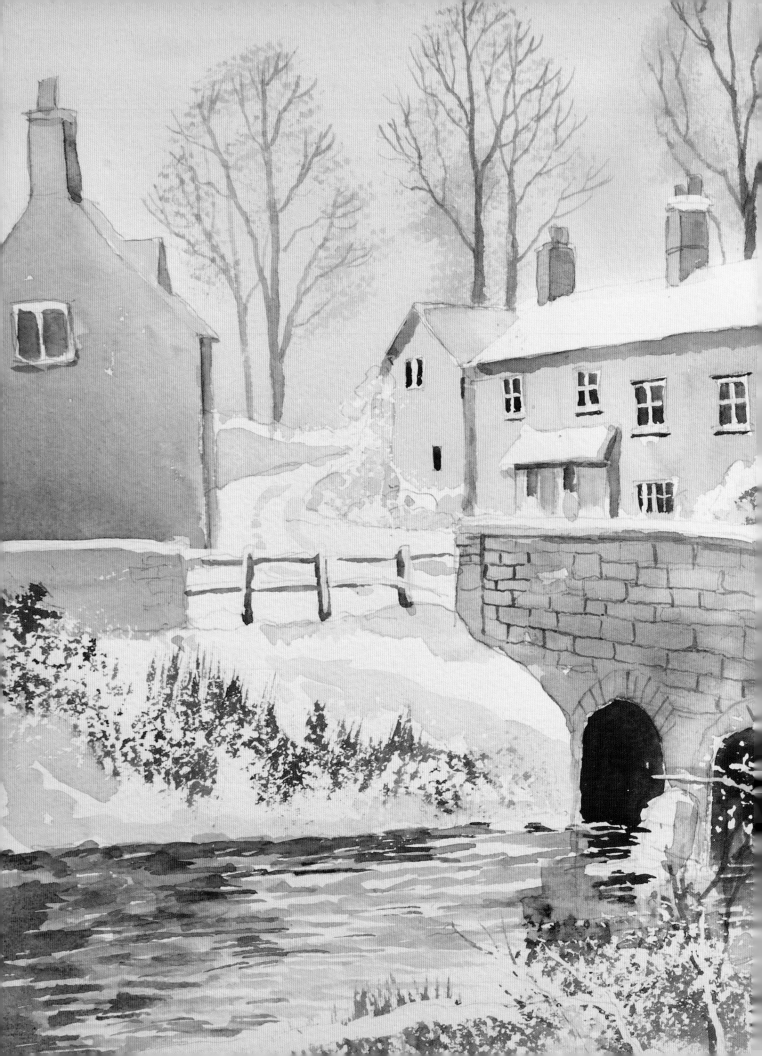

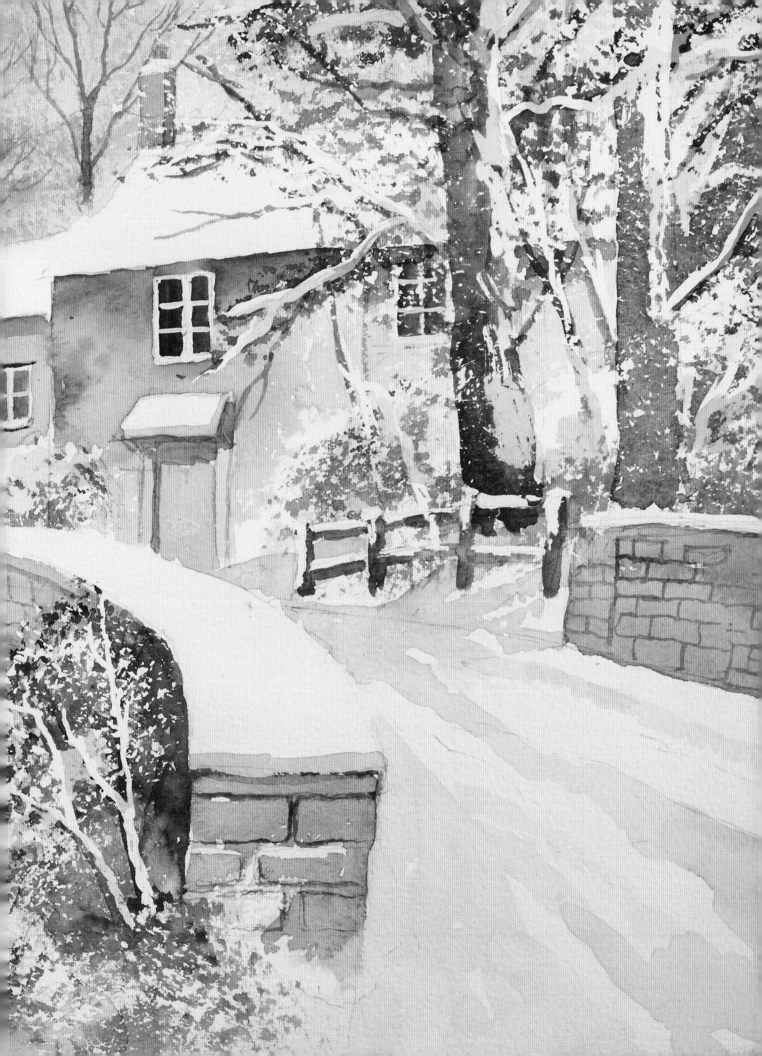

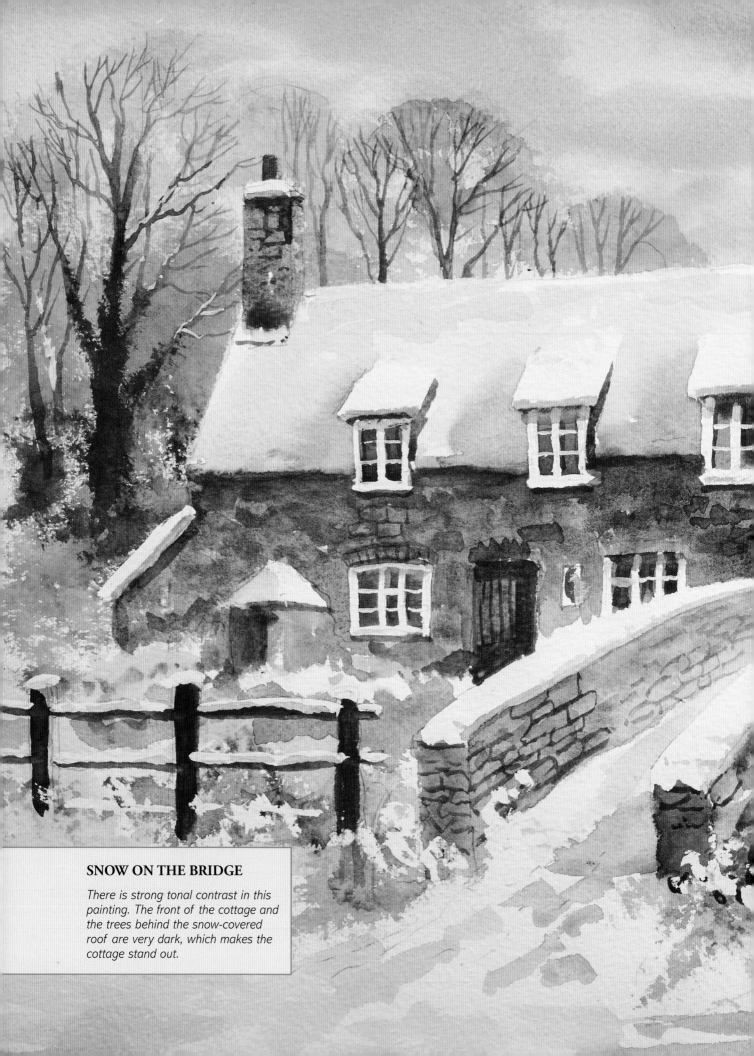

SNOW ON THE BRIDGE

There is strong tonal contrast in this painting. The front of the cottage and the trees behind the snow-covered roof are very dark, which makes the cottage stand out.

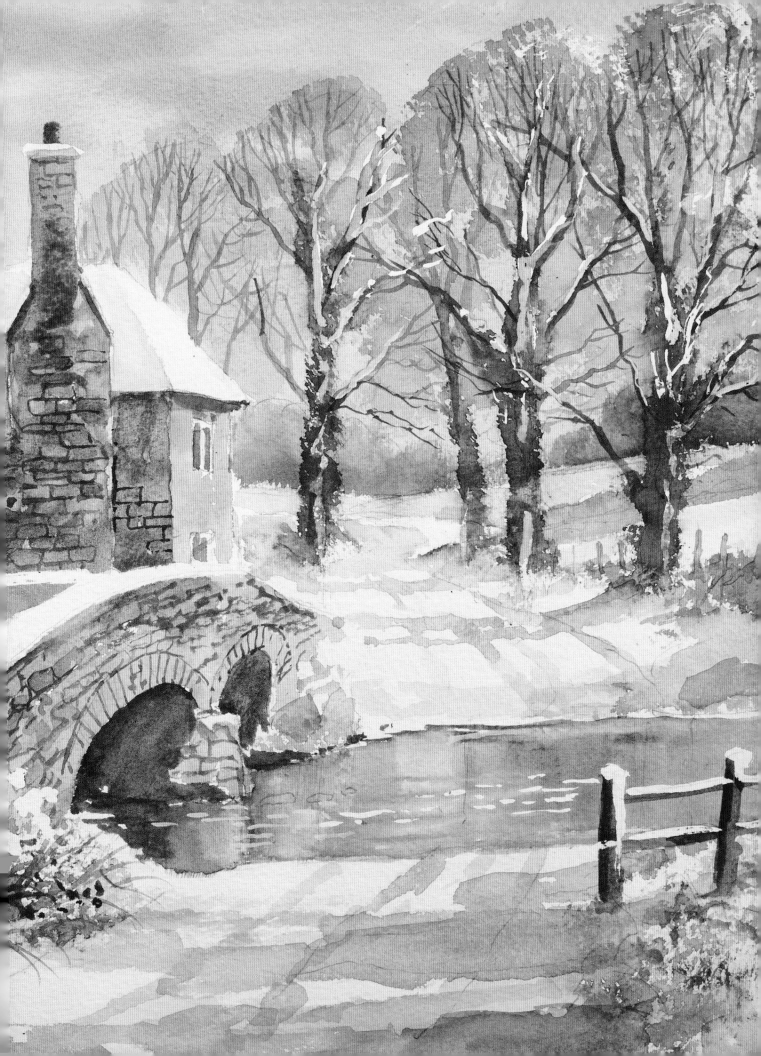

SUNSET REFLECTIONS

Winter scenes don't have to be cold and grey. By painting a sunset, you can introduce some warm colours that will transform your painting and make it more appealing. Here the distant, snow-capped mountains give depth to the scene and the warm colours of the sky are reflected in the foreground water.

1 Draw the scene. Apply masking fluid to the sun, the snow on the mountains and rocks and the tree trunks with a brush, then use a scourer with masking fluid to suggest snow in the winter foliage.

2 Wet the sky area down to the mountains with the golden leaf brush and drop in a mix of cadmium yellow and permanent rose at the bottom of the sky. While this is wet, paint permanent rose above it, then cobalt blue above that.

3 Pick up a thicker mix of shadow on the same brush and dab in clouds, still working wet into wet. Allow the sky to dry.

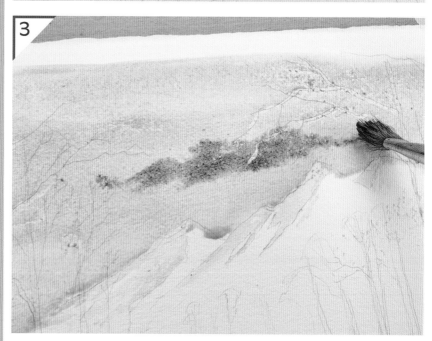

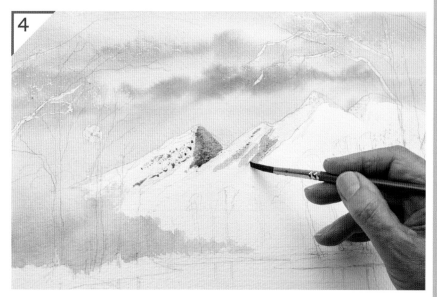

4 Use the golden leaf brush to paint a wash of shadow to the bottom left of the mountains to create a misty look. Change to the medium detail brush and paint the shaded parts of the mountains with shadow.

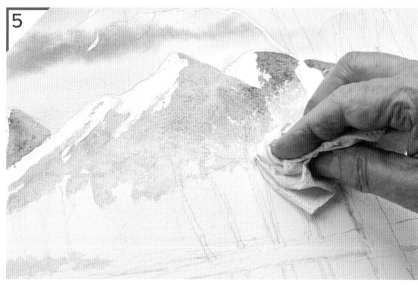

5 Lift out colour at the bottom of the shadows on the mountain using kitchen paper.

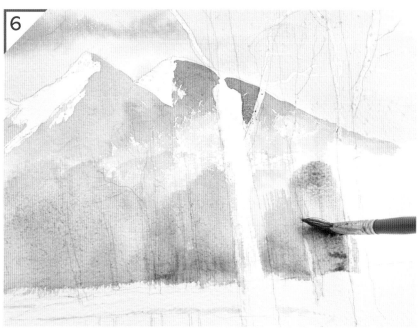

6 Mix cadmium yellow and permanent rose and use the wizard brush to paint this down to the base of the mountains. Drop in shadow at the bottom wet into wet, and then burnt sienna and more shadow.

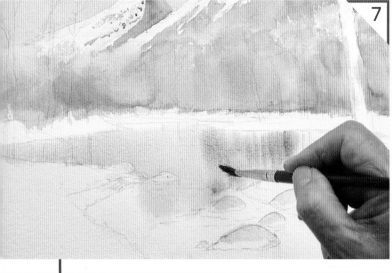

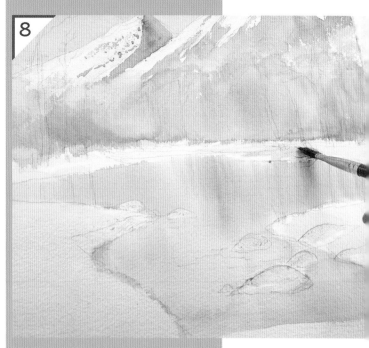

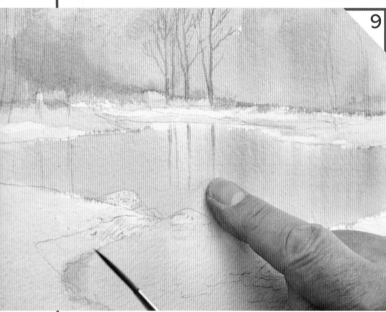

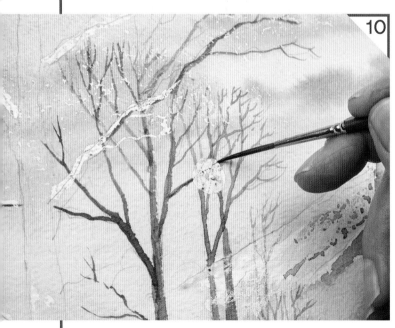

7 Wet the whole water area with clean water and use the wizard brush to stroke down a mix of permanent rose and cadmium yellow, then while this is wet, stroke shadow down.

8 Fade cobalt blue into the other colours at the bottom of the water area and paint it along the horizon with a touch of permanent rose. Allow to dry.

9 Use the half-rigger to paint misty trees on the far shore with shadow, then paint the reflections in the water and soften the lower ends of them with a clean finger.

10 Paint the larger tree trunks in the middle distance with the medium detail brush and a mix of burnt umber and shadow, going over the masking fluid. Change to the half-rigger to paint the finer branches.

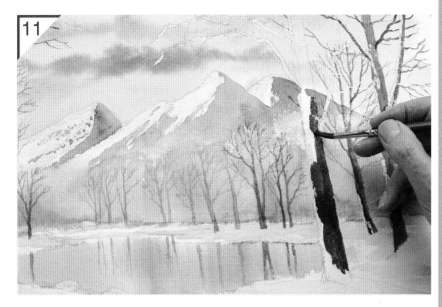

11 Paint the stronger, larger foreground tree trunks with the medium detail brush and a mix of burnt umber and shadow.

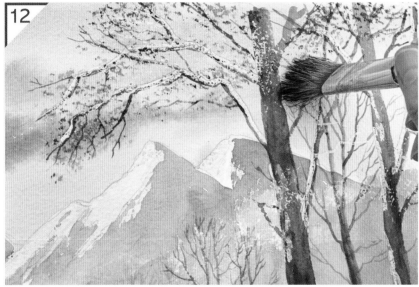

12 Again, change to the half-rigger to paint finer branches, then use the golden leaf brush with the same mix to stipple on foliage.

13 Continue painting trees and their reflections with the small detail brush and the same mix.

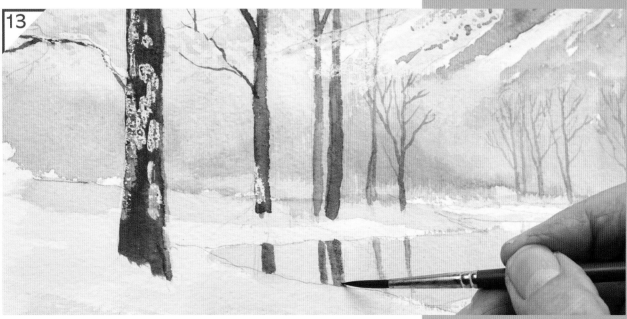

14 Use the small detail brush with burnt umber and shadow to paint the rocks in the water beneath their snowy caps. Add their rippled reflections with the same mix.

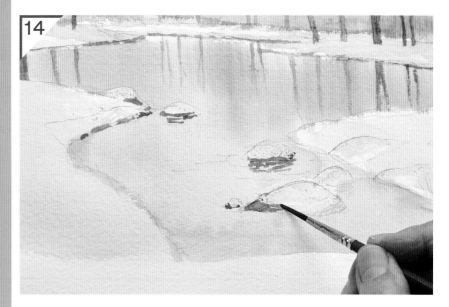

15 Change to the 19mm (¾in) flat brush to paint horizontal ripples in the lower part of the water. Use the same brush dampened with clean water to lift out ripples higher up the water, dabbing with kitchen paper after each stroke.

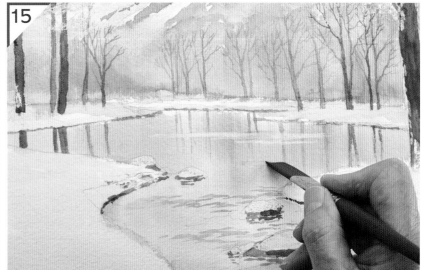

16 Allow to dry and remove all the masking fluid by rubbing with a clean finger. Use the small detail brush to paint shadow on the snow on the trees with cobalt blue.

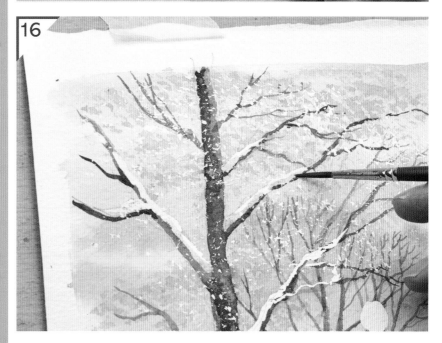

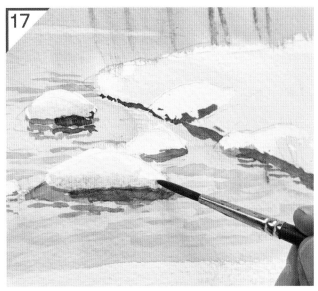

17

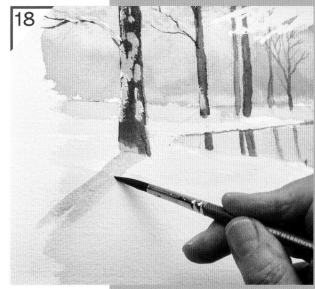

18

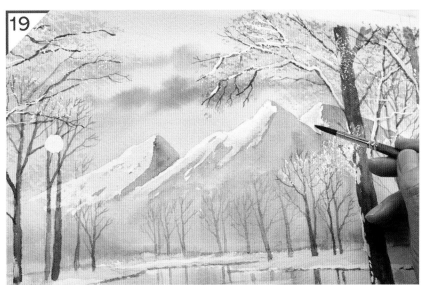

19

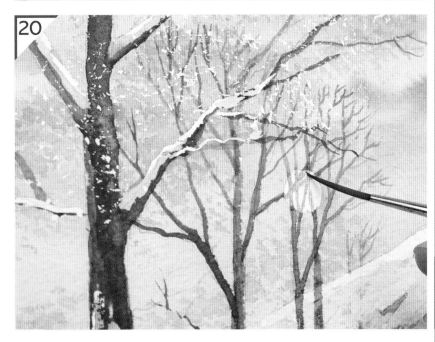

20

17 Add shade to the snow on the rocks in the same way, with the medium detail brush.

18 Paint cast shadows from the trees with cobalt blue.

19 Use cadmium yellow and permanent rose to paint the reflection of the sunset in the mountain snow.

20 Pick up a pale mix of burnt sienna on the half-rigger and use this to suggest the tree branches where they cross the sun. You can dab out colour with kitchen paper if it is too strong.

OVERLEAF

The finished painting.

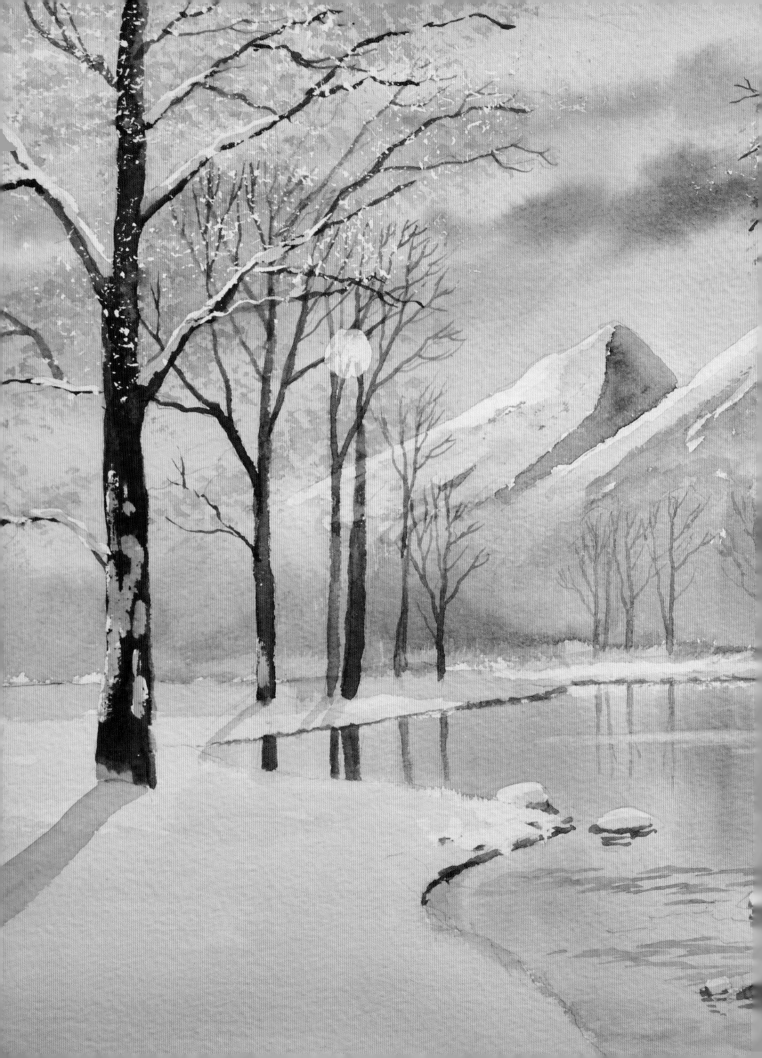

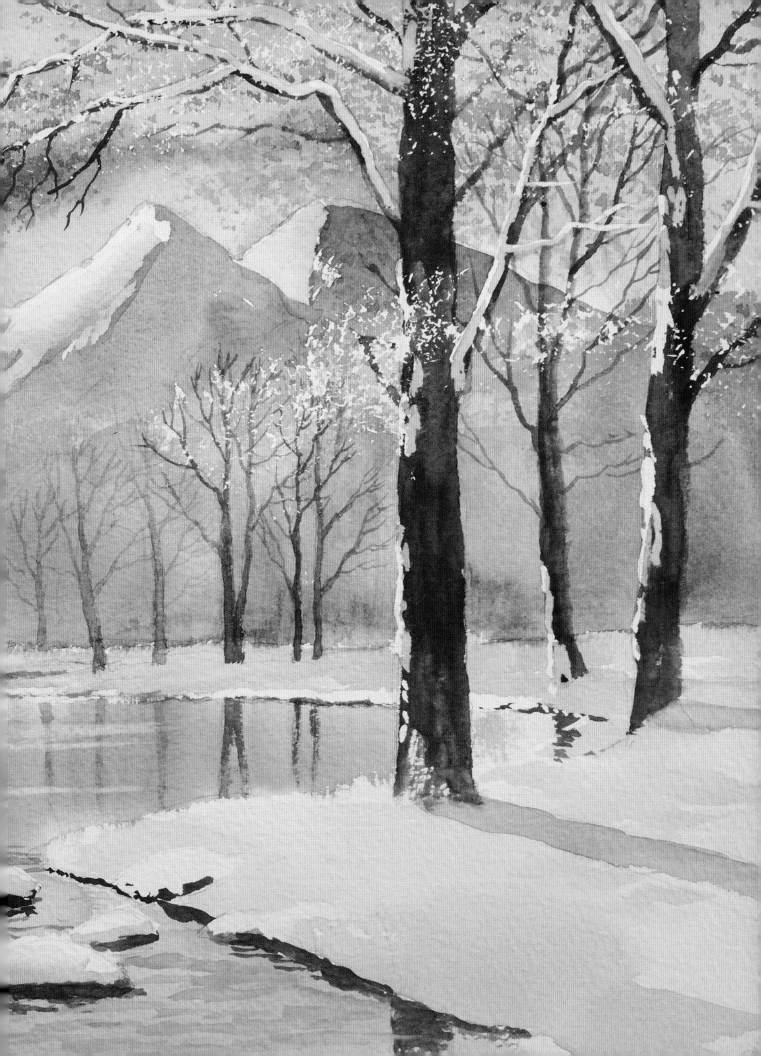

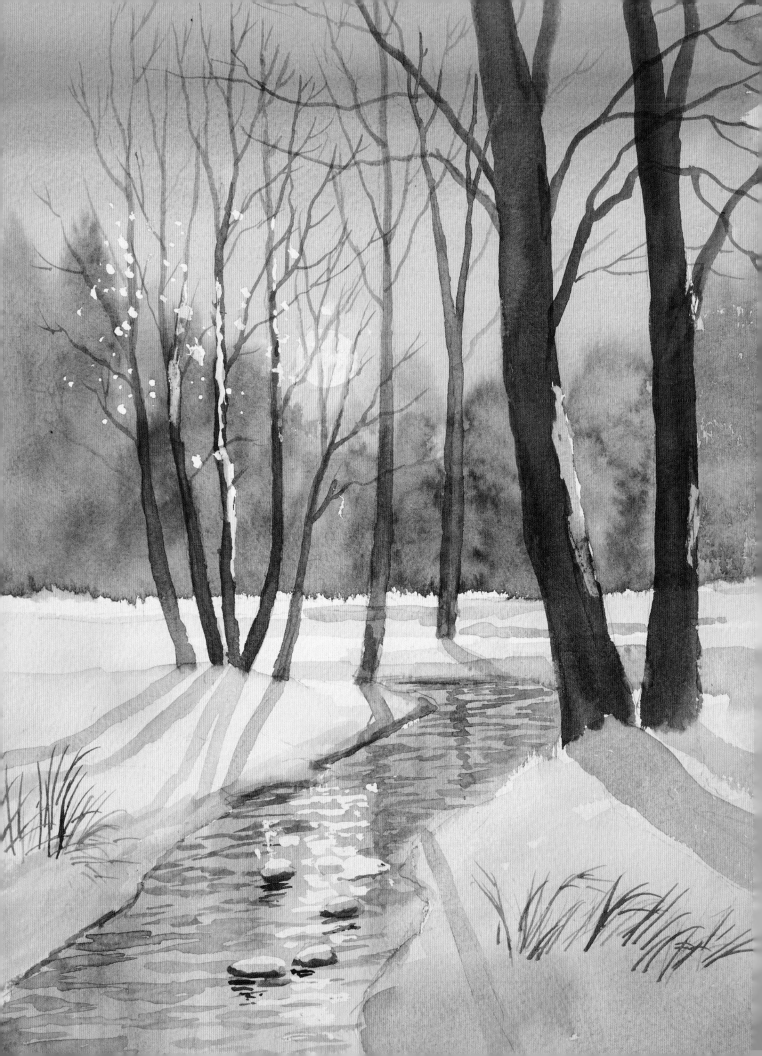

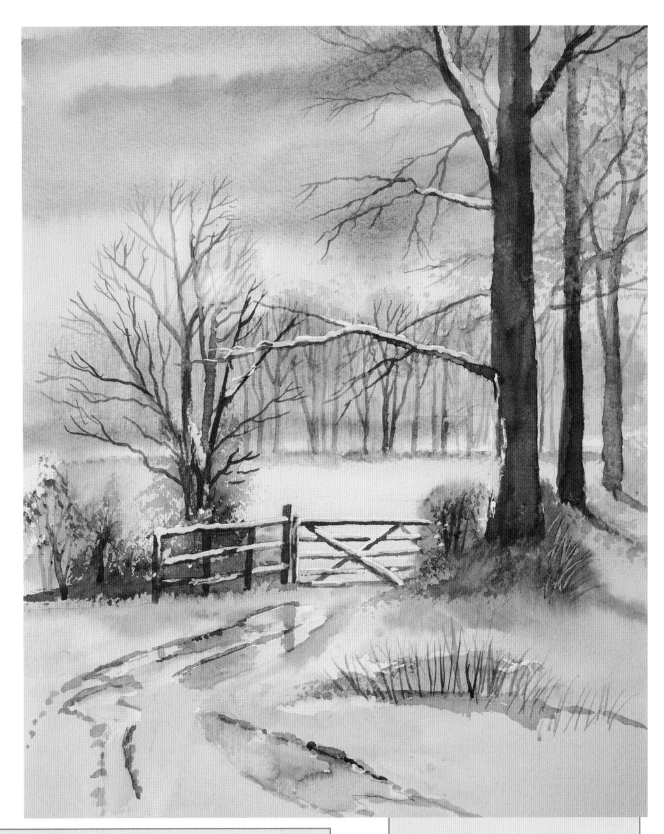

Opposite:

WINTER STREAM AT SUNSET

The setting sun behind the trees creates a warm glow in the sky. The long blue shadows in the foreground radiate away from the sun, giving a sense of perspective.

THE ICE BEGINS TO MELT

As the warm weather returns, the big thaw begins; this creates puddles in the cart tracks, which reflect the colours of the sunset.

SNOW STORM

It doesn't take long for a snow storm to cover everything with a thick blanket of snow. I would not recommend painting *plein air* (outside) in these conditions – instead, take photographs or just follow the instructions for this project! For the falling snow, I have used white gouache and varied the sizes of the snowflakes.

1 Draw the scene. Apply masking fluid to the road with a brush, and to the foliage with a scourer. Use the wipe-away tool to apply masking fluid to the snow clinging to the roof, chimneys and branches.

2 Wet the sky area with clean water and paint on ultramarine and burnt umber with the golden leaf brush. While this is wet, drop in a stronger mix with the fan gogh to create the trees. Use the brush on its side to paint a darker mix still.

3 Use the large detail brush to paint the bridge with burnt umber, ultramarine and a touch of raw sienna.

4 Wet the stone of the house and paint it with ultramarine and burnt umber. Add the chimney pots.

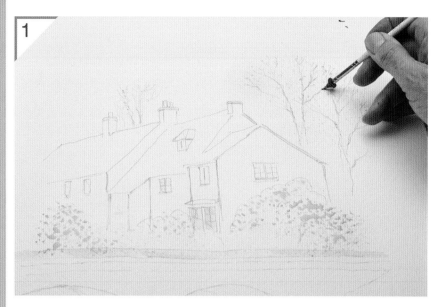

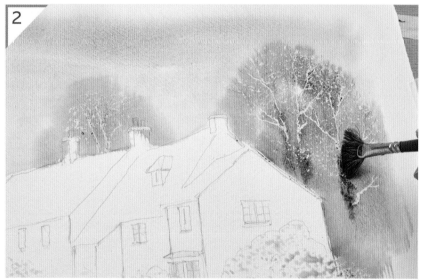

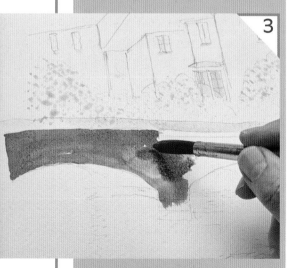

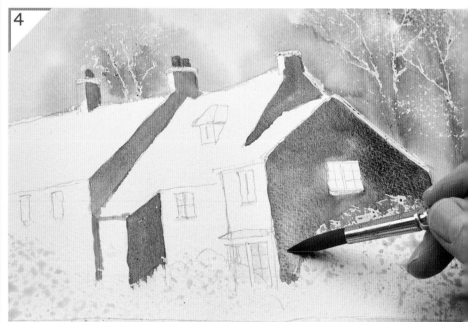

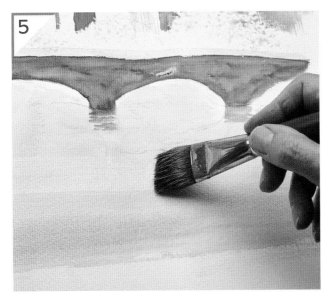

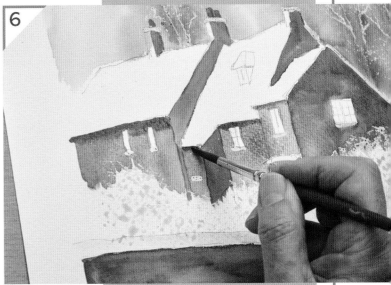

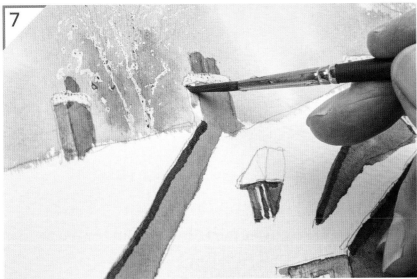

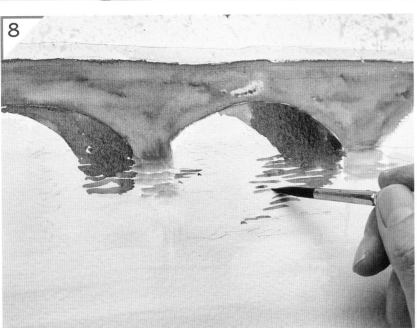

5 Wet the water area with the golden leaf brush and clean water, then paint on a wash of ultramarine with a little burnt umber.

6 Wet the front faces of the buildings with the medium detail brush and drop in raw sienna, then ultramarine and burnt umber for the darker parts under the roof.

7 Paint the dormer window and under the eaves with a dark mix of ultramarine and burnt umber. Change to the small detail brush to paint the lit sides of the chimneys with raw sienna.

8 Use the medium detail brush with a dark mix of ultramarine and burnt umber to paint the underside of the bridge and its rippled reflections in the water.

9 Mix ultramarine and burnt umber with a touch of raw sienna, and use the edge of the 19mm (¾in) flat brush to paint ripples reflecting the other parts of the bridge. Lower down, add ripples with ultramarine, then begin to suggest the reflections of buildings with ripples of ultramarine and burnt umber.

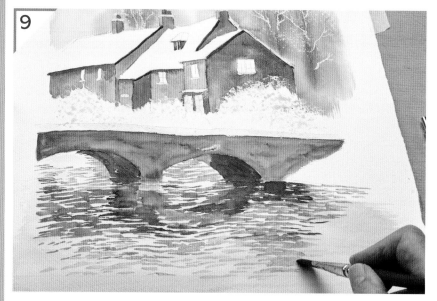

10 With the small detail brush and the same mix, paint the dark stonework details at the top of the bridge, and suggest the bricks over the arches. Allow to dry.

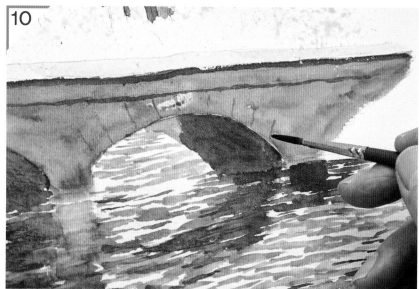

11 Mask the bridge with a straight-edged piece of scrap paper and use the golden leaf brush to stipple on the foliage behind it with a mix of shadow and burnt umber. Stipple ultramarine and burnt umber on top of this.

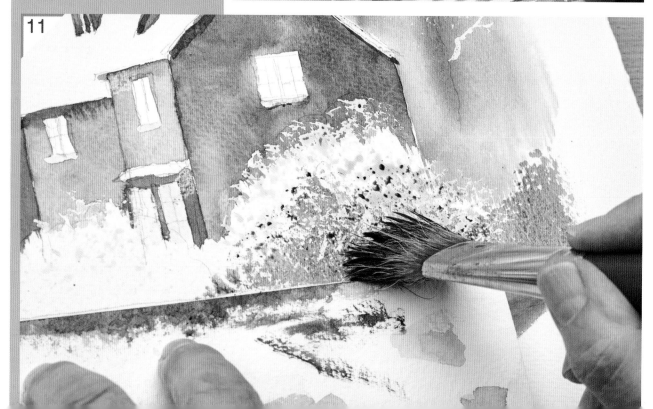

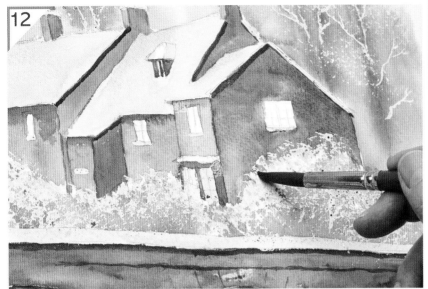

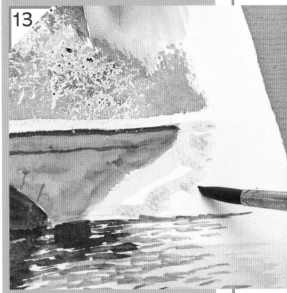

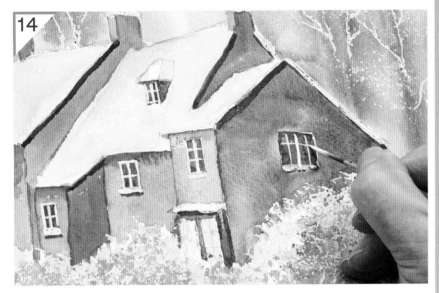

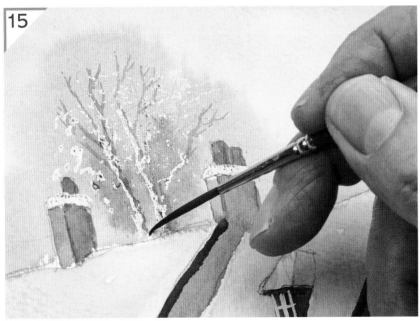

12 Paint the snow on the roofs and bushes with the large detail brush and ultramarine.

13 Shade the snow on the right-hand bank of the river in the same way.

14 Use the small detail brush with a dark mix of ultramarine and burnt umber to paint the window darks as vertical rectangles, leaving the vertical bars as white paper. When this is dry, use white gouache with the half-rigger to paint the frames and the horizontal bars.

15 Make a pale mix of ultramarine and burnt umber and paint distant tree trunks and branches.

16 Mask the bridge again and stipple the undersides of the bushes with the same mix of ultramarine and burnt umber on the foliage brush.

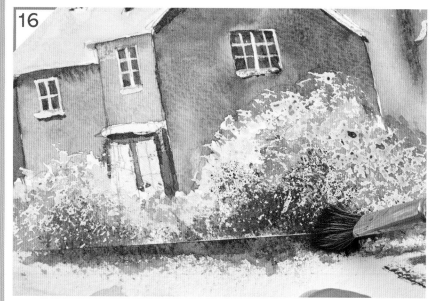

17 Allow the painting to dry, then remove all the masking fluid with a clean finger. Paint the light in the window with the small detail brush and a warm mix of cadmium yellow with a little cadmium red.

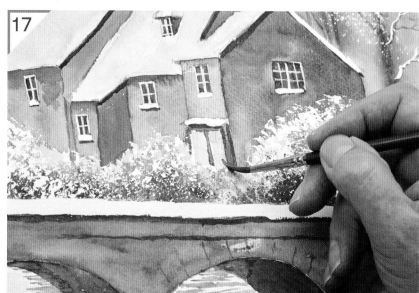

18 Shade the snow on the chimneys, trees, roof and bridge with cobalt blue.

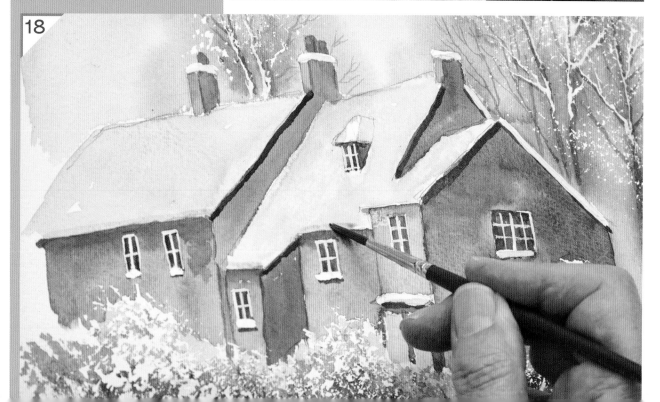

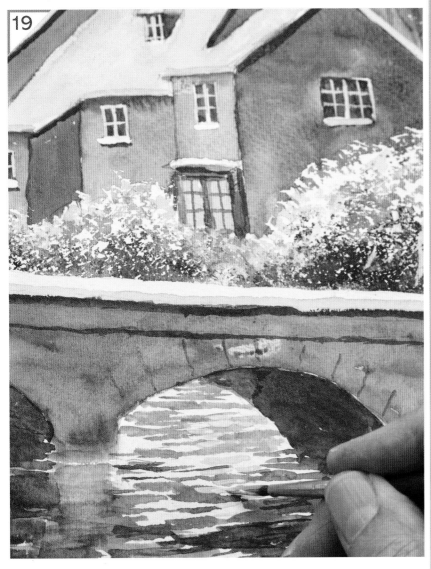

19 Paint the frame and bars of the lit window with burnt sienna. Mix white gouache with a little cadmium yellow and paint the rippled reflection of this lit window in the water.

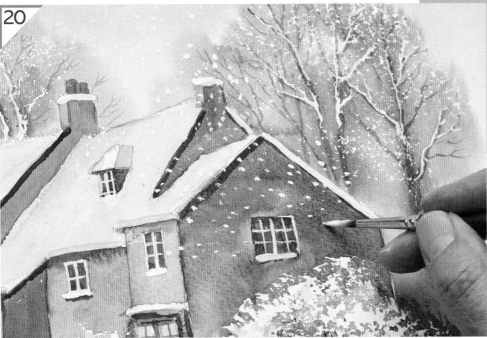

20 Finally, create the blizzard! Paint falling snow with white gouache on the small and medium detail brushes. Make sure the snowflakes are not too regular in shape, and that they vary in size.

OVERLEAF

The finished painting.

System Preferences

You can control the look and feel of your Mac by adjusting the settings in the System Preferences (similar to Control Panel on the PC).

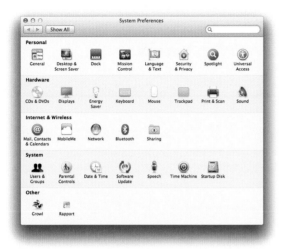

Change the Desktop

You may not like the background picture (called the desktop picture) Apple has chosen but you are free to choose any of the other options or even use one of your own photos instead. You will find this under **System Preferences > Desktop & Screen Saver**.

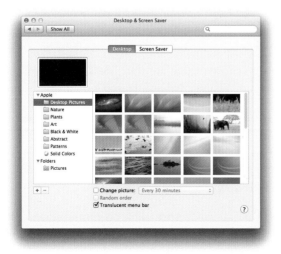

Hot tip

What are the colored buttons at the top of the windows?

Red: window close
Orange: minimize
Green: zoom.

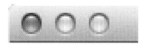

Hot tip

Play around with various desktop wallpapers until you find the one you want. They are easy to change if you get bored with them.

Mission Control

This feature in Mountain Lion allows you to see all your open windows which makes life easier if you have several programs open at once and the window you want to see is obscured by another window. In OS X 10.6 (Snow Leopard) you could have multiple desktops by using Spaces, and windows could be exposed by using Exposé.

1 Start **Mission Control**

2 Click the Mission Control icon in the dock

3 Or Swipe upwards with three fingers on the trackpad

14

Each rectangle represents a separate "desktop". You can move between these by pressing **Cmd** + → or ←

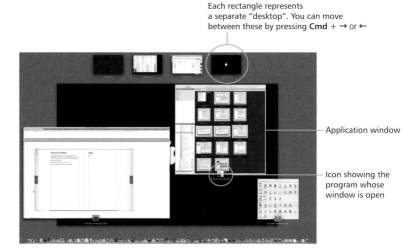

Application window

Icon showing the program whose window is open

In the example shown there are four "desktops", from left to right showing widgets, iTunes, InDesign, and an empty desktop.

In the lower part of the picture you can see three open windows, each representing a different program. From left to right you can see the InDesign window (with its icon at the bottom of the window), an Expression Media window and the System Preferences window.

To get out of Mission Control click on any window or the desktop.

Security

Macs are safe and secure, with few viruses around that target the Mac OS but basic common sense tells us that setting up basic security is sensible. This is covered in a later chapter but essentially you can make your Mac secure by:

Beware

Take computer security seriously and protect your Mac from hackers.

Setting up initial security features

1 Go to **Apple Menu > System Preferences**

2 Select **Security & Privacy**

3 Work through the options as required (if you have a wireless router the chances are it will have a firewall anyway so there is no need to set up two firewalls)

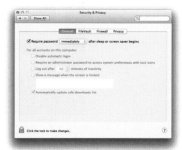

15

Gatekeeper

A new feature with Mountain Lion is Gatekeeper which prevents you installing software that may cause harm to your Mac. You can by-pass Gatekeeper's warnings by selecting **Allow applications downloaded from : Anywhere** in the Security & Privacy System Preference.

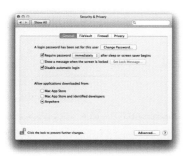

The Mouse and Trackpad

In general, desktop Macs use mice and MacBooks use trackpads, although separate trackpads can be purchased for use with desktop machines. The default settings are usually fine for most people but you may find the tracking speed (the speed at which the pointer moves over the screen) to be too slow, or the double-click speed too fast. You can adjust all these features by going to **Apple Menu > System Preferences > Mouse or Trackpad**.

Mouse options

Hot tip

The Natural Scrolling feels a bit odd at first. If you want to switch it off uncheck the button.

16

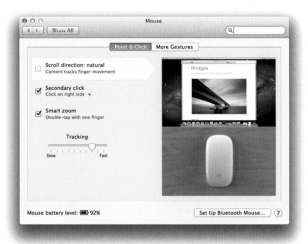

Trackpad options

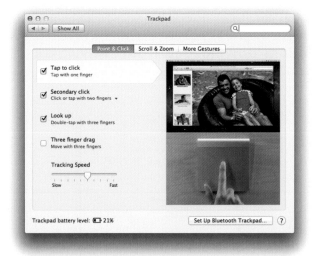

Keyboard Options

The keyboard has many settings including Repeat rate, Delay until Repeat, Modifier keys (e.g. Caps Lock key and others). Using the Keyboard System Preferences you can also modify all the keyboard shortcuts if you want to assign shortcuts to other functions.

Keyboard Repeat and Delay until Repeat

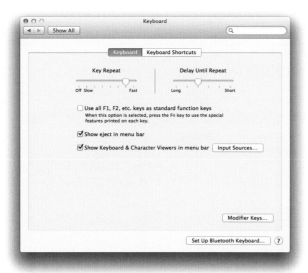

Keyboard Shortcut options

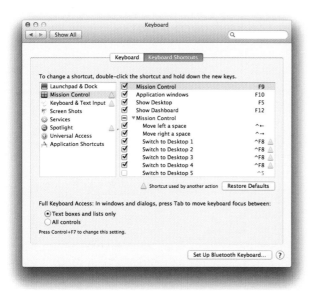

Don't forget

Keyboard shortcuts can save you time. Try to learn a few basic shortcuts like Copy, Paste, Cut, and Undo.

Adding Foreign Keyboards

You can add other languages and keyboards such as Arabic, Chinese, Dutch and many others.

To access other languages

1 Go to **Apple Menu > System Preferences > Language & Text**

2 Choose **Language** or **Input Sources** to change to, for example, the Arabic keyboard

Changing the language

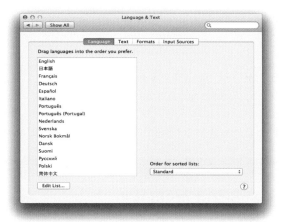

Changing the keyboard input

Mail, Contacts and Calendars

You can set up Mail, Contacts and Calendars within the individual programs (Mail, Contacts and Calendar) or you can use this System Preference to add new mail accounts, contact lists and calendars.

Apple Mail makes it very easy to set up accounts and will walk you through the whole process. Where possible try to choose IMAP rather than POP3 (this is discussed later in the book).

Set up a Mail account

1 Go to **Apple Menu > System Preferences > Mail, Contacts & Calendars**

2 Click **Add Account** to add a new account or click the − to remove an account

3 You can choose Microsoft Exchange server, iCloud, Gmail, Yahoo, AOL or other

This is covered in more detail in the relevant section of the book.

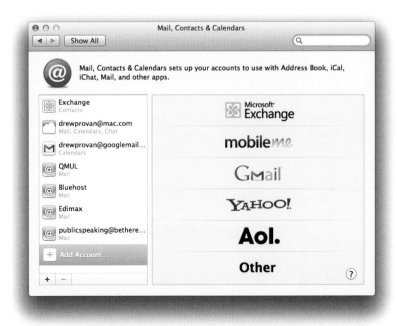

Networking the Mac

You can connect your Mac to a wired or wireless network, which will allow you to see other hard drives, printers, share files and many other items.

To access network settings

Hot tip

Your Mac can connect to other Macs, printers and other wireless devices easily.

1. Go to **Apple Menu > System Preferences > Network**

2. Adjust settings depending on network type (Ethernet, Wi-Fi, etc.)

This is discussed more fully later in the book.

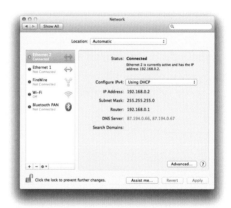

You can also add Bluetooth devices by going to **Apple Menu > System Preferences > Bluetooth**

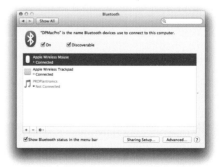

Setting up Sharing

To share files, folders and other content you have to allow the sharing of these items using the Sharing System Preference.

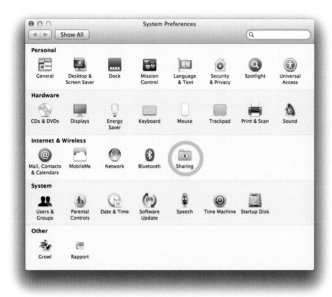

Beware

You cannot let other people share your files unless you have set up File Sharing using the Sharing System Preference.

Items you can share

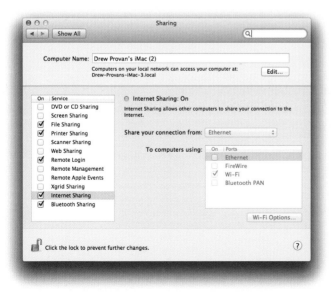

Date and Time

Your computer needs to be set to the correct date and time otherwise your files will be incorrectly dated, and keeping a diary using Calendar will be impossible.

1 Go to **Apple menu > System Preferences > Date & Time**

2 Choose location, server (e.g. *Apple Europe time.euro.apple. com*), type of clock (12 hour, 24 hour etc)

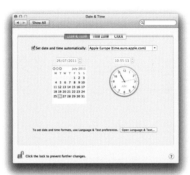

Choosing the server.

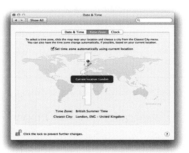

Make sure the time zone is correct. You may need to enter this manually if Wi-Fi fails to identify your time zone.

Choose the style and location of your clock.

Setting up Time Machine

Computers sometimes go wrong, and files are lost. People generally forget to back up their work until it is too late and a problem has occurred.

Backing up your files and folders can be done manually (dragging files around to separate drives) or you can allow Time Machine to do all the hard work for you.

Time Machine will back up your entire computer then do an incremental backup every hour. This means that if a file becomes lost or corrupt you can go back in time and retrieve a previous saved version.

To use Time Machine

1 Go to **Apple menu > System Preferences > Time Machine**

2 Choose the drive to use, and that's it!

Hot tip

Time Machine is a great app which will help you if you ever delete a file by accident or a file becomes corrupted.

Open Time Machine preferences, select the disk you wish to use (not your main hard drive – needs to be a distinct drive). If you don't want to back up certain files, e.g. applications, go to Options and exclude these.

Hot tip

Buy yourself a decent-sized external hard drive for Time Machine (e.g. 1–2 TB).

This picture shows the available drives that can be used with Time Machine.

Power Management

The Energy Saver setting is useful if you have a laptop, but can also be useful with desktop Macs. For example, if you want to use the printer attached to the computer you may not want the Mac to go to sleep, otherwise if you try to print remotely the printer may not be seen.

You can also use this panel to make your Mac wake up and sleep at specific times.

Setting up sleep and waken options

1 Go to **Apple menu > System Preferences > Energy Saver**

2 Choose options which suit you

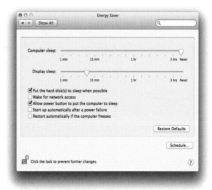

Choose when to make the drive and screen sleep.
There is an option to wake for network access
(this would include remote printing).

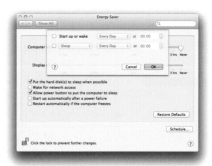

Set up your wake up and sleep options here.

Handling CDs and DVDs

If you insert a CD into the optical drive it will mount on the desktop, and may open iTunes if it is a music CD. Movies on DVDs will open DVD Player. You can change what happens when you insert different media through System Preference.

① Go to **Apple menu > System Preferences > CDs & DVDs**

② Choose options which suit you

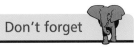

Don't forget

The default actions when you insert CDs and DVDs can be changed to whatever you want. You can even make the Mac do nothing when these media are inserted.

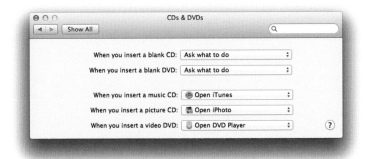

These are the default options which are generally fine for most people but you may not want DVD player to open when you insert a movie. You can instruct the Mac not to open DVD player using the drop-down options.

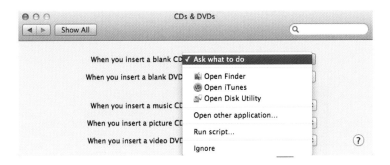

Using the drop-down menus you can tell your Mac exactly what you want to happen each time you insert different media.

Notifications and Reminders

Mountain Lion adds Notifications (similar to Apple's iOS devices (iPhone, iPad, and iPod touch). Notifications will show you what's in your diary, messages you may have received, software updates, and notifications from many of your apps.

Show Notifications

Click the Notifications icon at the top right of your screen or swipe left to right on the trackpad with two fingers.

You can adjust how you see Notifications (banners, etc.) using **System Preferences > Notifications**

Hot tip

If you use the Dashboard widgets (Control + left arrow) you may be pleased to learn that you can put your widgets into folders just as you would do with apps on an iOS device. This is useful if you have lots of widgets.

Go to Dashboard, click the + icon and drag one widget onto another. Simple.

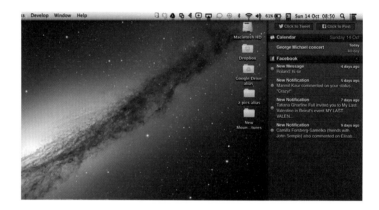

Reminders

This app provides a place for you to store reminders. It is simple to use but the great thing is you can make the reminders location-based (on arrival or leaving).

Facebook and Twitter

At last Mac OS X has Facebook and Twitter integration which means you can easily update your Facebook page and send Tweets from within many applications. You can do all this with a single sign-on for each app.

1. Open **System Preferences**

2. Go to **Mail, Contacts & Calendars**

3. Click on Twitter or Facebook and enter your credentials

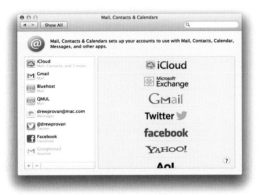

The image below shows how you can send a Facebook update directly from Safari (click the Share icon for options).

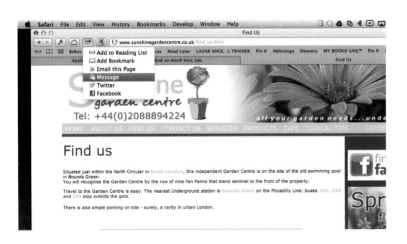

About This Mac

Want to know more about your Mac?

About This Mac tells you everything you need to know about your Mac including serial number, RAM, drives, installed software and much more. Familiarize yourself with the various panes by clicking on them in turn.

Hot tip

People get confused about "memory", confusing RAM memory with hard drive capacity. The hard drive is where you store files and apps. As you add files the disk will fill. RAM (Random Access Memory) is usually around 2–4 GB and is the space used to hold running apps and documents temporarily while the apps are running. It's like a workspace for the apps. If RAM is low, your Mac may slow down until you quit some apps or close windows to free up some RAM for the apps to use.

1 Go to **Apple Menu**

2 Select **About This Mac**

3 Select the tabs to learn about display, storage, and memory slots

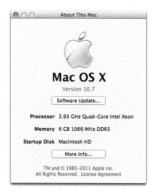

4 Click on **More info** to see the tabs below

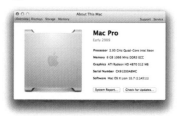

Basic information

Information about display

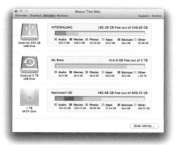

Attached drives

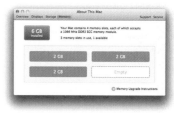

Memory slots

2 Dealing with Documents

With each app you use you will generate documents. Here we will look at how documents are best filed, copied, edited and handled by the Mac.

The Finder

This term refers to the file manager in Mac OS X, and has been used since the early days of the Mac. You use the Finder to open Finder windows, move files, and many other functions.

Open the Finder

1 Click its icon in the dock

2 A Finder window will open, which can be configured in many ways (column view and others)

Click on the Finder (bottom left)

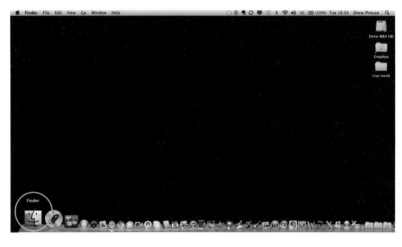

New Finder windows opens in column mode

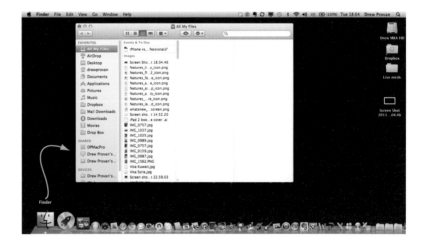

Finder Views

Apple has provided a number of different ways to look at Finder windows. For basic documents, List or Column view is useful. For pictures, the icon view is better. To preview documents (without actually opening them), choose the Cover Flow option.

Change Finder window view options

1 Open a new window and select from the icons at the top of the window

2 Or go to View at the top of the screen and select option

Choose from icons in Finder window or

Select View from Finder window

Finder window showing Icon view – files, folders and images are shown in full preview mode

Cover Flow is much like an iPod, iPhone or iPad where you can scroll through your files and images, preview them and see their contents without actually having to open the documents

Folders

You need folders to contain your files, text documents, photos, music, and many other items. It's worth learning how to make folders, name them, move and copy them.

Make a folder

⌘ is the Apple Command Key and is used for most shortcut combinations for Macs (similar to the Windows Key for PCs).

1 Go to **File > New Folder**

2 Or tap ⌘ **+ Shift + N**

Rename a folder

1 Click on the name of the folder, you will see the box turn blue, simply start typing and the name will be replaced by the new name

Move a folder

1 Click and drag folder to wherever you want

Duplicate a folder

To duplicate a file or folder you need to Option-Drag them (unless you are copying to a different disk in which case you can simply Drag).

1 Click on folder, and drag while holding down Option (Alt) key

Document file

Make an alias of a folder

An alias is like a dummy folder that points you to where the real folder is, and acts a bit like the real folder. For example, you may want easy access to your Mail downloads folder but it's a real pain having to navigate to your Home Folder > Library > Mail Downloads so you can click on the Mail Downloads folder, then right-click and choose Make Alias. Drag the alias (you know it's an alias because it has a black curved arrow on the folder) to the desktop. When you double-click the alias folder you can see all the Mail Downloads as if it were in that folder (it is actually still in its original location).

The same can be done with documents. You can move them around, rename them, make copies by Option-dragging them and make aliases to them.

Bento

my document.rtf

my document.rtf alias

New folder

New folder alias

From top left: an alias of an app (Bento), a document and its alias, a folder and its alias

Move Files into Folders

This is very straightforward.

Adding a file to a folder

1 Click and hold the file you want to add to the folder

2 Drag the file to the folder

3 The folder will turn darker and may spring open (depending on your settings)

4 Unclick the mouse (take your finger off)

5 The file will drop into the folder

To move the document out of the folder

1 If you add the wrong document to the folder immediately hit ⌘ **+ Z** (this is the Undo command – works with most programs, and will reverse your last action)

2 Or you can double-click the folder to open it and drag the file out

Copy (rather than move) a file to a folder

This leaves the original file (or folder) where it is but makes a copy.

1 Press **Option** and click the file you want to copy

2 **Drag the copy of the file** to the folder (you should see a green **+**)

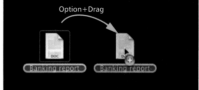

3 Your original file should remain in its position and the copy should be where you dropped it

Deleting Files from Folders

This is easy.

1 **Find the folder**

2 **Double-click** to open

3 **Locate file** and **drag to Trash**

4 Or **click once on the file** to select it then type
⌘ + **Backspace**

5 Or click once to select then right-click and choose Move
to Trash

6 To **undo** (retrieve a file or folder from the Trash) type
⌘ + **Z**

Delete multiple files/folders

1 Click the pointer on the screen and **lasso the
documents** you want to delete

2 Or hold down **Option** key and **click the files** you
want to delete

3 **Drag the files to the Trash** or type
⌘ + **Backspace**
or right-click and
select **Move to
Trash**

Hot tip

Delete files fast by
clicking once then typing
⌘ + Backspace.

Where's My User Library?

There are at least two libraries on your Mac – the main Library for the Mac HD that you shouldn't touch, and your own Library (**~/Library**) in your Home Folder (again, you shouldn't really touch this but many of us do look in the Library folder and delete and add items).

Until OS X 10.7 your Library file was visible in your Home Folder but with Mountain Lion it's disappeared! But it hasn't really gone, it's just hidden. Apple has chosen to hide this from us, probably to stop people deleting crucial files that keep your Mac working properly. *Note*: take care when tinkering with files in the Library – you could cause your Mac to crash!

To make your own Library visible

1 Go to the **Go** menu (top of Finder window)

2 Then hold down **Option**, and the Library folder will appear (take your finger off Option and Library vanishes)

To make your Library folder permanently visible

1 **Open Terminal** (one of your Utility programs)

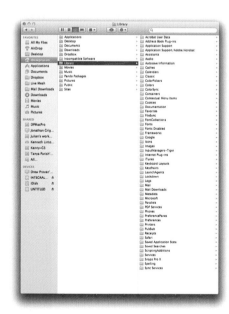

2 Type in **chflags nohidden ~/Library**

3 Hit **Return**

4 Your own Library will be visible permanently

Beware

Your User Library (~/Library) is hidden by default. You can access it temporarily by holding down Option then choosing Go > Library or use the permanent option using the Terminal app.

Labels

If you go to the Finder menu (top of Finder window) you will see Labels at the bottom. These are color-coded. You can use these codes for specific items – for example, very important files and folders could be red, and personal items green.

Take labeling even further

1 Instead of color-coding, you can actually name the labels

2 Go to **Finder Menu** (top of screen) and select **Preferences > Labels**

3 Next to the color box you can add whatever you want, e.g. Important, Personal, Banking, etc.

4 This makes it easier to sort and find your files

Hot tip

Labels can be given any names – just amend the ones provided by Apple.

Find files using label tag

If you want to find a file which you know has, for example, a Banking tag assigned by you:

1 Type ⌘ **+ F**

2 Type the name of the file if you know it

3 Select **Kind** and use drop-down menu to get **Other...**

4 Select **Label > Banking**

5 You should find your labeled files easily

Is your work saved?

As you work on documents the red button at the top left will have a small black dot in the center if you have not saved the document.

Unsaved (*note the black dot*)

Saved (*black dot gone!*)

Opening Documents

Usually when you click a document it will be opened by the program that was used to create it. But if you take pictures using a camera then transfer them to the Mac, you might find that when you double-click the photo it gets opened by Preview when you really wanted to open it in Photoshop.

Specifying a program to open a document

1. Locate the document

2. Right-click on the document and select **Open With**

3. Choose the program you want to open the file

4. If not shown, choose **Other...** or **App Store...** (to look for a program that will open the file)

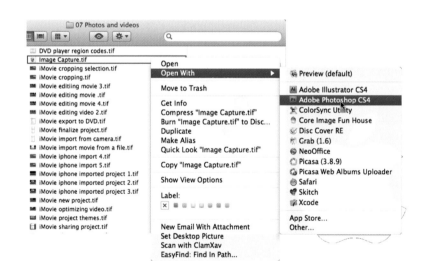

Saving documents

For most apps you can go to **File > Save** or **File > Save As...** But with OS X 10.7 Apple now uses **Versions** with many of its own apps (e.g. Pages). Now there is no Save As... so to open a document and save under a new name you need to choose **Duplicate**. Once the document has been duplicated you can rename it.

Quick Look at Documents

Often you want to find a document but you don't want the hassle of opening each one until you find the one you want. There are ways of viewing documents (Word or Pages files, PowerPoint, Keynote, mp3s, videos and many others) without opening any programs at all using Quick Look.

Using Quick Look

1 Find the document(s)

2 **Select** the document by **clicking once**

3 Go to **Quick Look** in the Finder menu

4 Or tap ⌘ **+ Y**

5 Or simply select the file and tap the **spacebar**

6 You can then preview the contents. If it's the document you need, double-click to make it open in its respective program

The above shows a PDF file which was viewed by selecting the PDF file then tapping Spacebar. After doing a Quick Look the document can be opened properly using Preview (see top right for Preview button).

Dictation

Rather than type documents you can use the internal microphone on the Mac to dictate text.

Activate Dictation

1 Go to **System Preferences > Dictation**

2 Click the radio button to switch it on

3 Within any app **tap the Function (fn) key twice**

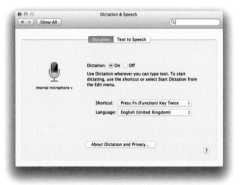

With no training at all the accuracy is extremely high (unlike most conventional voice recognition apps). Below shows some dictation in TextEdit. All text and punctuation are correct.

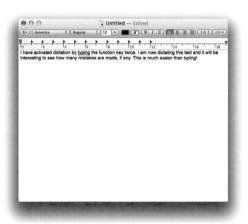

Notes app

The Notes app has been ported over from iOS devices, having gained popularity on the iPhone and other iOS devices. The concept is simple: Notes is a straightforward note-taking app that syncs to your iPhone or other iOS device (if you select this in the iCloud System Preference).

As well as text, you can drop in images.

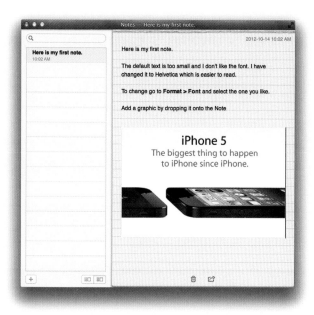

Sharing notes
Click the Share icon (bottom right) to send the note using email or iMessage.

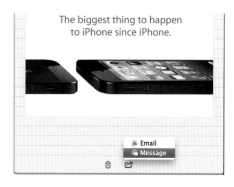

Mac and PC Compatibility

If you regularly work with documents on both Mac and PC (e.g. if you use Word for Windows on the PC at work and Word for Mac at home) you can copy your files onto a USB drive.

However, you cannot use PC-formatted (NTFS) disks with a Mac, or Mac-formatted disks with a PC.

Instead, use FAT32 which can be read by both Mac and PC.

Format a drive as FAT32

1 Open **Go > Utilities > Disk Utility**

2 Select your USB drive

3 Click **Erase** and give the drive a **name**

4 From the drop-down menu select **MS-DOS (FAT)**

5 The drive will be formatted and will be readable on PC and Mac!

Beware

PCs can't read Mac-formatted drives and vice versa. Use FAT32 as the format type if you intend to use a USB drive on both PCs and Macs.

42

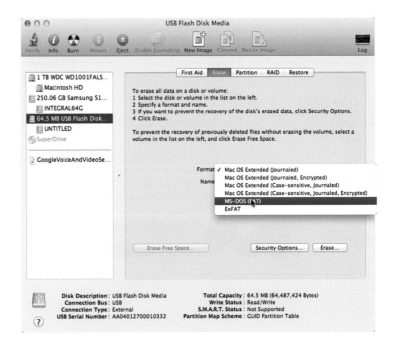

3 Working with PDF Files

Using Preview *on the Mac makes generating PDF files incredibly easy. For collaborative work or sharing of documents, PDFs make the whole process painless.*

What is a PDF?

PDF stands for *Portable Document Format*. Basically it means you can create a document in any program, with graphics and fonts and save it in a format that anyone can open (Mac or PC), even if they don't have the program you used to generate the document. For example, you may use Adobe Illustrator to generate a newsletter but there's no point sending this file to your colleague since he does not have Adobe Illustrator. Instead, save as PDF which he can open on his Mac or PC and see the document in all its detail.

Upsides

- Anyone can open and read a PDF even if they don't have the specific program used to create a document

- Small file size

- Quick and easy way to share documents

Downsides

- May not look 100% like the original document, e.g. the fonts may change

- Can be tricky to edit

Hot tip

PDFs are great for sending someone a document which was created using a program they don't have on their Mac.

FcyRIIB in autoimmunity

Programs to Read PDF files

There are many of these, some free, others are paid. It can be expensive if you want full functionality in terms of editing, for example:

- Adobe Acrobat Reader and Adobe Acrobat Pro

- Preview

Mac OS X comes with *Preview*,
a document and image viewer. It will open:

- PDFs

- Images

- Many other types of documents

Preview allows minor editing, cropping, rotation, etc.

Don't forget

Preview can open many types of file – not just PDFs.

Dropping PDF files into other types of document

Did you know you can drop a PDF file on a Word or Pages document, and even PowerPoint or Keynote? Simply drag the PDF file onto an open Word window and the PDF will be embedded within the Word file. There are many other programs that can handle PDFs – if in doubt try dropping a PDF onto a document window.

PDF dragged onto a Word page and displayed within the page

Opening PDF in Preview

To open a PDF document

1 Select the PDF you wish to open

2 Double-click and Preview opens the file automatically

3 Alternatively, you can right-click and select **Open with**

Zoom in/out Text Annotate toolbar Content only Search Box
 Move Select Thumbnails
 Table of contents
 Contact view

Basic page mode

With thumbnails

Contents view

Contact sheet

Add Text to PDF

Annotating PDF files

You can use Preview to annotate a document, adding text boxes, thought bubbles, arrows, and other symbols. This is useful if someone sends you a PDF of a document they're working on. You can then add your thoughts and comments to the document directly and email the document back, and they can incorporate your changes within the master document with the program they used to generate the PDF.

For example, if they're working on a Word document they can generate a PDF from within Word, and send that to you.

You can then add your comments, and they can then make the changes to the Word file based on your comments.

Preview lets you add bookmarks, strike through text, underline text, add shapes, speech and thought bubbles.

Creating a PDF

Creating a PDF using a Mac is very easy.

1 Within your program (Word, Pages, Photoshop, Excel, etc.) select **Print**

2 At the bottom left of the Print dialog box click the PDF drop-down menu

3 Choose **Save as PDF...**

4 Name the file and select the destination for the save

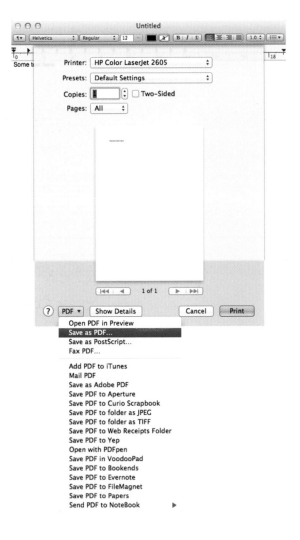

Making PDFs Secure

You can password-protect PDFs so that only those people with the password can open the document.

1 Choose Security options

2 Click **Require password** to open document

3 Type in the password then verify it

4 You can password-protect the editing of the document by using the settings in the dialog box

Don't forget

For a PDF that contains sensitive information consider password protecting it.

○ ○ ○　　　　　　　Save

Save As: | Untitled.pdf | ▼

Where: | 🗋 Documents | ⇕

Title: | Untitled

Author: | Drew Provan

Subject: |

Keywords: |

[Security Options...]

[Cancel] [Save]

PDF Security Options

☑ Require password to open document

Password: | •••••••• |

Verify: | •••••••• |

☑ Require password to copy text, images and other content
☐ Require password to print document

Password: | |

Verify: | |

(?)　　　　　　[Cancel] [OK]

Emailing PDF files

1 Create your PDF

2 **Open Mail** or other email program

3 **Drop PDF onto email** (or attach using ⌘ + **Shift** + **A**)

4 Send email

5 Alternatively, within the Print dialog box select **PDF > Mail PDF**

6 A new email will open

7 Address it, add subject and email content and click send

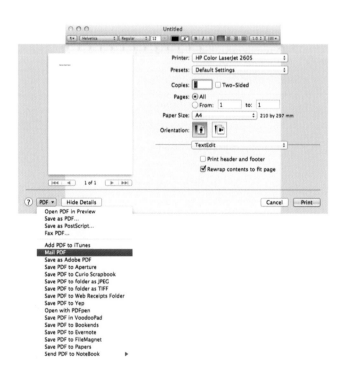

Acrobat Reader

This is a free PDF reader from Adobe with limited editing tools. Because Macs come with Preview there is little need for most Mac users to download Acrobat Reader. Preview is fast and has sufficient capability for most people.

Skitch

This is a freeware program which allows you to annotate PDFs quickly. It is more fun than Acrobat or Preview.

Hot tip

Skitch is a great free app for marking changes and annotating PDFs. You can download it from skitch.com

Heavyweight PDF Readers

For the professional who needs to edit documents extensively, add electronic signatures, with direct text editing of the PDF file, Adobe Acrobat Pro will be required.

The program is expensive and is only required if you work with PDFs regularly and need to directly edit the text within the PDF.

4 Mastering Email

Apple Mail *comes as part of OS X. It is a powerful and flexible email client. In this chapter we will look at the basics of* Mail *and how to get the best out of the program.*

The Mail Window

You will spend a fair bit of time writing and sending emails so it's worthwhile getting to know the layout of Apple's email program, Mail.

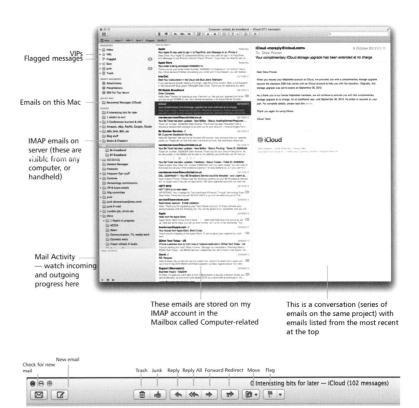

VIPs
Flagged messages

Emails on this Mac

IMAP emails on server (these are visible from any computer, or handheld)

Mail Activity — watch incoming and outgoing progress here

These emails are stored on my IMAP account in the Mailbox called Computer-related

This is a conversation (series of emails on the same project) with emails listed from the most recent at the top

New email

Check for new mail

Trash Junk Reply Reply All Forward Redirect Move Flag

0 Interesting bits for later — iCloud (102 messages)

The basic structure of an email is:

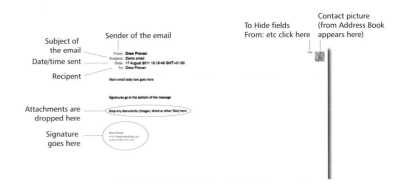

Subject of the email

Sender of the email

Date/time sent

Recipient

Attachments are dropped here

Signature goes here

To Hide fields From: etc click here

Contact picture (from Address Book appears here)

Add an Email Account

You cannot send or receive email until you set up an account. You can add others later but for now, let's just add one account.

1 **Launch Mail**

2 Go to **Mail menu > Preferences > Accounts**

3 Click **+** to add an account (click **−** to remove an account)

4 Enter your name, email address and password for that email account then click **Continue**

5 Choose the account type: **POP, IMAP, Exchange or Exchange IMAP** (POP is an old technology and IMAP is better if your email provider provides it. With IMAP email stays on the IMAP server and doesn't get dumped into one local device, which means you can read your email on any computer, smart phone, or tablet)

6 Give the account a description so you know which email account it is

7 Enter **Incoming Mail Server,** e.g. imap.gmail.com

8 Then enter **User Name** and **password** and click **Continue**

Hot tip

Try to use IMAP email whenever possible.

55

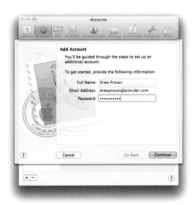

Create an Email message

1 Type ⌘ **+ N** or go to **File New Message**

2 A new email window will open

3 **To:** add the recipient's email address

4 **Cc:** add anyone you want to receive a copy

5 **Bcc:** if you want to send a blind carbon copy (the "To:" recipient won't see this email address) add that person's email address here

6 **Subject:** add something brief which describes the topic of email

Hot tip

If you want to send an email to someone and include (secretly) a third party but not let the main recipient know, add the third party's email address to the Bcc: box.

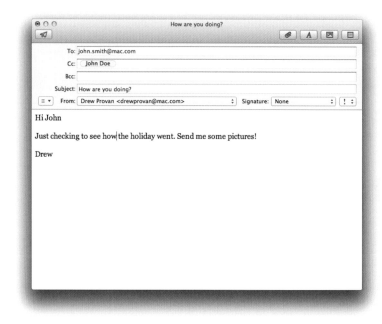

Send an Attachment

You can send most types of file by email. Be careful not to send huge attachments – generally up to 2MB is okay.

Add attachment

1 **Drop onto email body**

2 Or click the **paperclip** icon and locate the file you want to send

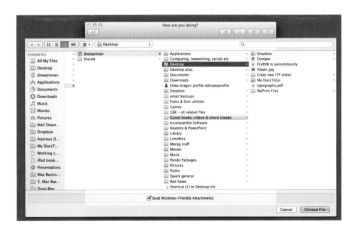

Receive Email Attachments

People often send you email containing attachments. Sometimes you can see the attached file in the email, e.g. photos. However, you may need to download the attachment first and then open it.

You can tell an email contains an attachment from the paperclip icon in the email window.

Hot tip

You can change the way Mail sends you notifications by going to System Preferences > Notifications and selecting Mail.

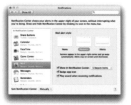

Click the **Save** drop-down to save the attachment:

Reading Emails

All your emails will be listed in the middle pane of the email window. If you click on one email its contents will be shown in the rightmost pane. You can quickly read through your emails by moving up and down through the middle pane using the up and down arrow keys.

Reply to an email

1 Tap the **Reply** or the **Reply All** button on the mail toolbar

2 A reply window will open and the cursor will be at the top of the text area

3 Write your reply and hit **Send**

Click here to
reply to sender

Beware

Don't overuse the Reply All. It gets very wearing seeing dull emails endlessly circulated around a group.

Hot tip

You can go to the top of your Inbox list by clicking the sort bar at the top of the message list!

59

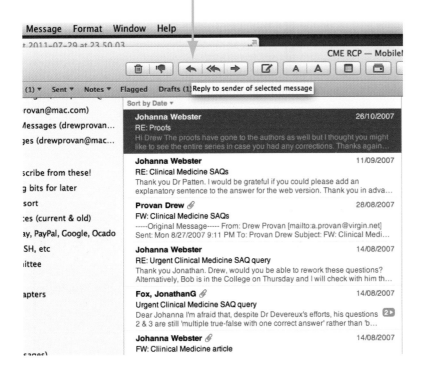

Mailbox Folders

Like snailmail, emails should be filed or trashed or your Inbox will become overloaded. You should develop a system where you can file your emails in mailboxes.

Create mailboxes

 In Apple Mail go to **Mailbox > New mailbox**

2 **Choose location** for the new mailbox: if you use MobileMe (IMAP) it makes sense to create your mailbox here – stored on the cloud and accessible from any computer, iPhone, iPad or other device

3 Give the mailbox a **name,** e.g. Personal, Banking Holidays, Work, Family, etc.

4 You can create as many mailboxes as you need (you can also create mailboxes within mailboxes)

5 Once created, file your emails!

Smart Mailboxes

If you regularly receive emails from your bank or other senders and you want to store these in a mailbox, you can drag them there or you can create a *rule*. The rule would tell Mail that any email from your bank (e.g. containing the address *hsbc.com*) gets moved to the Smart mailbox called Bank automatically. All the work is done for you by Mail.

This is similar to creating smart playlists in iTunes.

Hot tip

Smart Mailboxes do all the sorting for you!

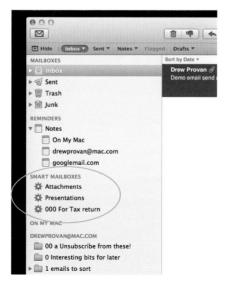

Smart Mailboxes are listed in the left pane as shown

Searching Mail

Search

The mail toolbar contains a search box at the top right. If you want to search for words within the email body, or for emails from a particular sender, type your search string into the search box.

You can select whether to search all your emails or just specific folders.

Flag emails

Sometimes you want to mark an email to read later. Since Mountain Lion, Apple has introduced a system of colored flags which can be applied to emails.

These will then be moved to the flagged email mailbox making it easy for you to review these emails at a later time.

Hot tip

Flag your emails so you can easily find them later.

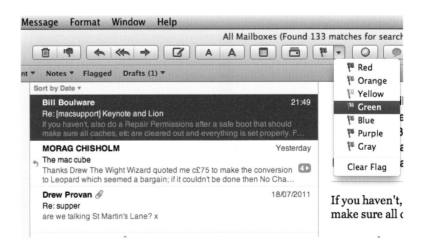

Change Fonts and Colors

If you do not like the default fonts or colors you can change these by:

1 Going to **Mail Preferences**

2 Selecting **Fonts & Colors**

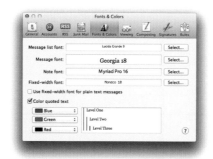

3 You can change the message list font, the message font, the note font, and the fixed width font. You can also change the color of the quoted text

Adding a signature to your email

You can add a signature (usually your name along with some contact details) by hand with every email, or you can set up a signature and have that added automatically at the end of your emails.

1 Go to **Mail > Preferences > Signatures**

2 Click the **+** button and enter your signature text in the window

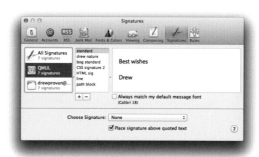

3 Assign it to email accounts by dragging the signature onto the account name

63

Hot tip

Set up at least one signature for your email to avoid having to type this in every time.

VIP list

If you want to make sure the emails from your boss or partner (for instance) are easy to find you can make them VIPs. This marks their emails as VIP as they are received and places them neatly in a special folder in Mail called **VIPs**.

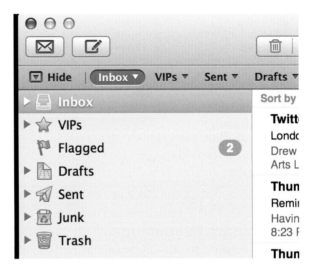

Add a VIP

1 Open an email from the person you want to add to the VIP list

2 **Click on their email address** and select **Add to VIPs** from the drop-down list

3 All emails from that address will be added to the VIPs mailbox automatically

5 Surf with Safari

Safari is a full-featured web browser. It is clean and fast. OS X Mountain Lion brought even more features to Safari, and for the majority of users, Safari is the only browser you will need.

Go on Safari

Safari is Apple's web browser – a fast and efficient browser with a very simple interface making it very easy to use.

Hot tip

Like Google Chrome, Safari now has a unified search and address box.

Layout of Safari window

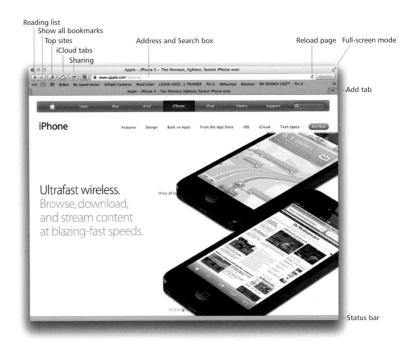

Reading list
Show all bookmarks
Top sites
iCloud tabs
Sharing
Address and Search box
Reload page Full-screen mode
Add tab
Status bar

Don't forget

You can change the Homepage (i.e. the web page that opens when you launch Safari) to anything you want.

Set Homepage
You may not want Safari to open at Apple's homepage each time you launch the program.

1 Go to file **Preferences > General**

2 Where it says **Homepage:**, delete the Apple URL (*Uniform Resource Locator*, i.e. a web address) and enter the URL of the page you want to see when you start Safari

Full-Screen Browsing

The Safari window can either float on your desktop, which is the standard mode for most computers, or you can make Safari fill the entire screen. *Note*: most programs can be used in full-screen mode.

Activate full-screen mode

1 With the Safari window open, click the full-screen icon at the top right of the window

Deactivate full-screen mode

1 Press **Esc**

Switch between pages

1 **Swipe** Left or Right using **two fingers**

Zoom in/out

1 **Double-tap** with two fingers

2 Or **stretch** to zoom in or **pinch** to zoom out

How to exit full-screen browsing

1 Type **Esc**

2 Or move mouse pointer to the top of the screen until you see the **blue full-screen icon** – click this and you will exit full-screen

Hot tip

To exit Full-Screen mode in any program tap the Esc key.

Reading List

In the past, if you wanted to save a page to read later you had to save this as a bookmark. With OS X Mountain Lion, the latest version of Safari allows you to save pages to a Reading List. This means your pages are easy to find, and it also avoids cluttering up your Bookmark list.

Save page to reading list

1 Go to **Bookmarks > Add bookmark**

2 Select **Add this page to: > Reading List**

3 Alternatively type **Shift + ⌘ + D**

Search the Internet

Safari has a search box at the top right of the window. Google is the default search engine but you can change this to Yahoo! or Bing.

Changing the search engine from Preferences

1 Open Safari and go to **File > Preferences**

2 Go to **General** tab

3 Change from Google to Yahoo! or Bing

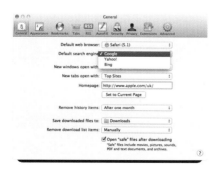

Hot tip

You can switch from Google to Yahoo! or Bing as your search engine.

Bookmarks

It is a good idea to keep the sites you visit frequently as bookmarks. These can be stored in the Bookmarks Menu or on the Bookmarks Bar – this gives you fast access to frequently-visited sites.

To save current page as bookmark

1 Go to **Bookmark > Add Bookmark...**

2 Or type ⌘ + **D**

3 When you see **Add this page to:** click the drop-down menu and choose from the options **Reading list, Top Sites, Bookmarks Bar, Bookmark Menu**

4 Navigate to the folder where you want to store the bookmark and the bookmark will be saved there

Organizing Bookmarks

Much like email, you need to create folders for your bookmarks so you can save your bookmarks according to topic, e.g. Personal, Music, Fitness, etc.

Organize bookmarks

1 Go to **Bookmarks > Show All Bookmarks**

2 Or type **Option + Control + B**

3 Click on the **Bookmarks Menu** in the left pane

4 To add a new folder click **+**

5 Enter the name for the new folder

Don't forget

Organize your Bookmarks or you'll end up with a huge list of disorganized links! Make folders for different topics.

Deleting bookmarks folders

1 Type **Option + ⌘ + B**

2 Use the delete key to remove the folder you wish to remove

Importing Bookmarks

You may have been using another browser, Mac or PC and want to import all your previously-saved bookmarks.

Import bookmarks

1 Using your previous browser, export your bookmarks (for most browsers this is achieved by going to **File > Export Bookmarks...** and saving this file to the desktop)

2 On your new Mac open Safari and go to **File > Import Bookmarks...**

3 Find the export file you made previously and click **Import**

Browsing Using Tabs

Tabs represent different web pages and make browsing multiple pages faster and much easier. Each page is represented by a separate tab at the top of the Safari window.

You can jump from page to page quickly by clicking on the various tabs.

To open a new tab

1. Go to **File > New Tab**

2. Or type ⌘ **+ T**

3. A new tab will appear

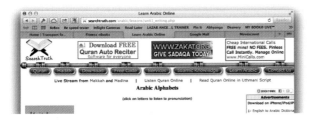

Use Tab View

1. Click the Tab view icon

Making Browsing Secure

Browsing the web involves interacting with various websites, accepting cookies and pop-up windows. When you go online you leave a trail which can potentially make you vulnerable to attacks by hackers.

Safari makes it very easy to clean up your browsing history, cookies and other items.

Beware

Don't forget to reset Safari (see page 217) from time to time to clear out temporary files and delete cookies!

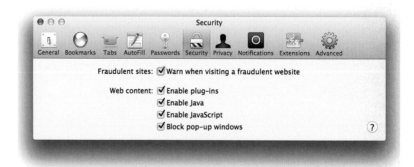

74

Hot tip

Don't forget to clear out cookies and other browsing data regularly (see Chapter 19).

6 Calendars and Contacts

We all keep diaries and contact lists.

The apps Calendar *and* Contacts

integrate well. In this chapter we will

look at how best to use these so you get the

most out of the apps.

Calendar

Calendar is the Mac OS X calendar program. You can create events (appointments), set alarms, and add recurring events. You can also add appointments to Calendar directly from Mail.

Click forward or back arrows
to go through months

Your calendars
and Calendar Create Quick Day Week Month Year views Search
sidebar (below) Event Calendar

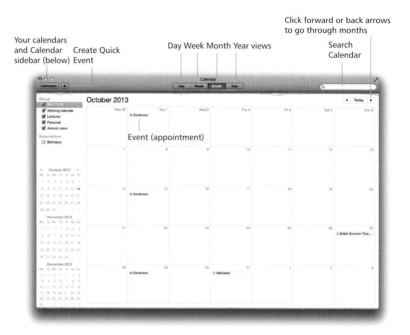

Event (appointment)

Set your default calendar
If you have more than one calendar you can tell Calendar which one should be used for new events.

You can also set up the first day of the week, day start and end time, as well as default time for event alerts.

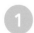 Go to **Calendar > Preferences > General**

Calendar Views

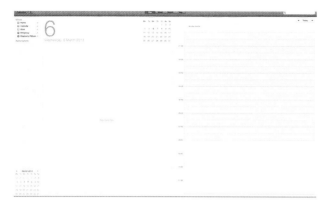

Calendar Day view

Calendar Week view

Calendar Year view

Add an Event

1 **Open Calendar**

2 **Double-click** on the date of the event

3 A new event window will open

4 **Add details** of event

5 Make sure the start and end dates are correct

6 **Add the time** if necessary

7 If recurrent (e.g. birthday) click the **repeat** drop-down menu and select every year

8 Add **invitees** if you want to send email invites

9 If the appointment is an all-day appointment, check the **all-day** box

10 If you have multiple calendars (e.g. Work, Home) ensure the event is assigned to the correct calendar

The Inspector

This window provides details of your events. It is useful to have the Inspector at the side of the calendar. This makes it easier to edit events (saves you having to double-click to open the event window).

Bring up the Inspector window

1 **Edit > Show Inspector**

2 Or type **Option + ⌘ + I**

Hot tip

The Inspector window (Option + ⌘ + I) makes it very easy to edit your events.

Editing Events

You can change any of the event details by

1 **Clicking on event** – if the Inspector window is open you can edit there

2 If the Inspector window is not open, **double-click the event** and edit

Delete events

1 **Click once on the event** and use the **delete** key

Dragging events

If you want to change the day of an event you can simply drag the event to another day as shown here:

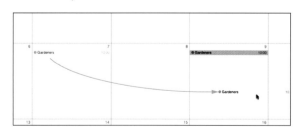

Multiple Calendars

What is the point of having multiple calendars? You may want separate calendars for work and home. You can add almost as many calendars as you want. Multiple calendars are useful if you want to print off or view only work-related events or home-related events.

Add new calendar

1 **File > New Calender**

2 Or type **Option + ⌘ + N**

Personalize your calendars

1 Click **Calendars** on toolbar

2 Select a calendar

3 **Right-click** on the one you want to change

4 Select **Get Info**

5 You can **rename** and change the **color**

6 You can also use this window to **publish** a calendar online (e.g. let work colleagues view the calendar)

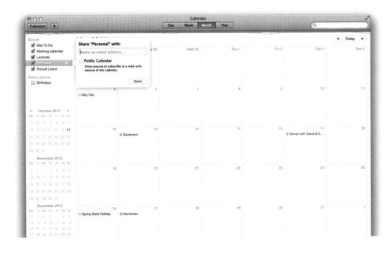

Sending Invites

If you are setting up an appointment where other people need to attend you can send invites to people who are in the Contacts. If you want to invite people who are not in the Contacts you can simply type their email address into the invitees box.

To send an invite

1 Edit the event (**double-click** then edit or use the Inspector)

2 Click the box next to **invitees**

3 Enter the first name or the surname, and a list of names from those in your Contacts will appear

4 Choose the correct email address

5 For multiple invitees, separate these with a comma

6 Click **Send** and the invite will be sent

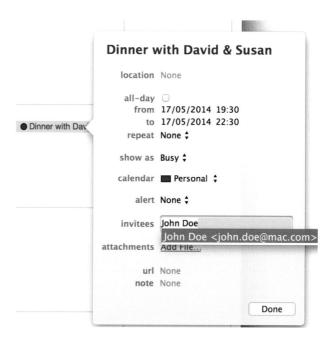

Searching Calendar

If you want to search Calendar but you have many appointments it is generally easier to let Calendar find them rather than trying to find them manually.

1 Go to **search box** at the top right of the Calendar window

2 Enter the search term

3 The results will be displayed at the bottom of the Calendar window

To view all events as a list

1 Unfortunately, there is no list view in Calendar but you can see appointments as a list if you **type "."** into the search box (omit the quotes)

2 All appointments are listed below the calendar

Hot tip

Generate a list of all events by typing a period into the search box.

Contacts

With OS X Mountain Lion, Contacts has been completely redesigned to look very much like Contacts on the iPad.

Make sure the Address Format is correct

Your address layout may be incorrect unless you tell Contacts which country you are in.

1 Go to **File > Preferences > General**

2 Use drop-down menu next to **Address Format** to specify your country

Click to see Groups Search for contacts here Drop photo here

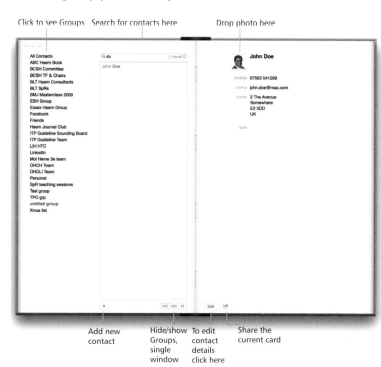

Add new contact Hide/show Groups, single window To edit contact details click here Share the current card

Add a New Contact

1. Go to **File** > **New Contact**

2. Or type ⌘ + **N**

3. Enter the contact's first and last names

4. Enter company name if necessary

5. Enter phone numbers – home, work, mobile – you can change the order of these by using the drop-downs, e.g. change mobile to work if you want the phone numbers listed in a different order to the default

6. Add one or more email addresses

7. Add work or home addresses

8. You can **add a photo** by dragging a picture onto the photo box

9. When complete, click **Done**

10. To edit a contact's details click **Edit**

11. To email your contact details to someone else click **Share**

Remove a contact

1. Select the name of the contact you wish to delete

2. Use the **Delete** key

3. Or go to **Edit** > **Delete Card**

Hot tip

Add a photo to your most popular contacts.

Add a Contact From Email

If you want to add someone who has emailed you to your contacts

1 In Mail, **click once on the email** from the person

2 Go to **Message > Add Sender to Contacts**

3 To edit their details, click **Edit**

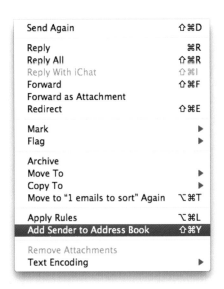

Send Again	⇧⌘D
Reply	⌘R
Reply All	⇧⌘R
Reply With iChat	⇧⌘I
Forward	⇧⌘F
Forward as Attachment	
Redirect	⇧⌘E
Mark	▶
Flag	▶
Archive	
Move To	▶
Copy To	▶
Move to "1 emails to sort" Again	⌥⌘T
Apply Rules	⌥⌘L
Add Sender to Address Book	⇧⌘Y
Remove Attachments	
Text Encoding	▶

Contacts Groups

Sometimes you want to email a group of people on a regular basis. Rather than adding each person's email address to the email it is much easier to make a group, add their names to the group and simply email the group each time

1 Go to **File > New Group**

2 **Name** the Group

3 Add contacts to the group by clicking All Contacts at the top of the Contacts, then go through your list of contacts and **drag them onto the group** you have just created

7 Photos and Videos

iPhoto, iMovie *and* DVD Player *make it fun to create and share movies. We will look at how to import still photos and movies into their respective programs, then have a look at how we can share these with our friends and family.*

Programs for Viewing Photos

The Mac has a number of inbuilt programs for viewing photos:

- iPhoto

- Preview

- Image Capture

Other programs can also be used to view photos:

- Safari

- Text Edit

With these programs you may need to drop the photo onto an open Safari or Text Edit window or you can right-click the photo and choose **Open with...** then choose **Other...**

Image capture will let you view photos if you connect an iPhone or digital camera to your Mac

Safari and other browsers will let you view photos and movies – just drop them onto a Safari window

Preview is a fast photo app with some editing facilities

iPhoto

This program comes with OS X and is the default photo (image) viewing and editing program. It is not as powerful as Apple Aperture or Adobe Photoshop but has sufficient options for most people.

You can use iPhoto to

- Import your photos

- Create albums

- Edit your photos (Crop, Rotate, Straighten, and other functions)

- Create slideshows and books which you can upload to Apple to be made into printed photo albums

- You can also create Calendars or cards

Hot tip

iPhoto probably has enough editing tools for most users.

Don't forget

Click the Share icon to share your photos by email, Facebook and other sharing options.

Opening iPhoto

You will find iPhoto in the Applications folder or you can use
Launchpad.

1 After opening iPhoto you will be asked a few questions
to see whether you want to import your photos every
time you connect a digital camera, allow iPhoto to use
geotagging so you can see where your photos were taken,
and other options

2 Answer **Yes** or **No** to these questions (in general it is
better to answer Yes)

3 iPhoto will then open and you will see a layout similar to
the one shown below

Importing Photos

You can import using several methods

- **Attach a digital camera** to the USB port
- **Insert an SD card** into an SD card reader

- You can also copy photos from an external drive, including **USB, CD or DVD**
- You can **drag photos** from any folder on your Mac onto the iPhoto window

- You can also import using **File > Import to Library...**

Create a New Album

Once you have your photos imported it is best to create albums so you can keep related photos together. Otherwise you will have to scroll through hundreds of photos to find the ones you want.

1 Go to **File > New Album**

2 Change the name from **untitled album** to something more meaningful

Sorting photos into albums

1 View the album by **clicking on the album name**

2 Only the photos within that album will be shown in the main window on the right

Viewing all photos

1 Click **Photos** in the left-hand pane and all photos are shown

View events

1 A collection of photos imported together are grouped into an event. The event will initially be shown as a date that you can change to something more useful such as Holiday 2011

Editing Photos

① **Double-click** a photo – the photo will open and occupy the main window

② Click **Edit** and make changes (rotate, fix red-eye, etc.)

③ **Double-click** the photo when finished

④ Check out the Effects and Adjust options too

Viewing iPhoto in full-screen
Apple introduced full-screen with OS X Mountain Lion

① With iPhoto open, click the full-screen icon at the top right of the window

② iPhoto will now fill the screen

③ To return to normal view tap **Escape**

Videos on the Mac

The Mac is great for viewing videos, and using software that comes with OS X Mountain Lion you can create your own movies using iMovie. There are other programs on your Mac that can play video, including:

- DVD Player

- QuickTime Player

- iTunes

- You can also drop movies onto a Safari (or any browser) window and play them there

iMovie comes as standard with OS X and is a great app for editing your movies

DVD Player is the default app for viewing commercial DVDs

QuickTime Player is a versatile app for viewing movies. You can also use the program to record screencasts (movies of your screen, e.g. if you want to make a screen demo)

iTunes is the portal for music and movie purchase, but the program can also be used to view movies you have added to its library or purchased from the iTunes Store

DVD Player

Insert a commercial DVD into the optical drive of your Mac. DVD Player will recognize that you have inserted a movie DVD and will open and play the movie.

You will be prompted to accept the DVD region for that disc.

- If you are in North America you should make sure the **Region Code is 1**

- If you are in Europe the **Region Code should be 2**

- The Mac *cannot* be made multi-region, i.e. you cannot play discs from different regions

- You can only change the Region Code **5 times** and from then on the region code remains fixed at that region permanently

Beware

Set your DVD region code or the Mac will set it for you – permanently.

95

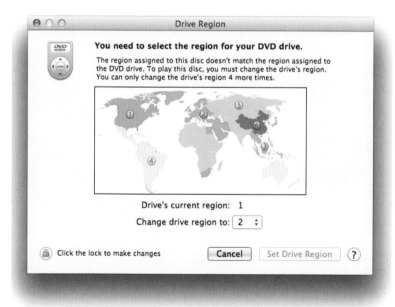

Drive Region

You need to select the region for your DVD drive.

The region assigned to this disc doesn't match the region assigned to the DVD drive. To play this disc, you must change the drive's region. You can only change the drive's region 4 more times.

Drive's current region: 1

Change drive region to: 2

Click the lock to make changes Cancel Set Drive Region ?

Editing Your Own Movies

You can import your home movies into iMovie and edit them there.

Import movie

1 Attach a DVD camera to the Mac using USB or FireWire (USB is most common nowadays)

2 **Open iMovie**

3 Import the video by clicking **Open Camera Import Window**

4 Or go to **File > Import from Camera...**

5 Navigate until you see the video you want to import

6 View the clip in the timeline

7 Edit unwanted footage by removing material using cropping

8 Save the movie project (this file will not be playable yet) add titles and other effects such as scrolling titles to the movie using the **Title** window options

Select theme for the new project

Importing video from an iPhone

Drag the bars on left and right to crop and perform other edits

Sharing Your Movie

Once complete, you will want to export your movie onto a DVD or file so that others can appreciate your efforts!

1 If you are happy with your video, audio, theme, credits etc. click **File > Finalize Project**

2 iMovie will create an HD 1080p movie

3 You can then export this in a large number of optimized formats, e.g. YouTube, Facebook, and others

4 Or you can save in a format that iDVD will recognize and play

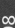

98

Photo Booth

This app lets you take passport-type pictures similar to a real photo booth. There are also effects which distort and change the image in many ways.

8 The World of iTunes

iTunes *is at the heart of every Mac and iOS device like the iPhone, iPad, and iPod Touch. It's worth spending time learning to navigate your way around the* iTunes *interface, since so many other functions rely on it.*

What is iTunes?

iTunes is an app that is the central hub for iPhone, iPad, and iPod integration, purchasing and playing music, films, podcasts, and other content.

You can import your audio CDs. Genius will suggest other music based on your current iTunes library.

Controls Volume iTunes Views Search box Full-screen

Media on this Mac

iTunes Store and purchases

Current track album artwork

Rating

New playlist

Shuffle

Repeat

Show/hide album artwork or video

Choose speakers to use

Start Genius

Show/hide sidebar

iTunes showing Cover Flow view

Importing Audio CDs

It is very easy to import your CDs into iTunes

1 **Insert CD** into the optical drive

2 iTunes will show the CD contents

3 You will be asked "*Would you like to import the CD into your iTunes library?*"

4 Click **Yes** to import all

5 Or **uncheck** any tracks you do not want to import

6 iTunes will import tracks

7 You will hear a chime when the import is complete

8 **Eject the CD** by dragging to the Trash, or click the eject symbol in the left pane in the iTunes window

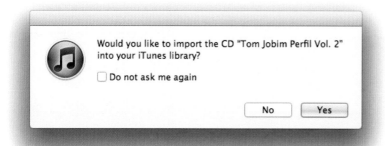

iTunes Preferences

It is worth checking out the preferences, since you can change the import formats and set up many other features within the Preferences section.

Select this if you intend to allow others to listen to your iTunes content

Controls iPod, iPhone, and iPad sync

Tell iTunes what to show, e.g. Movies, TV shows, etc. – the default settings are fine for most people

This is useful for parents to prevent children accessing inappropriate content

Allows crossfading of music if you like this effect – sound check will make all tracks the same volume (avoids having some tracks which are really loud)

Allowing iTunes to organize your media folder is very useful – if you don't you will have media files scattered all over your hard drive

Playing Audio

1 **Open iTunes**

2 **Find artist/album/song** you want to play, select this (click once) then select the play icon

3 Or **double-click** the track

4 Or **tap the spacebar**

5 Finding music tracks in your library is easy – you can type the name of the artist into the **search box** at the top right of the iTunes window

6 Or you can **select a column**, such as Artists, and type the first couple of letters of the artist's name

Buying Music from iTunes

1 As well as importing your own CDs, you can buy music from the iTunes Store

2 The iTunes Store icon is in the left pane of the iTunes window – click this once then, once loaded, click **Sign In** at the top right of the iTunes window

3 Enter your **iTunes name and password**

4 If you don't have an iTunes account, iTunes will help you set one up

5 You can find new music by browsing the main page, or click the music tab at the top of the window, or search for specific songs or artists using the search box

6 Once you have identified the music you want to purchase, click **Buy Album,** or to buy individual songs rather than albums click **Buy** next to the right of the song title

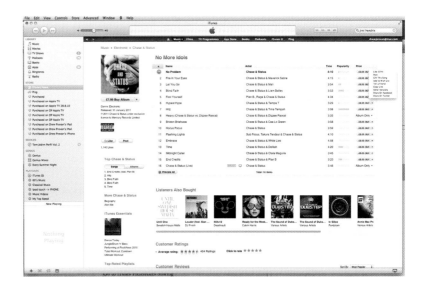

Pause and Skip

This is pretty much like any music player, with icons for Play, Pause, Skip Back, Skip Forward, Rewind, and Fast Forward.

Controls are found at the top left of the iTunes window

Skip to previous track if clicked once. Click and hold to rewind through current track

Play or pause (turns to Play icon when paused and Pause icon when playing)

Skip to next track if clicked once, or fast forward through currently-playing track

iTunes Preferences
There are many user-configurable options if you go to **iTunes > File > Preferences**.

General Preferences (shown here)

- Use this to decide what iTunes should show (Movies, TV Shows etc.)

- Text size

- Decide what happens when you insert a CD into the Mac

- Download missing artwork

- Other options

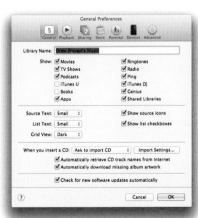

Playlists

It is worth getting to grips with playlists since you may have an iPhone, iPad or iPod and want some music on these devices. Your whole music library probably won't fit onto your device but by creating playlists you can sync specific playlists to the devices.

1 Click the **+** symbol at the bottom left of the window or go to **File > New Playlist** or type ⌘ **+ N**

2 You will see *untitled playlist* appear at the bottom of the playlist group

3 Give the new playlist a **name**

4 To get songs into your playlist, find them in your main music window and **drag** them to the new playlist you have created

5 When you sync your iPhone or other device to your Mac, make sure that the playlists you want to sync are checked in the sync options window

6 To remove music from playlists, select the songs you wish to remove and **tap the delete key**. *Note:* your original music files remain in the main music library and have not been deleted even although you have deleted them from the playlists

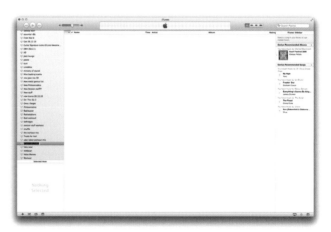

Smart Playlists

People don't use these often enough! They are very easy to set up.

Why are smart playlists so useful?
Basically, you set the rules, e.g. any track with a three star rating automatically gets added to the smart playlists. This saves you having to drag songs to the playlist manually.

To remove songs, simply change the star rating for the song and the song will be removed from the smart playlists.

Smart Playlists make it simple to update your playlists with new music.

1 Go to **File > New Smart Playlist...**

2 Or type **Option + ⌘ + N**

3 You will then see the rule window

4 Choose something like **Rating contains 3 stars**

5 Make sure **Live Updating** is checked

6 **Name** the smart playlist

7 Then go to your music library and assign some music with three star ratings

8 You will see these have been added to the smart playlist

Changing iTunes Views

As well as the standard iTunes view (see page 96) you have a couple of other options.

You can view iTunes as

- List
- Album list
- Grid
- Cover Flow

List view (default)

Album covers

Grid view

Cover Flow

Column options

You can choose which columns are displayed in the list view. Select the columns you would like to display by clicking the check boxes for those columns.

Genius

Genius creates playlists based on songs in your iTunes library. For example, if you are playing a jazz track, Genius will create a jazz playlist for you using music already in your library.

1 **Choose a song** to play

2 **Click Genius icon** at the bottom right of the iTunes window

3 A Genius playlist with similar music to the current track playing will be shown

4 You can make a new playlist by clicking the **+** symbol at the bottom left of your iTunes window

5 **Drag the Genius selection** made earlier onto your new playlist which you have just created

6 If you do not see the Genius icon at the bottom right of your iTunes window you may not have Genius switched on. To switch on Genius go to **Store > Turn On Genius**

109

Sharing Your Music

You can share your iTunes library over a wireless network.
Any Mac or PC on the same network can see and play your music
but they cannot (easily) copy the tracks onto their computer.

1 Your Mac needs to be running in order to allow sharing

2 Go to **iTunes > Preferences > Sharing**

3 Select **Share entire library** or **Share selected playlists**

4 You can **password protect** (enter password required into the box Require password). You can also play audio and video on Apple TV if you switch on **Home Sharing**

5 Go to **Advanced > Turn On Home Sharing**

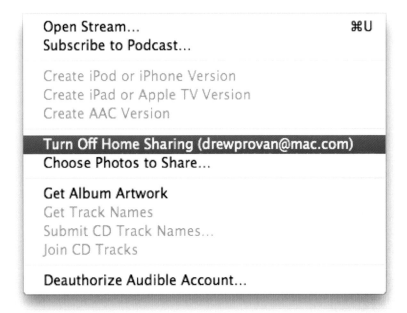

Open Stream...	⌘U
Subscribe to Podcast...	

Create iPod or iPhone Version
Create iPad or Apple TV Version
Create AAC Version

Turn Off Home Sharing (drewprovan@mac.com)
Choose Photos to Share...

Get Album Artwork
Get Track Names
Submit CD Track Names...
Join CD Tracks

Deauthorize Audible Account...

Burning music CDs
This is covered in Chapter 14.

9 Networking the Mac

Networking computers is usually a fairly geeky affair on many platforms. Macs make networking very simple whether it be to other Macs, PCs, printers, or other devices.

Networking is Easy!

Macs can network to other Macs, networked printers, or local networks and use Virtual Private Networks (VPN).

Network System Preferences

1 Go to **Apple Menu > System Preferences**

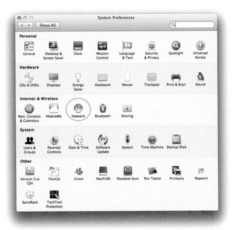

2 Look for the network icon

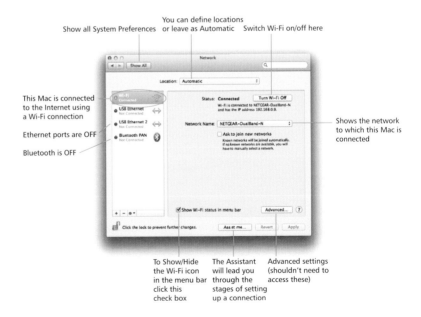

Show all System Preferences

You can define locations or leave as Automatic

Switch Wi-Fi on/off here

This Mac is connected to the Internet using a Wi-Fi connection

Ethernet ports are OFF

Bluetooth is OFF

Shows the network to which this Mac is connected

To Show/Hide the Wi-Fi icon in the menu bar click this check box

The Assistant will lead you through the stages of setting up a connection

Advanced settings (shouldn't need to access these)

Getting Online

To access the Internet you have the option of choosing a wired connection to a router (Ethernet) or wireless (Wi-Fi).

Setting up a wireless Base Station

1 Using a standard Ethernet cable connect your Mac to the broadband router, AirPort Extreme Base Station or Time Capsule (Apple's router with hard drive inside)

2 Launch **Utilities > Airport utility**

3 **Scan** for wireless devices

4 Once the device appears in the pane on the left-click **Continue** and the Airport Utility will lead you through the various settings

5 Check to make sure your Wi-Fi signal is good (toolbar) and open Safari. Try opening a web page to check that you are connected to the Internet

Sharing Internet Connection

Some Internet Service Providers (ISPs) don't like you to share your connection so take care if you decide to share the Internet connection with another computer. *You have been warned!*

Why share an Internet connection?

You may be in a hotel and have a wired connection to the Internet but need to get a second computer or mobile device such as an iPhone or iPad online. The best way to do this is to get a laptop online using the wired connection then set up an *ad hoc* (computer-to-computer) Wi-Fi network from the laptop which the other devices can use.

114

1 Go online with the laptop

2 Make sure you're connected to the Internet (do a Google search or open any web page)

3 Go to Wi-Fi the top of the screen and scroll to **Create Network...**

4 Give the network a name or leave as the default

5 Add security if necessary (40-bit WEP will need a five letter password)

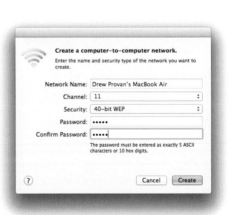

6 Click **Create**

7 The Wi-Fi icon will change to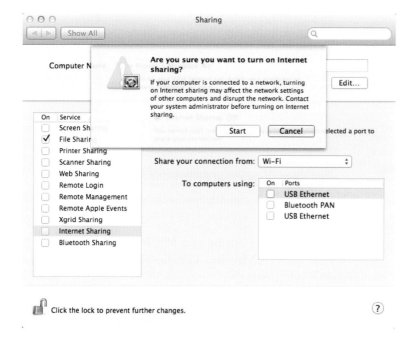

8 Now go to **Apple Menu > System Preferences > Sharing**

9 Click **Internet Sharing** (make sure the dialog box says *Share your connection from Ethernet to computers using Wi-Fi*)

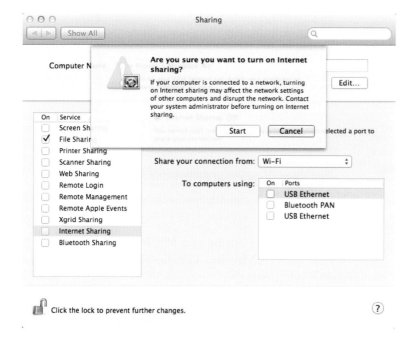

10 Click **Start**

11 The Wi-Fi icon will change to

12 Now check for the Wi-Fi signal using your other laptop, iPhone or iPad. Connect by entering the password you specified when you set the network up

Connecting to Other Macs

If two Macs are on the same wireless network they can "see" each other. This is one way of sharing files, viewing folders and documents on one Mac using another Mac. You can also network to Windows machines but this will not be covered here.

1 On both Macs go to **Apple Menu > System Preferences > Sharing**

2 Make sure **File Sharing** is **ON** (or you will not be able to see any files!)

3 Let's suppose we're sitting at a MacBook Air and want to view files on a Mac Pro. On the MacBook Air, **open Finder window**

4 Look for the Mac Pro we want to connect to (if not shown under **Shared** make sure both Macs are on the same network)

5 Click the Mac Pro icon in the left pane

6 You will then see **Connect and Share Screen...**

7 Click **Connect**. You may only have **Guest Access** (not very useful) so click **Connect As...** and enter the **username** and **password** for the MacBook Air

8 You should now see all files and folders and you can delete files, or copy across to/from the MacBook Pro

Screen Sharing

You can share another Mac's screen using several methods, e.g. iChat, Skype, and screen sharing using the same method as file sharing (see page 110).

Let's share a MacBook Pro screen using a MacBook Air, i.e. view the MacBook Pro screen *from* the MacBook Air screen.

Note: both Macs must be on the same network. Screen sharing must be switched on for the Mac screen you want to share. You can check this by going to **Apple Menu > System Preferences > Sharing** and click **Screen Sharing**.

1 **Open a Finder window** on the MacBook Air

2 Click the MacBook Pro under **Shared**

3 Click **Share Screen...**

4 You will be prompted for the password for the MacBook Pro – enter this and the MacBook Pro screen should display on the MacBook Air

Hot tip

You can now copy files and folders in screen sharing using drag-and-drop.

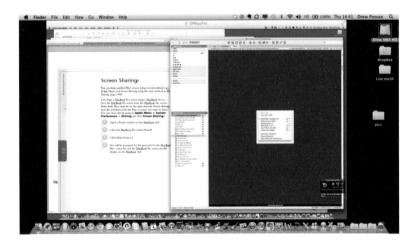

Here you can see the MacPro screen *within* the MacBook Air screen.

In Mountain Lion (OS X 10.8) you can use drag-and-drop to copy files from the remote Mac to the local Mac, and vice versa! This feature was missing until OS X 10.8.

Share Files Using AirDrop

This is a feature of OS X Mountain Lion that allows users on the same network to drag-and-drop files onto other Macs. Amazingly, you do not need to be online to use AirDrop – but both Macs must have Wi-Fi switched on in order to see each other.

How to transfer files using AirDrop

1 Click on **Go** at the top of the screen – **select AirDrop**

2 Or type **Shift + ⌘ + R**

3 An AirDrop window will open showing all Macs on the network

4 To send a file to another Mac **drop the file onto the other Mac's icon** in the AirDrop window

5 The person using other Mac **must accept** the file before transfer will occur

Wireless Printing

If you're using a laptop in the lounge you may want to print documents without having to leave the sofa!

To print a document wirelessly using a printer connected to another Mac

1 On the Mac with printer attached (the one called DPMacPro in the illustration below) go to **Apple Menu > System Preferences > Sharing**

2 Make sure **Printer Sharing** button is **checked**

3 On the Mac with no printer attached go to **Apple Menu > System Preferences > Print & Scan**

4 Look for available printers – if none, **click the +** symbol and add the printer connected to the other Mac (i.e. the wired printer connected to the remote Mac)

5 Now go to your documents and click **Print** – make sure the printer selected is the one attached to the other Mac

6 Collect the printed pages later!

10 Video Chat

Video chatting is incredibly popular, largely due to the arrival of this technology on smartphones and other hand-held devices. In this chapter we will look at how to set up video chats in FaceTime, Messages, *and other apps.*

FaceTime Video Chat

Most Macs (iMac and MacBook series), come with FaceTime HD video cameras built in. Now with the advent of the iPhone, iPad and other mobile technologies with cameras as part of their hardware, video chatting is becoming increasingly popular.

FaceTime software is now the Mac standard video chatting program and comes with OS X 10.8 and iOS 6.0 (iPhone, iPad and iPod touch). The software has a very simple interface.

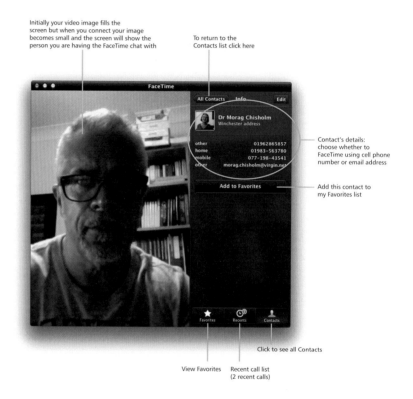

Initially your video image fills the screen but when you connect your image becomes small and the screen will show the person you are having the FaceTime chat with

To return to the Contacts list click here

Contact's details: choose whether to FaceTime using cell phone number or email address

Add this contact to my Favorites list

View Favorites

Recent call list (2 recent calls)

Click to see all Contacts

Video chat using FaceTime

1 **Launch FaceTime** from the dock or the Application folder

2 All your contacts from your Address Book will be displayed

3 You can view **All Contacts** or **Groups**

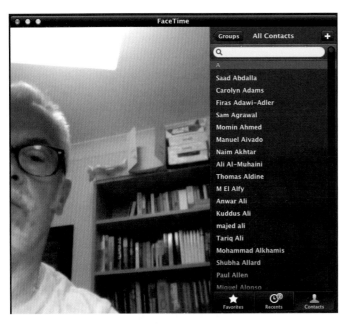

4 To FaceTime a friend, find their name on the list and choose the method for FaceTime, e.g. iPhone, or using a Mac (select their email address to FaceTime them using their computer)

5 If you FaceTime some people regularly **add them to your Favorites** list. Go to Favorites, click **+** (top right) to add a contact to the Favorites list

6 To call using FaceTime, **click the contact number** or **email**

7 To end the call click **End**

FaceTime from Messages

From Messages, click the video camera icon (top right) and choose email or phone number to video chat with someone.

Hot tip

Add people you regularly FaceTime to your Favorites.

Skype

This is not part of OS X so you need to download the latest version from **skype.com**
Once installed, set up your account. Open the program by clicking the dock icon or launch from the Application folder.

You will be shown here, and this icon means you are Available and online

All your Contacts are here — online Contacts at the top 5 of 50 are online

Add Contact or Group

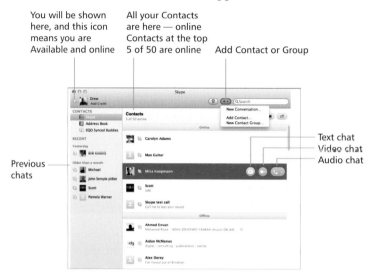

Previous chats

Text chat
Video chat
Audio chat

Using Skype

1 **Launch Skype**

2 Your online contacts will be at the top of the screen

3 **Click on contact**

4 You can talk to them using text, video, or audio – you will see the icons for these various options to the right of the screen name

Add contacts

1 Click **+ Add Contact...** or **New Contact Group...**

2 When the search box appears, type in the contact name or search for them online using the search box

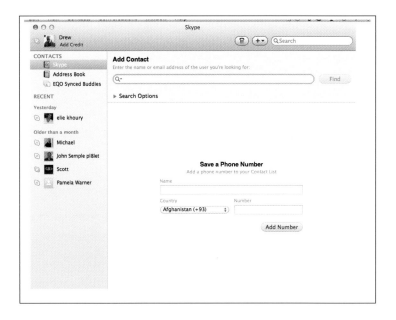

Block contacts

There may be people you do not want to speak to, in which case:

1 **Right-click the contact name**

2 Select **Block** *contact name*

Beware

You will occasionally receive invites from strangers on Skype. It is best to block these.

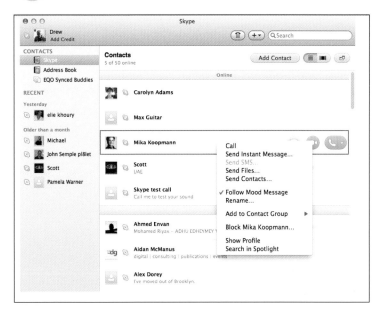

Google Voice and Video Chat

This is a new Google app, which runs within Google mail. If not installed, download the plug-in from **google.com/chat/video**

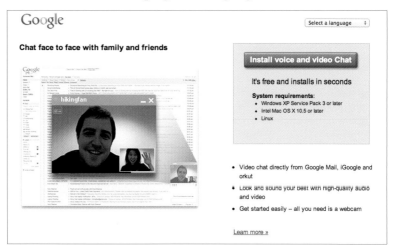

To use Google Voice & Video chat

1 **Log in to your Google mail account**

2 Make sure you have installed the **Voice & Video Chat** plug-in (*see above*)

3 In the left pane you will see the chat window towards the bottom of the screen

4 Your name will be at the top

5 Set your status to **Available/ Busy/ Invisible** or create your own custom message

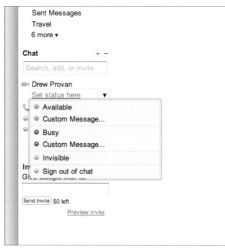

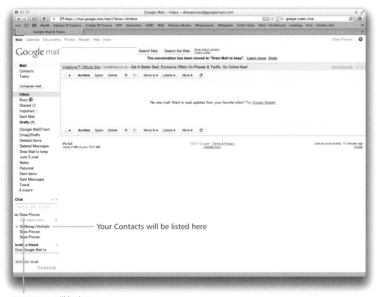

Your Contacts will be listed here

Your name will be here.
Set your status so people
know whether you are
available for chat

Video chat with a contact

1 Select a contact – make sure they are online

2 Click the video icon

Microsoft MSN Messenger

Until recently, Microsoft's MSN Messenger only offered text-based chat on the Mac, but with the release of Version 8 came video chatting.

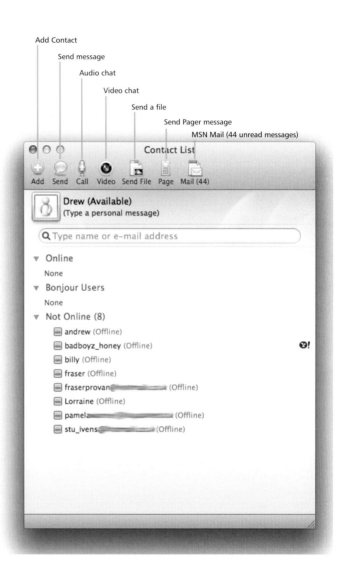

Add Contact
Send message
Audio chat
Video chat
Send a file
Send Pager message
MSN Mail (44 unread messages)

1 **Log in to MSN messenger**

2 You will see your online contacts as well as Bonjour users (these are people on your wi-fi network) and Offline (i.e. not online) contacts

3 To video chat, **select an online user** and **click the video icon** at the top of the window

4 If all you want is an audio chat, click the **Call** icon

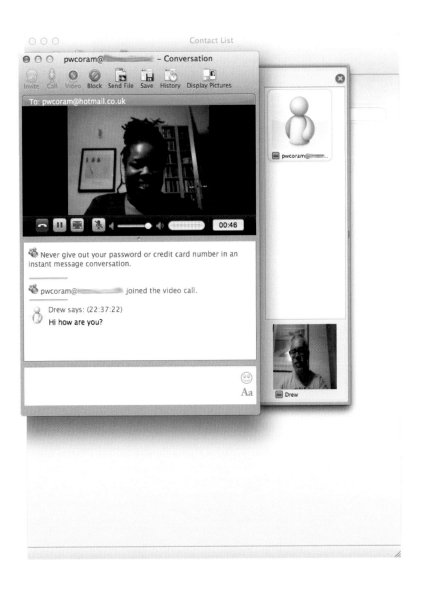

Other Video Chat Options

Facebook video

This is now available and makes it really easy to chat to your "Facebook friends" when they're online. Simply click on the video icon in the top corner of your Online Friends chat window in Facebook.

ISPQ video chat

1 Go to **ispq.com/download**

2 **Set up your account** and start chatting

3 Various "Rooms" are available depending on your area of interest

4 Probably best to start in the general area section

11 Personalizing Your Mac

There are many ways in which you can make your Mac work and look just the way you want. This section explores some of the features you can modify.

Name Your Hard Drive

We are dealing here with software personalization – making your Mac run the way you want to with an appearance that suits your taste, rather than talking about hardware, hard drives, adding more RAM etc.

Hot tip

Naming your Mac's hard drive will make it easier to identify on the network.

1. By default, your Mac drive will be called *Macintosh HD*, which is accurate but dull. If other people are on the network their Mac drives will have the same name. Why not give yours an original name?

2. Make sure your hard drive is visible on the desktop (**Finder preferences > Show these items on the desktop:** (make sure Hard Disks is checked))

3. Click slowly twice on the name Macintosh HD

4. When the color changes to the highlight color, delete the original name and type the name you want to change it to

The name Macintosh HD was clicked twice – the color has changed to the highlight color. Start typing the name

I called this Drew's MBA HD (my MacBook Air's HD) so that when I network to the MBA from another Mac, I can be sure I know which drive I am looking at

Using Wallpapers

Wallpapers are photos or images that cover the entire desktop. You can choose plain colors, abstract designs, photos including your own photos.

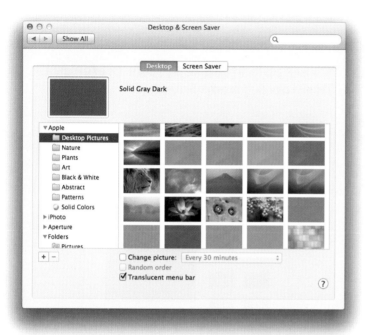

You can choose various options suppled by Apple, including Nature, Plants, Art and many others. You can also choose photos from your iPhoto collection, or you can download artwork from many sites, e.g. *interfacelift.com*

Screen Savers

These have been around for many years, and were intended to prevent your CRT tube screen being burned if you left an image on the screen for a prolonged period. There is probably less need for screen savers today but they remain popular. After a period of inactivity the screen saver kicks in and displays an image, photo, or random animated colors.

1 Go to **Apple Menu > System preferences > Desktop & Screen Saver**

2 Choose the Screen Saver tab

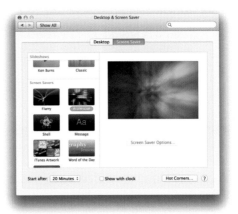

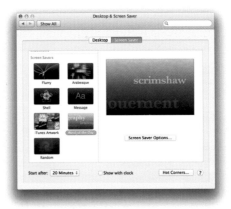

Wake and Sleep Options

You can set your Mac to wake up at certain times of the day and go to sleep at night. You can also set up a time for the Mac to boot up and switch off.

1 Go to **Apple Menu > System preferences > Energy Saver**

2 Set the Computer and Display sleep times (when the computer goes to sleep the hard drive spins down)

3 If you want specific start up and shut down times click **Schedule**

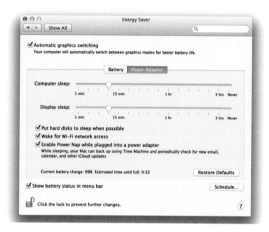

135

Don't forget

Macs tend to run their internal maintenance programs overnight so don't switch your Mac off every night.

Power Nap

This is a new feature in Mountain Lion which, when enabled, allows system updates, and also updates email, notes and reminders even if your Mac is asleep. It will also still perform time machine backups!

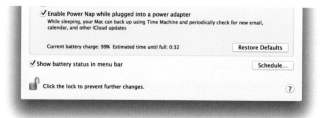

Change the Clock Display

1 Go to **Apple Menu > System Preferences**

2 Select **Date & Time**

3 You can choose whether to show the time and date in the menu bar by checking the box

4 You have the options of either a **digital** or **analog** clock, as well as showing the time with seconds

5 You can also use a **24-hour** or **12-hour** clock depending on your taste

6 There is also an option to announce the time on the hour although I cannot imagine many people using that option!

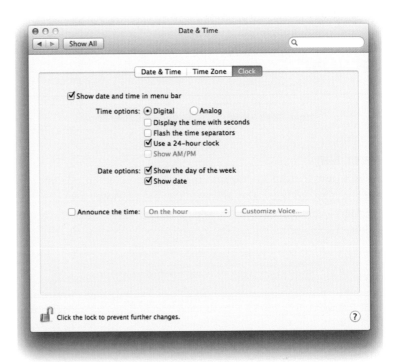

Set Your Time Zone

Setting the time zone is a useful function since you will need this for Calendar and other apps.

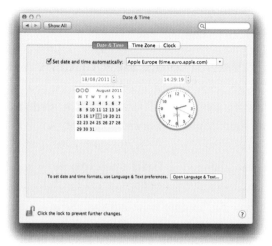

Don't forget

Set the time zone for your Mac or the Calendar app and many other apps will behave oddly.

1 Make sure the box is checked for **Set time zone automatically using current location**

2 A pin should drop on the world map showing your location

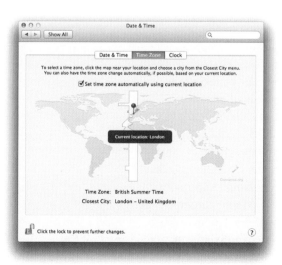

Change Your Icon Sizes

You can change the size of the icons representing folders, documents, and apps to suit your requirements. Some people like very small icons in folders or on the desktop, while other people like the icons to be large so they are easier to see.

To change icon size

1 Go to **View > Show View Options**

2 Select the icon size by **moving the slider** at the top until your icons are the size you want

3 You can change the **Grid spacing** by using the slider

4 You can also modify text size and the position of the labels to either Bottom or Right

5 You can **switch off icon preview** (icon preview provides you with a thumbnail of the document contents within the file, so that Word documents do not have a generic icon but instead will show miniature versions of the text within the documents; likewise, photos will show miniature versions of the photo contained within the photo file. The *downside* is that the Mac has to generate the thumbnails on the fly, and this takes processing power so if your Mac is underpowered then you might be best to switch **Show icon preview** off)

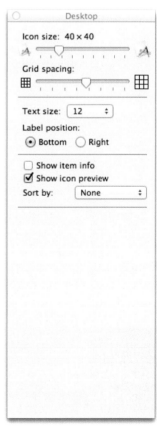

The Dock Options

The dock has several options.

1 You can modify the size of the apps on the dock from very small to very large

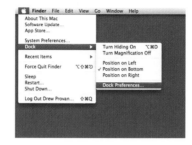

2 You can adjust the magnification which means that when you roll your mouse pointer over an icon it can magnify slightly or greatly depending on which you find more helpful

3 The dock can also remain in its default position, i.e. Bottom of the screen, but if you prefer, you can move it to the left or the right

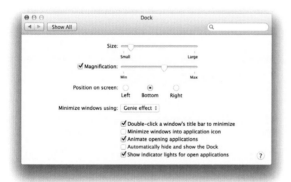

Resize your Dock fast!

Drag the divider bar to the *left* to make icons smaller or *right* to make them larger (no need to open System Preferences).

Hot tip

The fast way to resize your Dock icons is to drag the bar on the Dock left or right.

Add Folders to the Sidebar

The sidebar has three main sections:

1 **Favorites**

2 **Shared** – networked drives

3 **Devices** – disk drives both real, and virtual from disk images

How to make best use of the sidebar

If you are working on a project which has documents in a folder, rather than navigating your way to that folder each time to use a document, it is simpler to drag the folder onto the sidebar Favorites section.

To access the folder and its contents simply click once on the folder and its contents will be displayed in the right pane.

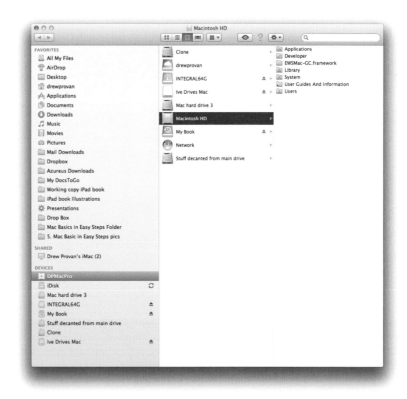

Set the Screen Corners

The four corners of your screen can be used as shortcuts for various functions. In the figure shown, the bottom left corner activates Mission Control, the right bottom corner puts the display to sleep. Other configurable functions for the hot corners include:

1 **Start Screen Saver**

2 **Disable Screen Saver**

3 **Application Windows**

4 **Desktop**

5 **Dashboard**

6 **Launchpad**

141

You can set up any corner to do any of these functions.

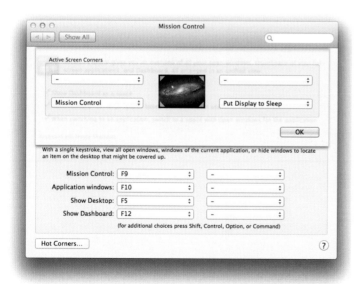

Mouse and Trackpad Settings

The mouse and trackpad are highly configurable. You can change the tracking speed of the mouse or the trackpad. You can also modify the gestures functions as well as scrolling direction.

The Point & Click section lets you set up the right side of the mouse as right-click

If you are left handed you can set up the left side as the "right" click

This option lets you switch on/off the two-finger swipe gesture which works with photos and other apps

This trackpad option controls the Look up gesture

You can zoom in/out of documents and photos using two fingers on the trackpad, much like other touch screen devices (iPhone, iPad, and iPod Touch)

Empty Trash Without Warning

If you place files in the Trash and then go to **File > Empty Trash** a warning will come up asking if you really intend to empty the contents of the trash. You can click Empty Trash each time or you can configure the trash so that it empties *without* giving you the usual warning.

Be careful, though, because you will now have to be 100% certain you do want to empty the Trash or you will lose work!

To disable the warning before entering the Trash

1. Go to **Finder > Finder preferences**

2. Select the **Advanced** tab

3. **Uncheck** the Show warning before emptying the trash

Hot tip

For fast Trash emptying disable the Show Warning message.

143

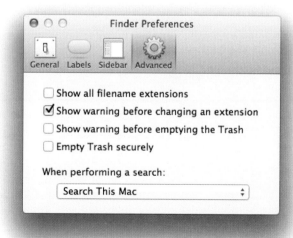

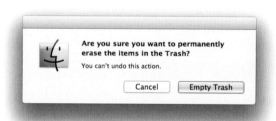

Pimp Your Windows!

You can change most of the elements of the Mac windows:

- Open hard drive Finder window in multicolumn view but make other windows open in icon view

- Change the menu bar colors

- Change the highlight color

- Make scroll bars always visible

- Have scroll bars at top and bottom of window or together

- Minimize windows by double-clicking their title bar

- Rearrange the order of the sidebar items

- Customize the toolbar

Customize Keyboard Shortcuts

There are many keyboard shortcuts. Lots of these are common to all apps, e.g. ⌘ + C (copy), ⌘ + P (print), ⌘ + V (paste), ⌘ + X (cut), ⌘ + Z (undo), etc. You can easily make your own shortcuts:

1 Go to **Apple menu > System preferences > Keyboard**

2 Select **Keyboard Shortcuts**

3 You can modify as many of these as you like

Change the Alert Sounds

The alert sounds are those made when there is a problem or tasks have completed. You can find these options under:

1 **Apple menu > System preferences > Sound**

2 Select **Sound Effects**

3 Play around with the various alert sounds until you're happy with these. In general, the default sounds are fine and there is little reason to change them

Can I add my own alert sounds?
Absolutely – it's easy! The file must be in AIFF format.

1 Go to **~/Library/Sounds**

2 Drag your AIFF file to the Sounds folder

3 Go to **System Preferences > Sound**

4 Click the **Sound Effects** tab

5 Your sound should appear in the alert sound list – select it to use it

12 Installing Software

You will want to add more apps to your Mac, and at times you will want to delete unused apps. This section describes the installation and removal of apps from the Mac.

Installing Apps is Easy!

There are several ways of getting new programs (apps, software) onto your Mac:

1. From an installer CD or DVD

2. From a disk image file (.dmg)

3. The App Store

4. Drag-and-drop onto the Applications folder

Beware

You should not directly copy apps from one Mac to another. You should always install properly.

What happens when you install software?

Sometimes when you drag a program onto a USB disk from one Mac to copy onto another the program won't run on the second Mac. This is because the original installer placed files in numerous locations all over your Mac in various folders, in the Library folder and elsewhere. When you drag your program from the Applications folder on one Mac onto the USB drive you do *not* copy across all the supplementary files required to run the program and so, on

.dmg decompresses to virtual disk

Skype_5.3.0.1074.dmg Skype

the second Mac the program would not run because it is missing some key pieces of information required to run the app. Theoretically, you could find the various components of the program on the hard drive if you knew which files are installed and where they are located but this is not practical.

For that reason it is never a particularly good idea to copy programs from one computer to another simply by dragging the program across.

Installing From a .dmg File

Many apps are installed from disk images. These are generally downloaded from the Internet and once downloaded they appear on the desktop after they decompress, much like a physical drive connected to your Mac, but obviously they are not. Instead they are "virtual" drives.

How to identify the .dmg file?

The .dmg file has a white document icon with an image of the disk in the middle and if you look at the name of the file it will end with .dmg.

To install software from this type of image file

1. You need to **double-click the dmg**

2. Then a temporary virtual disk will mount on your desktop as if this were a disk drive plugged into your Mac

3. **Open the disk image** (white drive icon)

4. Generally, to install the software you have to **double-click an installer file** within this virtual disk but sometimes you will see instructions telling you to **drag the application to your Applications folder** (this does *not* mean that there was only one file for this program. Instead, when you first run the program it will then place lots of other files to the scattered locations mentioned earlier)

What do you do with .dmg and the virtual disk once the program has been installed?

After you have installed your software, you can drag both the disk image file and the white disk icon to the Trash.

Hot tip

Once an app has been installed you can drag the installer (.dmg files and the virtual disk) to the Trash.

Put an App onto the Dock

After installing a new app you can find it by

1 Going to the **Applications folder** and finding it there

2 Using **Launchpad** (you can find this on the Dock)

3 Typing ⌘ + **Spacebar** and searching for the app by name

4 If you have used the program recently, you can go to the **Apple menu > Recent Items** and look for the app there

If you intend to use an app regularly why not put it into the Dock so you don't have to search for it?

How to place an app on the Dock

1 **Find the app** in the Applications folder

2 Click the app, and hold down the mouse button

3 **Drag the app to the Dock**

4 Move it to the exact location sideways on the Dock until you're happy with its position

Remove an app from the Dock

1 Simply click and hold the pointer on the app and **drag it upwards off the Dock**

2 You will see and hear a puff of smoke

Removing Preference Files

Sometimes a program may misbehave, start crashing, or otherwise act erratically. Preference files store various bits of information such as page size, etc. and are required in order to run the program, but occasionally the preference files become corrupt and they cause the app to misbehave.

One way of sorting software problems is to remove the preference file from your Home Library.

To remove a preference file for Apple Pages program for example

1 Go to your **Home Folder** (the one that looks like a little house and has your name on it)

2 Then locate **~/Library/Preferences**

3 Scroll down the list of preferences until you find, in this case: **apple.iWork.pages.plist**

4 **Drag this file to trash**

5 **Reopen the Pages app** and see if the problem has now resolved

 Hot tip

.plist files can be trashed if programs misbehave.

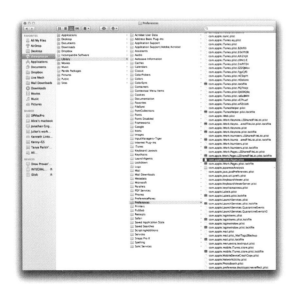

How to Uninstall Apps

PCs have uninstallers, e.g. the Add/Remove Program Control Panel. Unfortunately Macs don't have the same method for removing software.

Beware

Dragging an app to the Trash does not fully uninstall it – various files are left behind.

To remove apps

1 **Locate the app** in the Applications folder

2 **Drag the app to the Trash**

3 **Empty trash**

This is pretty simple but does not remove all the other supplementary files scattered around hard drive when you installed the program, e.g. the preferences file and other files.

Although the Mac does not come with an uninstaller there are third-party programs which will uninstall all components of the program so you can remove the program completely leaving no traces of files the installer has placed on your hard drive.

Examples of uninstallers

AppCleaner (**appcleaner.en.softtonic.com/Mac**) – free

AppDelete (**reggieashworth.com**) – $7.99

AppZapper (**appzapper.com***) – $12.95

(Note – prices correct at time of printing)

Hot tip

Use an uninstaller app to remove all the little files the original installer placed on your hard drive.

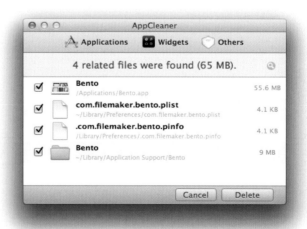

13 Switch from PC to Mac

Many people are switching to the Mac from Windows, largely driven by devices such as the iPhone, iPad and iPod Touch. The transition from PC to Mac is easy, and here we will look at the issues that may confuse users switching from the world of Windows.

Mac Desktop and Windows

There are some differences between the window layouts on PCs and Macs but these are pretty minor and you will soon get used to the Mac window layout. The desktop on both platforms is also fairly similar with the Task Bar on the PC being replaced by the Dock on the Mac.

The figures below show the main items on a basic Mac window and the Mac desktop.

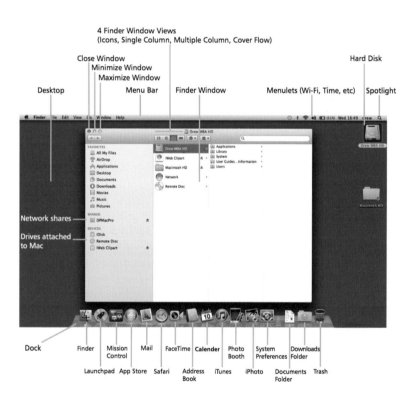

What you get when you right-click on the desktop

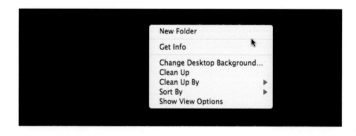

Single-Click Mouse?

Macs were sold originally with a one-button mouse which made right-clicking difficult. The Mac mouse is now a two-button mouse although it would appear when you first start using it to be only one button with no right-click.

Although the Magic Mouse does not appear to have distinct left and right sides, if you use your index finger on the left side this is a left-click and if you click your middle finger on the right side this constitutes a right-click.

To configure the mouse for right & left click

1 Go to **Apple Menu > System Preferences Mouse Point & Click**

2 You can configure the secondary click to be either right side or left side using the drop-down option

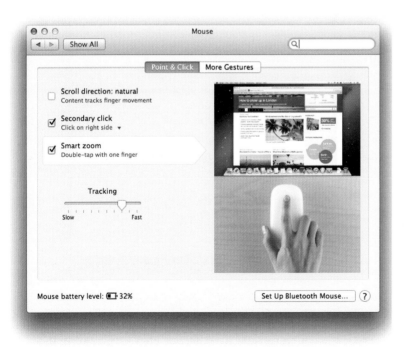

Where's Windows Explorer?

Windows Explorer is the program used on Windows computers to browse folders and their contents. The equivalent on the Mac is the Finder which is found on the Dock at the extreme left side. You can also use the Finder by typing ⌘ + **F**.

Clicking the Finder will bring up a Finder window showing the drives, folders, and files. What you see will depend on how you have set up your Finder windows, and can be icons, single column or multicolumn view. The multicolumn view is probably the most useful since you can see the hierarchical structure of your folders on any attached drive.

Don't forget

The Finder is the Mac equivalent of Windows Explorer.

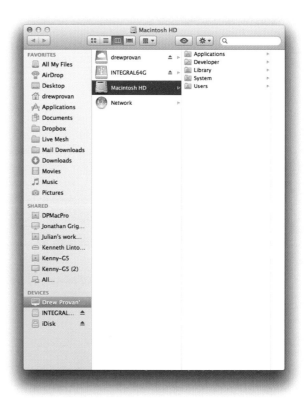

Resizing the columns

To **resize** a column **click and drag the separator** line. To **resize ALL columns** click and drag while **holding down the Option** key. To resize a column so it is as wide as the widest file name **double-click the column separator**.

The Start Menu

There is no Start Menu on the Mac and the nearest equivalent would be the Dock onto which you can drag your favorite apps.

When you start using a Mac there will already be some apps on the Dock, such as Finder, Mail, Safari, DVD Player, iMovie, and several others. But as you install more apps yourself you will probably want to drag some of these to the Dock.

On a PC you can shut the computer down from the Start Menu and on the Mac you can press the Power Button and you will be asked *"Are you sure you want to shut down your computer now?"*.

Alternatively, from the Apple Menu choose

- **Apple Menu > Sleep**

- **Apple Menu > Restart...**

- **Apple Menu > Shut Down...**

Keyboard Shortcuts

Keyboard shortcuts save huge amounts of time. If you know some PC shortcuts you will be relieved to hear that they are similar on the Mac, mainly replacing the Control key with Command (⌘) key.

PC	Shift	Control	Alt	WinKey	Backspace
Mac	Shift	Control	Option	Command	Delete
Symbol	⇧	^	⌥	⌘	⌫

Action	PC	Mac
Copy	Control + C	⌘ + C
Paste	Control + V	⌘ + V
Cut	Control + X	⌘ + X
Undo	Control + Z	⌘ + Z
Print	Control + P	⌘ + P
Screen capture	PrntScrn	⌘ + ⇧ + 3
Capture active window		⌘ + ⇧ + 4
Close window	Control + W	⌘ + W
Copy file/folder	Control + Drag	^ + Drag
Create alias	Right-click and create shortcut	Right-click and create alias OR ⌘ + L
Find	Control + F	⌘ + F
Get item info	Alt + Enter	⌘ + I
Max window	Control + F10	None
Min window	Windows + M	⌘ + M
New folder	Control + N	⌘ + ⇧ + N
Open file	Control + O	⌘ + O
Quit app	Alt + F4	⌘ + Q
Save file	Control + S	⌘ + S
Select all	Control + A	⌘ + A
Send item to trash	Delete	⌘ + Delete
Toggle through apps	Alt + Tab	⌘ + Tab
Type special chars	Alt + Key	⌥ + Key
Force quit app	Control + Alt + Del	⌘ + ⌥ + Esc

Control Panel

Control Panel on the PC is used to set up preferences for networking, printers, sharing, user accounts, screen display, sound, and many other functions. These same functions exist on the Mac but they are called **System Preferences** and if you are comfortable using Control Panel on the PC then you will almost certainly have no problem with system preferences on the Mac.

Search for System Preference by name

1. Go to **Apple Menu > System Preferences**

2. Type the name of the System Preference you are looking for in the **search box** (top right)

Search for System Preference by function

Suppose you want to know which System Preference controls the Mac sleep function

1. Type *sleep* into the search box

2. The System Preferences that control Mac sleep are highlighted while the others are dimmed

3. You also have other options shown below the search box

Hot tip

To help find a System Preference associated with a specific function, type the function into the search box.
The relevant System Preference(s) will be highlighted.

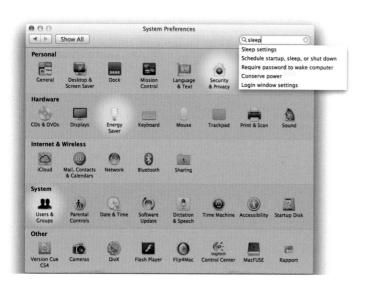

Network Settings

Networking Macs is very straightforward and arguably much easier than networking PCs. In general, Macs on the same network see each other with no problem. They also see peripheral devices attached to other Macs such as printers or drives, with minimal fuss.

Network settings are covered in Chapter Nine.

Connect to server

1 If you know the IP address of the server you can connect by choosing **Go > Connect to Server...**

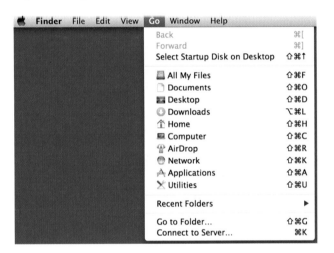

2 **Enter the IP address** in the address box

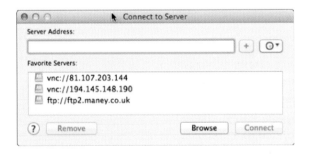

3 Hit **Return**

Print and Scan

Adding printers to a Mac is extremely easy. OS X comes with inbuilt printer drivers for most printers around.

To add a printer

1 **Plug the printer into the Mac**

2 Go to **Apple Menu > System Preferences > Print & Scan**

3 Click the **+** to add a new printer

4 The Mac searches the hard drive for the printer driver, after which time your printer will appear in the left pane

5 You can then **close** the Print & Scan window

Hot tip

If a document fails to print to a wireless (or wired) printer try deleting the printer and re-installing it.

Deleting Print Jobs

1 You can delete old print jobs by going to **Apple Menu > System Preferences > Print & Scan > Open Print Queue...**

2 Select the job(s) to delete and click the delete icon at the top

To check printer RAM and other functions

1 Go to **Apple Menu > System Preferences > Print & Scan > Open Print Queue... >Printer Setup > Driver**

User Accounts

User Accounts on the PC is replaced by **Users & Groups** on the Mac.

Setting up a new account

1 Go to **Apple Menu > System Preferences > Users & Groups**

2 Click **padlock** and enter **password** to make changes

3 Click the **+** to add a new account

4 Decide on the **account type** (Administrator/Standard/ Managed with Parental Controls/Sharing Only) – Administrators have full rights to install and delete apps. If unsure set up as Standard

5 Enter **Full Name, Account Name, Password and Hint**

6 Click **Create User**

Login options

1 You can allow **Automatic login** (no password required) or switch this off

2 On shared computers it is better to switch **OFF** automatic login to prevent people having access to your files

Beware

Do not disable Automatic login if more than one person will be using the Mac.

Migrate Your PC Files to Mac

There are several ways to get your PC documents onto the Mac. Obviously PC *programs* will not run on the Mac so you are mainly looking to copy across pictures, music, Microsoft Office documents, and others to the Mac.

Using removable media

1. The easiest way is to use a USB stick: plug it into the PC, navigate to My Documents and drag this folder to the USB stick

2. Unplug the USB stick from the PC and plug it into the Mac

3. Copy pictures to Pictures folder on the Mac, music to Music folder, and so on

The network option
You can network PC and Mac wired (Ethernet) or wirelessly:

1. On the Mac select **Go > Connect to Server**

2. Type in your PC's network address using the format *smb://DNSname/ShareName* or *smb://IPaddress/ShareName*

3. Click **Connect** and follow the on-screen instructions

4. Once the PC appears on the Mac **drag and drop** the PC files onto the Mac desktop

5. You can also mount the PC on the Mac desktop wirelessly and drag and drop files that way

If you are running Windows on your Mac
If you have installed Boot Camp and Windows 7 or 8 (or VMWare Fusion or Parallels Desktop) run the Windows Easy Transfer Wizard. See **www.vmware.com/Fusion, http://www.parallels.com** and Apple's help pages: **http://www.apple.com/support/switch101**

Run Windows on the Mac

Since Macs have Intel processors you can run Microsoft Windows using two different methods:

 Boot Camp – creates a Windows partition on your Mac. Windows is installed onto this partition. *Downside*: this option requires you to boot up the Mac into *either* Mac OS X *or* Windows

Virtualization – using VMWare Fusion or Parallels Desktop. Creates a Windows partition on your Mac onto which you install Windows. When running OS X you can boot up Windows and have the Windows desktop running *on top* of the Mac desktop with sharing of files, folders and drives between Mac and Windows

Boot Camp installation

1 Go to **Utilities > Boot Camp Installer**

2 Run the installer, allocating sufficient disk space for Windows

3 Insert your Windows installation disk and follow the on-screen instructions

VMWare Fusion and Parallels

These come with installer DVDs. Follow the on-screen instructions or visit the manufacturers' websites.

14 Burn CDs and DVDs

Although USB drives are getting cheaper we still need to burn files onto CD and DVD. This chapter walks you through the various choices available for burning different media onto CD and DVD.

Burning Music to CD

Burning is the term used for copying files onto CDs or DVDs. You can copy files onto these discs using a variety of methods, e.g. using the Mac's inbuilt burning software or using third-party apps such as Toast Titanium.

Making your own music CDs

1 **Insert a blank CD-R** into the optical drive

2 When you see the message *"You inserted a blank CD. Choose an action from the pop-up menu or click ignore."* **Click OK**

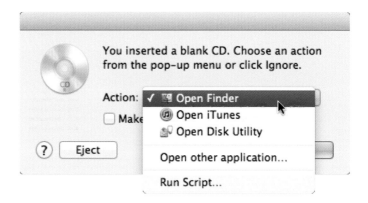

3 **Open iTunes**

4 **Make a new playlist** (File > New Playlist)

5 **Select the tracks** you want to copy onto the CD

6 **Drag the tracks onto the new playlist** (give the new playlist a title)

7 **Right-click on the new playlist** and select **Burn Playlist to Disc**

8 Or go to **File > Burn Playlist to Disc**

9 iTunes will burn the tracks onto the CD

10 Once finished you can eject the CD

Burn Photos onto CD/DVD

You can burn photos from iPhoto either as photo files or as slideshows.

Copy photos onto CD/DVD

1 **Insert CD/DVD** into the optical drive

2 **Open iPhoto**

3 **Select the album** you want to copy

4 Click **Share > iDVD or Burn** (for photos select *Burn*; for slideshows select *iDVD*)

Besides burning photos to DVD there are several other ways to share your pics.

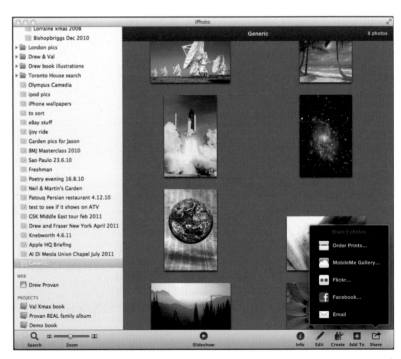

You have other options

- Facebook
- Flickr
- Twitter
- Order prints

Copy Files/Folders onto CD/DVD

You can copy files and folders onto CDs or DVDs easily.

① **Insert a blank CD/DVD** (can be -R or -RW) into optical drive

② At the message "*You inserted a blank CD. Choose an action from the pop-up menu or click ignore.*" **Click OK**

③ You will see Untitled CD on the desktop

④ Copy your files/folders onto the CD by **Option-dragging** the files or folders (if you only drag the file you will simply copy an *alias* onto the CD and *not* the files/folders)

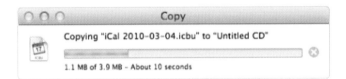

⑤ After you see the files being copied onto the CD or DVD right-click the CD icon and choose **Burn "Untitled CD"...**

⑥ Once burned, you can eject the CD

Burn CD/DVD with Disk Utility

You can copy files onto CDs or DVDs using the Mac app Disk Utility (in the Utilities folder **Go > Utilities**).

1 **Open Disk Utility**

2 Select **New Image**

3 Give it a name

4 Disk Utility will create a .dmg file on the desktop and will also create a virtual drive called *Disk Image* on the desktop

5 **Drag your files or folders to Disk Image**

6 You will see them copy across

7 **Right-click Disk Image** and select **Burn "Disk Image" to Disc...**

8 **Eject the CD/DVD** once burned

9 To see the files, insert the CD/DVD into the optical drive

15 Explore the App Store

The App Store is a huge repository of apps covering all categories. Here we look at how to find, purchase and install apps from The App Store.

What is the App Store?

The App Store is a relatively recent innovation by Apple, and aims to mirror the App Store seen on iOS devices (iPhone, iPad, iPod). Rather than buying software in a shop or from a website, this app lets you browse thousands of software titles and when you find the one you want you simply click to download.

Updates are easy

Because of the Updates tab, you can easily see when there is a new version of your app. It's a simple matter of clicking to update the software.

Basic layout of the App Store

Beware

You cannot use the App Store unless you have set up an iTunes account.

172

Click for Featured apps

Click for Top Charts

Click to view Categories

Click to see your Purchased apps

Click for to see if there are any updates

Highlighted apps appear in this window

Other featured apps

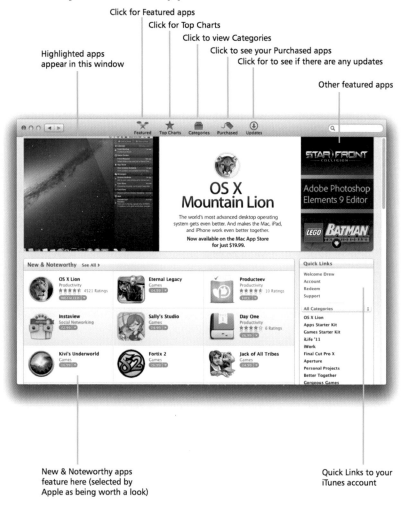

New & Noteworthy apps feature here (selected by Apple as being worth a look)

Quick Links to your iTunes account

Top Charts

Apps that are selling well appear in the Top Charts. Generally they have received good user reviews (always read the reviews for any app – it prevents you from buying something which has bugs, crashes or is substandard).

There are thousands of apps and not all are worth buying.

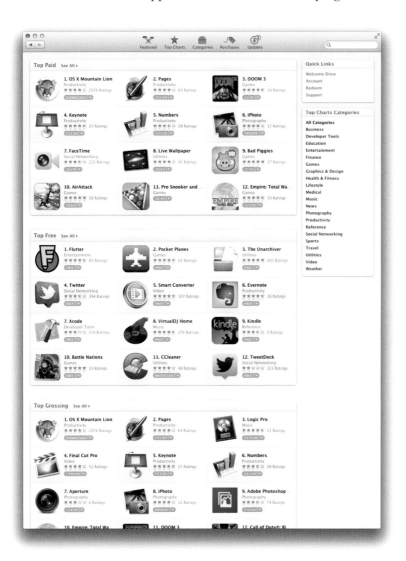

Hot tip

Always read the software reviews. Just because an app is available to purchase does not guarantee its quality! There are some dubious apps on the App Store!

Categories

With so many apps, it can be a nightmare trying to find what you are looking for. Sometimes it's a good idea just to start by category. For example, if you are interested in sport, working out, and fitness try clicking the Fitness category and browsing there.

But beware, there are many apps in each category so it may still take a long time to find exactly what you want.

Once you select a category you can browse the top Paid and Free apps, and explore other features.

Purchased

Are you spending too much? Which apps have you bought? It's easy to see what purchases you have already made by clicking the Purchased tab.

Hot tip

You can review your purchases by clicking the Purchased tab.

Information about a purchased app
Click on the title of an app to get more information, details about the developer, etc.

Updates

Once you have bought and installed an app, the developers will from time to time post updates, fixing the software or adding new features. You can see what updates are available by clicking the Updates tab.

Interestingly, it looks as though the App Store does not recognize apps you have bought outside the App Store so you will probably have to update those the conventional way (launch the app and check Updates).

Check for Unfinished downloads

1 Go to **App Store > Store > Unfinished downloads**

How to Buy an App

You will need to be signed in to the App Store before you can buy anything. The App Store uses your iTunes account details. Sign in using your usual name and password.

How to buy an app

1 **Find the app** you want

2 **Click the price** (or Free, if it's free)

3 The app will download

Don't forget

You still need an iTunes account even if the app you want to download is free.

Tell a Friend

If you see a great app and want to alert a friend, there's a Tell a Friend button.

1 Click the drop-down next to the price

2 Select **Tell a Friend**

3 This will open Mail and the link will be in the message

See More Apps

See more apps by the developer

Many developers have created more than one app, and you can find their other apps by clicking the link shown below.

Visit the developer's web site

If you have problems with an app, or want to learn more about the developer, try visiting the developer's site.

Hot tip

You will find lots of information if you visit the app developer's website.

Searching for Apps

You can search for specific apps or categories using the search box.

 Enter the search term

2 Hit **Return**

<div class="hot-tip">

Hot tip

If you can't find an app easily on the app store, trying doing a Google search and see what other people are recommending.

</div>

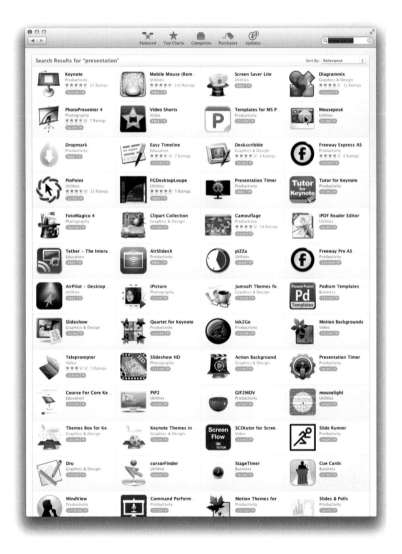

16 Keep Things in Sync

With our data such as calendars, contacts, and documents held on so many different devices these days it is useful to be able to keep these in sync. Here we will look at options for syncing all your important information.

Keeping Email in Sync

It is very useful to be able to see all your emails on all your devices – Mac, PC, iPhone, iPad, and other devices. It is far more useful than having to use one particular device to view your mail. This is very easy to achieve if you use any email service that allows you to setup your email as IMAP (Internet Message Access Protocol) as opposed to the older POP3 type account.

Why is IMAP so useful?

It lets your email program see your emails on a server. The emails do not reside on your Mac so you can view all folders and emails using any device since no device actually holds the email.

Which services use IMAP?

There are several but the two commonly used are

- iCloud
- Google Mail

Set up an IMAP account

This is covered in Chapter Four.

The biggest advantage?

All your emails are synced and all devices can see identical emails and attachments.

The same IMAP folders on iCloud using the Safari browser...

And viewed on an iPad...

And finally, on the iPhone

183

Calendar Syncing

If you use Calendar on your Mac you may also want to access Calendar using your iPhone, iPod Touch, or iPad. You may also view Calendar on multiple Macs or even using a PC (e.g. by logging into iCloud on the PC using a browser).

Best apps for keeping calendars in sync

- iCloud

- Google Calendar

Both of these are web-based. If you add an event to Calendar on your Mac the event will sync via the cloud to the iCloud server and be "pushed" to other devices such as an iPhone if you have set up an iCloud account on the iPhone.

Synchronization can be wired, e.g., using an iPhone/iPad/iPod Touch with iTunes

 Hot tip

Wireless syncing is much more convenient than the wired method.

1 Attach your iPhone to your Mac

2 Check the radio button to sync data

Or you can sync wirelessly using iCloud – use the Mail, Contacts & Calendars System Preference to set this up.

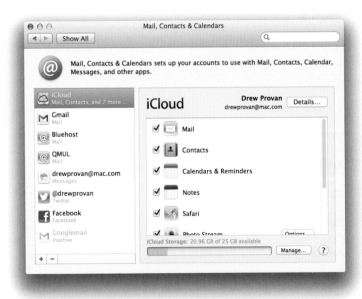

Google Calendar

Google Calendar can be viewed on any PC or Mac so you can see all your appointments even if you're away from your own Mac. Calendar can be configured to sync with Google calendar.

Setting up Calendar sync with Google Calendar

1 Open Calendar

2 Go to **Calendar Preferences > Accounts**

3 Add the **+ to add a new account** and choose **Google** from the drop-down menu

4 Enter your **name and password** to configure the account

Hot tip

It is easy to add your Google Calendar to Calendar.

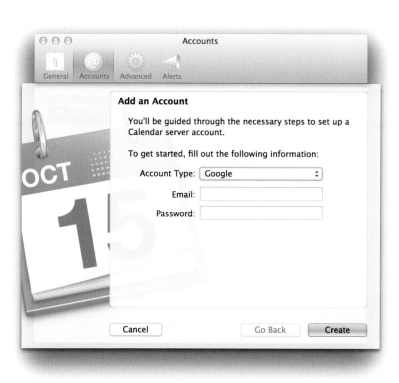

Syncing Contacts

It is useful to have the same set of contacts on all your Macs and mobile devices. This is easy to set up using:

- iCloud

- Google Contacts (log in to Google Mail to view Contacts)

- Configure iCloud to sync Address Book contacts

Syncing Google contacts in Address Book

Hot tip

Apple Address book makes it simple to import all your Google Contacts.

1 **Launch Address Book**

2 Click on the **Address Book menu > Preferences**

3 Click on the **Accounts** tab

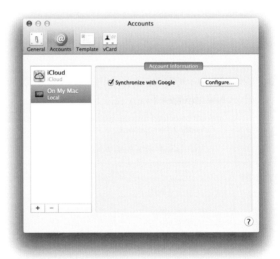

4 Select **On My Mac** under the accounts on the left

5 Check the checkbox accompanying **Synchronize with Google**

6 Click on **Configure...** and follow prompts

Keep Your Notes in Sync

Mobile devices such as iPad and iPhone have a Notes program. With previous versions of OS X, Notes was part of Mail but now they have their own app, Notes.

Setting up the Notes sync

1 Go to **System Preferences > iCloud**

2 Check the Notes box

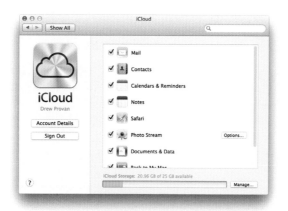

3 Do the same on your other devices (other Macs, PCs, iPhones, etc.)

4 Now your Notes will be synced across all devices and pushed to the devices from iCloud

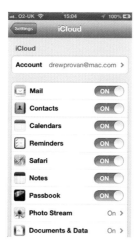

Above shows Notes ON in the iCloud configuration screen on the iPhone

Keeping Safari in Sync

It is great having Safari bookmarks synchronized on all devices and your Mac. This is very easy to set up:

Using iCloud

1 Go to **Apple Menu > System Preferences > iCloud**

2 Make sure **Bookmarks** is **ticked**

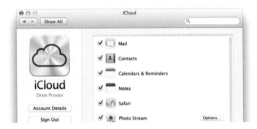

Wired route (e.g. no iCloud account)

1 **Connect** the iPhone/iPad/iPod Touch to Mac using USB cable

2 **Open iTunes**

3 Click the **Info** tab

4 Make sure **Bookmarks** is **ticked**

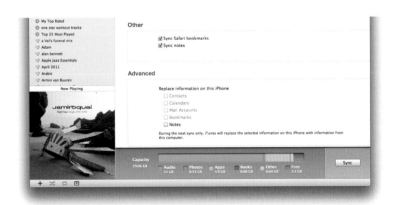

17 Back up Your Files!

No-one likes doing backups but if your computer dies you could lose a serious amount of hard work. Here we look at various backup strategies to help recover your work if you suddenly have a hard drive failure.

Simple Copy Methods

The simplest method of backing up is to drag folders or files to a separate disk. If your Mac has a external USB drive plugged in you could copy your important files from the internal drive to the external USB drive.

Pros

- Quick
- Easy
- Cheap

Cons

- You need to remember to do it
- If you leave the drive plugged in and your Mac is stolen, you lose all your work!
- USB drives can fail without any warning

How to do it

1 Make sure you can see the backup drive on the desktop

2 **Locate the files** you wish to back up

3 **Click and drag** these to the backup disk

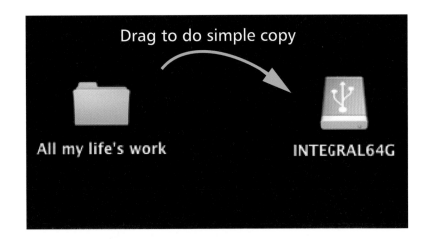
Drag to do simple copy

All my life's work INTEGRAL64G

Keep Files on the Cloud

Rather than copy folders and files to a physical hard drive attached to your Mac, you could use a cloud service. There are several services available including:

- iCloud
- Dropbox
- Windows Live Mesh

Pros
- Files are kept away from your home and your Mac so if the house burns down you could retrieve your work easily
- Easy-to-use

Cons
- You need to remember to do it
- Expensive if you need lots of storage space

How to do use Dropbox

1. **Open account** (dropbox.com)

2. **Copy files to the dropbox folder** on your Mac

3. These files will automatically sync to the dropbox cloud

4. You can **access all your files** using any PC or Mac by logging into your dropbox account

Time Machine Backups

Time Machine comes built-in with OS X and provides an automated backup solution (encrypted if you want to be extra safe), backing up your Mac to an external drive. After the initial backup of your entire drive it will back up your work every hour, backing up only those files you have changed. In the event of a disaster or accidental deletion of a file you can go back in time and salvage the file and bring it back.

Configure Time Machine

1 **Connect an external drive** to your Mac

2 You will usually be asked *"Do you want to use* diskname *to backup with Time Machine?"*

3 Click **Use as Backup Disk**

4 Time Machine will then format the drive ready for use

5 Time Machine will then perform an initial backup of your entire drive (this may take some hours depending on how much data you have on your hard disk)

6 After the initial backup Time Machine will perform hourly backups, backing up all the files which have changed

Should you back up everything?

The lazy way to do it is to let Time Machine back up everything but it is better to exclude some files from the backups, e.g. System, Applications folder.

Set up an exclusion list

1 **Open Time Machine preferences**

2 Click **Options...**

3 Click on the **+** symbol to add files or folders to the exclusion list

Beware

Don't skimp on your Time Machine backup drive. Buy a large one, at least 1 Terabyte (TB).

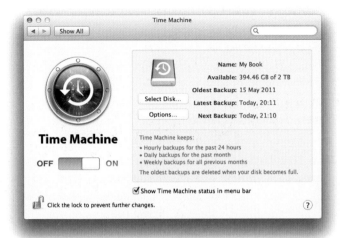

This is the basic Time Machine System Preference. You can **Select Disk...** to choose which drive you use for backups. **Options...** lets you exclude certain files from the backup.

Hot tip

You can now encrypt your Time Machine back-ups for added security.

193

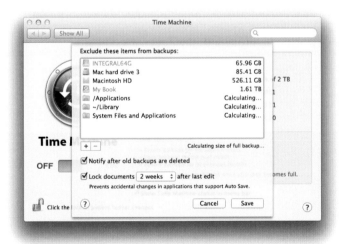

Options: you can see that some items have been excluded from the Time Machine backups. These include the user library (**~/Library**), **System files**, **Applications** and some other hard drives.

Restore Files with Time Machine

If you accidentally delete a file or folder you can bring it back as follows:

1 Make sure the Time Machine backup drive is connected to your Mac

2 **Open Time Machine** (click its icon on Dock)

3 **Use the timeline on the right** side of your screen to step back in time and locate the file you want to retrieve. *Note*: you will need to remember which folder contains the file you deleted. If the file was on the desktop then make sure you are browsing the desktop files in Time Machine

4 Once you see the file **click once**

5 Click **Restore**

6 The file will be copied to the correct place, i.e. to the folder which contained the deleted file or folder

7 Time Machine will then exit and you'll be returned to the current time

Don't forget

To restore a file using Time Machine you need to know its location (which folder was it in?) otherwise it is going to be very difficult to locate it once Time Machine is launched.

Scheduled Backups

There are third-party apps for carrying out scheduled backups. This is useful if you carry around your work on a USB stick. If you lost a USB stick your work would be lost. ChronoSync is a paid app that lets you carry out scheduled backups, e.g. daily or weekly, or each time you plug the USB stick into the Mac it will automatically copy the files which have changed on the USB stick back to the Mac.

- The synchronization can be one way, e.g. USB to Mac or two-way

- The two-way sync keeps the USB stick and the Mac files completely in sync with each other

195

Hot tip

Scheduled backups mean you don't have to remember to perform the backup. The whole thing is automated.

The above screenshot shows a one-way ChronoSync sync. From the image below you can see that the app has many user options

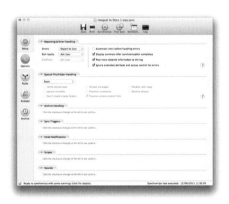

Cloning Your Drive

Time Machine is good at backing up your drive contents but it is useful to have an *exact replica* of your hard drive which is bootable (by bootable, we mean the drive can be used to boot up your Mac if your main hard drive was to fail).

Carbon Copy Cloner

If your main drive fails you can use the cloned drive to start up your Mac since the bootable cloned drive will have identical folders and files to the main drive and once the bootable drive is running you can then troubleshoot the main (failed) drive.

Options

- Carbon Copy Cloner (**bombich.com**) – Free
- SuperDuper (**shirt-pocket.com/superduper**) – US $27.95

Note – price correct at the time of printing

Using Carbon Copy Cloner

1. Launch Carbon Copy Cloner

2. Select **Source** (the drive you want to copy)

3. Select **Destination** (will become the carbon copy)

4. Click **Schedule this task...**

5. Choose an option such as Weekly (mine is scheduled for Sunday evenings)

6. Click **Clone**

7. The drive will be cloned

Note: the Destination drive should be larger than the Source drive or it will not be able to copy the contents to the clone.

Hot tip

A cloned hard drive can be used to boot up your Mac and help you salvage the main hard drive if problems occur.

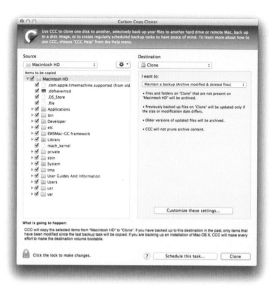

This is the main Carbon Copy Cloner interface. You select the drive to be cloned on the left and the destination (clone) on the right.

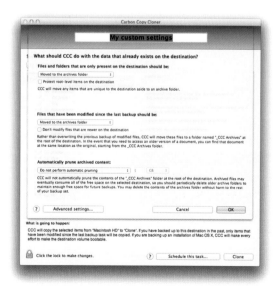

There are many user options available to customize the cloning process.

SuperDuper

This works very much like Carbon Copy Cloner, possibly with a simpler interface.

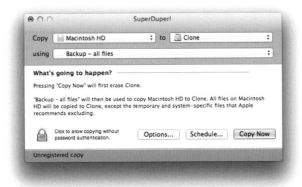

18 Tips & Tricks

In addition to altering settings in the System Preferences there are loads of other tricks to get more out of your Mac.

Keyboard Tricks

Typing special characters

If you need to type accented or other foreign characters there are two ways of getting these:

1 Go to **Menu Bar > Show Character Viewer**

2 Choose **Latin** and then find the character you want

Second method

1 You can hold down some keys and special characters will pop up (much like the iPhone and iPad)

2 These keys are **e y u i o a s l z c n**

200

Meet at the cafe

Take snapshot of the screen or window

● To take a snapshot of the whole **desktop** type ⌘ + ⇧ + **3**

● To take a snapshot of a **selected area** type ⌘ + ⇧ + **4**

● To take a snapshot of only one **active window** type ⌘ + ⇧ + **4 + spacebar**

Commercial apps for taking screen snapshots

http://www.ambrosiasw.com/utilities/snapzprox/

Organizing System Preferences

If you go to Apple Menu > System Preferences you will see a series of icons. Apple has arranged these for you but you can change the order. You can even remove them so they are hidden:

1 Go to **Apple Menu > System Preferences**

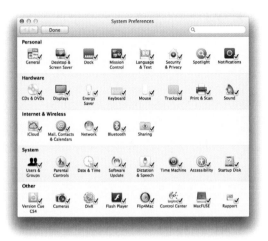

2 Go to menu bar **View > Customize**

3 The icons will have a **X** beside them – click to hide the icon

4 You can also Organize by **Category** or make them **Alphabetical**

Compare Documents Quickly

Sometimes you can have two documents that look identical – but are they? You could open them both and check the differences but a quicker way is to:

1 **Click once on both documents** (to select them)

2 Type ⌘ + I (provides Information, hence the "I")

3 Look at the document size and date last opened

4 You can now work out which is the most recent

Although they look similar in terms of date and time, the document on the left is only 25 KB while the other has had an image embedded and is much larger at 918 KB.

How Much Disk Space is Left?

As you add videos, documents, and programs to your hard drive it will fill up, until eventually there is no more space left.

How can you see how much you have used?

There are two ways

1. Go to your Mac HD icon

2. Click once then type ⌘ + I

3. Look at **Capacity, Available**, and **Used**

The other method

1. Go to **Apple Menu**

2. Select **About this Mac > More Info > Storage**

3. You will see a diagram which will reveal how much disk space has been used and how much is free

This is a 1TB (1000GB) drive which has 776.81GB free

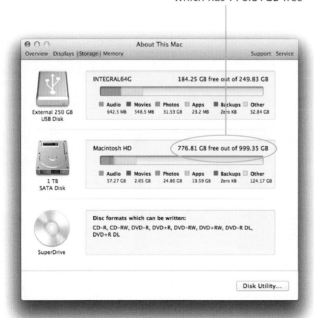

Extract Pictures from PDFs

You can grab pictures from PDFs, web pages and other documents easily.

PDF files

1 Open the PDF file

2 Make sure the picture is as large as you can make it, i.e. it fills the screen

3 Take screen snapshot ⌘ + ⇧ + **4**

For web pages

1 You can **right-click the image** on a web page

2 Then select **Download** linked files as... (choose destination)

Where are the Scroll Bars?

If you are using OS X 10.8 you will notice that the scroll bars have vanished until you start to scroll, then they appear.

Do you want to see them all the time?

Scroll Bar

1. Go to **Apple Menu > System Preferences**

2. Select **General**

3. Choose **Show Scroll Bars: Always**

205

Hot tip

Make scroll bars permanent by selecting this in the General System Preferences file.

Application Switcher

How do you switch between apps quickly? You could click the app's icon on the desktop but there is a way to see what's running, bring an app to the front, and even quit the app effortlessly using a couple of keystrokes.

1 Type ⌘ + **Tab**

2 A bar will pop up on the screen showing all running apps

3 To select an app (make active and bring to the front) click it

4 To quit, hover the pointer over it to select it, and press ⌘ + **Q**

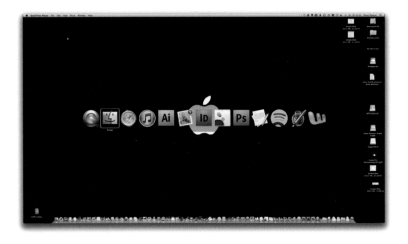

Dim screen fast!

If someone walks in and you want to hide what's on your screen you can:

1 Move pointer to the Sleep corner (if you have set that up in **System Preferences > Desktop & Screen Saver > Screen Saver > Hot Corners...**

2 *Or even faster* – type **Ctrl + Shift + Eject**

The screen will go black (Sleep mode).

Select the Default Browser

You may not want Safari as your default web browser each time you click a link to a web page.

How to select your default browser

1 **Open Safari** (odd, but this is where the settings are buried)

2 Go to **General > Default web browser:**

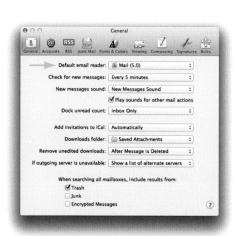

3 From the drop-down menu **choose** the one you want to be the default browser

Hot tip

To set up a browser other than Safari as the default you need to configure this in the Safari Preferences file.

Incidentally...

The same is true for email, if you want to use an email program other than Apple Mail you need to:

1 **Open Mail**

2 Go to **Preferences > General**

3 **Default email reader:** choose from the list

Boot up into Windows

If you have Boot Camp installed, you can tell your Mac which partition you want to boot into – Mac or PC.

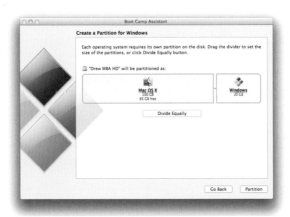

Setting up the Windows partition with Boot Camp installer

To select drive at startup:

1 As Mac starts hold down the ⌥ key

2 You will see all available drives

3 Click Windows to start up in Windows

Access Someone's Drop Box

If you want to give someone a file that is too large to email, one option is to log into their computer and drop the file into the user's Drop Box (not to be confused with Dropbox, the third-party app).

Accessing a user's Drop Box

1 **Go > Network**

2 Look under **Shared** for the User's Mac

3 Connect to it as a **Guest**

4 Click the user's **Mac**

5 Click on the user's **Public Folder**

6 You should then see **Drop Box**

7 **Drop your file** onto that (you cannot open the Drop Box)

8 The user can then navigate to his or her Drop Box and drag the file out

Change the Login Picture

The login screen is good, but you may want to change this. There's no System Preference for this so you need to do a bit of digging to find the picture file then replace it.

1. Find the original background file at */System/Library/ Frameworks/AppKit.framework/Versions/C/Resources*

2. The file is called **NSTexturedFullScreenBackgroundColor.png**

3. **Back up the original file** (copy onto another drive, e.g. USB stick)

4. Choose the image file you want to use, and take it into Photoshop or other image editor program

5. The image file needs a **resolution of 72 pixels per inch**

6. Save your own image with the name **NSTexturedFullScreenBackgroundColor.png**

7. **Move it** to where the original image was

8. You will need to **Authenticate** using your password

9. **Reboot** to make sure it works

Hot tip

The login picture can be changed but be careful when removing the original file – keep a copy somewhere in case your efforts go badly wrong!

Undo Mistakes with Versions

Apple now provides Versions, a bit like Time Machine. If you are working on a document it will save various versions. If you want to go back to a previous version you can activate Versions and you will see a screen which resembles Time Machine, with a timeline down the right side of the screen.

You can step back until you find the version you want to use and bring this to the present desktop.

Not all apps support Versions, but Text Edit, Pages and several other Apple apps fully support Versions. In time, more apps will have this feature.

To use Versions

1 As you are working on a document, save frequently

2 When you want to see earlier versions, click the drop-down menu near the title of the document to bring up the Versions screen

Hot tip

Versions makes it easy to go back to an earlier version of your document.

Make Mac Always Open With

When you double-click a photo it will usually open with Preview which is fine for most people. But you may prefer to have the photo opened with Adobe Photoshop instead.

To open a photo or image with Photoshop instead of Preview

1 **Click once on the image file** to select it

2 Right-click and choose **Open With**

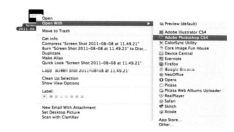

3 Then scroll down the list until you see Adobe Photoshop

If you always want a specific program to open the document

You can tell the Mac to always open a photo or image with Photoshop by default, rather than Preview

1 **Click once on the photo** to select it

2 **Right-click** but hold down the **Option (⌥)** key until you see **Always Open With**

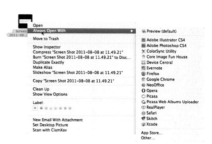

3 Now, whenever you double-click a photo it will open with Adobe Photoshop if you chose that option

19 Mac Maintenance

Macs run pretty smoothly even if you do no maintenance but it is a good idea to clear out unwanted files and do some basic housekeeping. This will keep your Mac running as fast as it was when brand new.

Repair Permissions

Mac OS X is based on Unix. This uses a permissions system for read/write access to files. Over time, permissions can become wrongly set or corrupt, and this will cause your Mac to behave erratically or slowly.

If you find your apps start to crash, fail to open, or behaving strangely it is worth repairing permissions.

To repair permissions

1 On the menu bar select **Go > Utilities**

2 Select **Disk Utility**

3 **Launch Disk Utility**

4 Select your main hard drive and select **Repair Permissions**

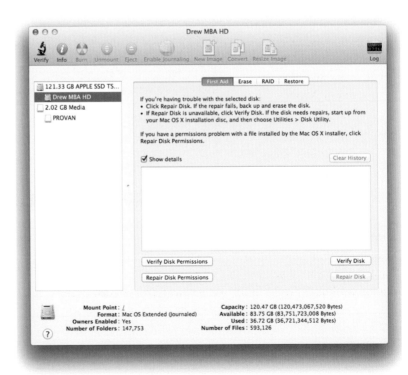

Maintenance Programs

Some basic maintenance of your Mac will keep it running smoothly and prevent any slowing down.

Inbuilt maintenance programs

1 On the menu bar select **Go > Utilities > Disk Utility**

2 Select your main hard drive

3 Select **First Aid, Verify Disk,** or **Repair Disk** if the drive appears to be having problems

Tech ToolPro 5

This is a heavyweight paid application. TechTool Pro 5 can check drives for faults, and it will also check your RAM, volume structures and perform many more functions. You can download the program from **www.micromat.com**

1 Launch TechTool Pro 5

2 You will see all the drives connected to your Mac

3 Select which tools you want to use

DiskWarrior

This is another powerful suite of tools that can scan your drives for errors and may be able to fix unmountable drives. You can download DiskWarrior from **www.alsoft.com/diskwarrior**

Don't forget

The OS X app Disk Utility is useful for performing basic maintenance.

Beware

Make sure you back up any important data before you perform any of these functions in case there is a major crash – you could lose your files!

Clear Your Desktop!

People with messy physical desktops at work tend to have messy desktops on their computers! Having loads of Word files and other documents strewn across your Mac desktop may make it slightly easier to find the documents you're working on, but this clutter means your Mac has to redraw and keep track of these files constantly. The net result is that your Mac will probably start to slow down.

File those docs!

1 Go to your **Home Folder > Documents**

2 Create some **New Folders** (⌘ + N)

3 **Name them**, e.g. Household, Personal, Work, etc.

4 **Make folders within folders**, e.g. Personal > Banking, Personal > Dental, etc.

5 **Drag the desktop files** to their appropriate folders

6 Aim to have no documents (or other files) on your desktop!

Hot tip

Keep the desktop clear of documents and folders!

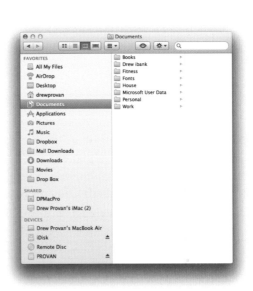

Reset Safari

Over time, Safari (and other browsers) will accumulate large amounts of cache data – text, images, sound files, etc. It is worth clearing:

- History
- Top Sites
- Web page preview images
- Downloads window
- Cookies

To reset Safari

1 Go to **Safari > Reset Safari**

2 Tick all boxes *except* **Remove saved names and passwords**, and **Remove other Autofill form text**

3 Click Reset

Remove cookies

1 Go to **Safari > Preferences > Privacy**

2 Select **Remove all Website Data...**

3 Your browser is now cleaned up!

Beware

Websites collect information about you as you browse, using cookies. Reset Safari regularly and clear out the cookies!

217

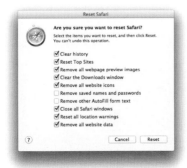

Rebuild Spotlight Index

Spotlight (the search app) keeps a database of all your files, both their names and also text within the files. It is sensible to delete the Spotlight Index and force it to rebuild it from time to time. This makes finding files much easier since Spotlight is working from a fresh index.

1 Open **System Preferences > Spotlight**

2 Select **Privacy** tab

3 Drag your main hard drive onto this window

4 This deletes your current index (Spotlight thinks the entire hard drive is to be made private and therefore not indexed)

5 **Quit** System Preferences then **reopen**

6 Go to **System Preferences > Spotlight > Privacy**

7 Select your hard drive and click the – button to remove your hard drive

8 Spotlight will now re-index the entire hard drive since it is no longer private

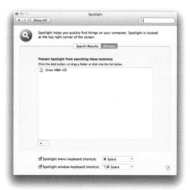

Rebuild Mail's Database

To ensure smooth running of Apple Mail it is useful to rebuild Mail's database from time to time. This makes Mail run faster especially if you have a large number of saved emails.

1 **Select the account** you want to rebuild

2 **Select Inbox**

3 Select Mailbox on the menu bar and scroll to the bottom and select **Rebuild**

4 The mailbox will now be rebuilt

5 Do this with all the mailboxes you wish to rebuild

Take All Accounts Online
Take All Accounts Offline
Get All New Mail ⇧⌘N
Synchronize All Accounts
Online Status ▶
Get New Mail ▶
Synchronize ▶
Erase Deleted Items ▶
Erase Junk Mail ⌥⌘J
New Mailbox...
New Smart Mailbox...
Edit Smart Mailbox...
Duplicate Smart Mailbox
New Smart Mailbox Folder...
Rename Mailbox...
Delete Mailbox...
Export Mailbox...
Go To Favorite Mailbox ▶
Move To Favorite Mailbox ▶
Use This Mailbox For ▶
Rebuild

Hot tip

Mail can become sluggish if you have tons of emails. Rebuild your mailboxes periodically.

219

Alternative method

1 **Quit Mail**

2 Locate file **user/library/Mail/V2/MailData/Envelope Index**

3 **Make a copy** of this file and keep it somewhere safe – in case all goes wrong!

4 **Drag** user/library/Mail/V2/MailData/Envelope Index **to the Trash**

5 **Restart Mail**

Defragmenting Drives

There is much debate about whether you actually need to defragment the hard drive under OS X. When hard disks contain large amounts of data, big files are split (because of insufficient space to write the large file as a single file). Theoretically, computers may slow down if they have many fragmented files. Defragmentation of hard drives has been part of the PC world for many years and older Macs seemed to benefit from defragmentation too.

If your hard drive is relatively small, e.g. 320–500 GB, and you have little free space left then it probably is worth defragmenting.

Tools available

There are no inbuilt defragmentation tools with OS X. You need to use a third-party app, e.g. iDefrag 2. Download this from **www.coriolis-systems.com**

iDefrag 2 works with OS X Mountain Lion, although some features are not available at the time of writing this guide, the developer will have full compatibility soon.

Remove Unneeded Login Items

Some programs will open when you first log in to your computer. However you may not need all of these, and having these launch at login may slow your Mac down especially if it is short of RAM or if you have a slightly older Mac. So it is a good idea to remove any unnecessary items that you will not be using when you first log in to your computer.

To remove login items

1 Go to **Apple Menu > System Preferences**

2 Open **Users & Groups**

3 Click the name of the **main admin account** (your account)

4 Click **Login Items**

5 Look through the list and decide what you want to remove – are there any apps that you do not use regularly?

6 **Click the check box** for the item you wish to remove and that item will be prevented from booting up at login

Hot tip

Any login items not needed? Get rid of them.

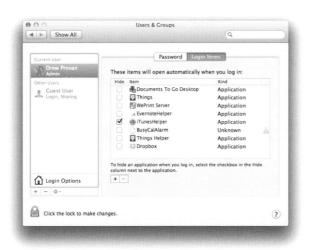

Don't Ignore Software Updates

Apple and other third-party developers release updates regularly for their software. For most apps you will be notified of an update when you launch the app.

1 Go to **Apple Menu > System Preferences > Software Update**

2 You will then be taken to the **Updates** section of the App Store

3 See what updates are available and download

4 You can also go straight to the App Store for updates, rather than via the Apple Menu, which saves time

5 The App Store provides updates for purchased as well as OS X software

Don't forget

Software Updates provide security patches and updated software. Don't ignore it when it alerts you to the fact that updates are available.

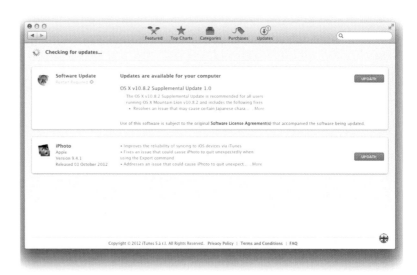

Remove User Accounts

You may let other people use your computer and you may have given them their own user accounts.

If they are not regularly using your Mac, remove these accounts since this will free up space and possibly improve your Mac's speed. Overall it helps slim down your system.

1. Go to **Apple Menu > System Preferences > Users & Groups**

2. **Click the padlock icon** and enter your **password** to make changes

3. **Select the account** you wish to remove

4. **Click the − button** and the account will be removed along with the documents and settings associated with that account

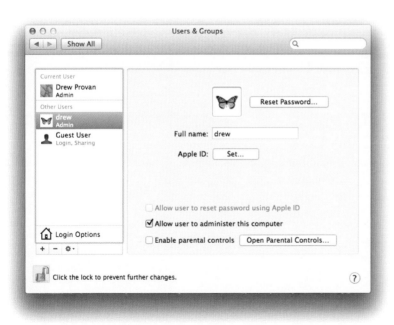

Scan for Viruses

The PC world is full of viruses. Luckily there are very few for the Mac at present but if you receive an email with an attachment containing a virus you can spread this if you email the attachment to someone else. It is therefore useful to detect and eliminate viruses as they come into your system.

Antivirus software

There are several programs available, e.g. Virus Barrier (**www.intego.com**). But you may as well use free software, e.g. ClamXav (**www.clamxav.com**). This Open Source (and hence free) app is fine for most users. It uses very little resource, i.e. RAM.

Install ClamXav

1 **Download ClamXav** from **www.clamxav.com**

2 **Install**

3 **Run** program

4 **Update virus definitions** (click the update definitions button)

5 **Start Scan** and select the drive or the folder you wish to scan

6 If you choose to scan an entire hard drive this may take some time

7 Infected or suspect files will be quarantined and you can delete these later if necessary

20 Troubleshooting

In this section we will look at how to solve the common problems encountered with the Mac.

My Mac Won't Start!

Empty Blue or Gray Screen

This is commonly due to incorrect disk permission problems, third-party software problems, or occasionally hardware issues.

1 **Unplug all peripheral devices** and try starting again

Start in Safe Mode (Safe Boot)

1 **Hold down Shift** while you turn on the Mac

2 Release Shift when you see a gray Apple with a spinning gear

3 SafeBoot should appear during startup or in the login window

4 To leave Safe Mode, restart the computer, without holding any keys during startup

Start Mac using Apple Installer DVD

1 **Insert a Mac OS X Install disk** (hold down the mouse button while you turn on your Mac to open the CD tray)

2 **Hold down C key** while you turn on your Mac (let go when the gray Apple appears)

3 Choose **Utilities > Disk Utility**

4 Select your hard drive icon on the left and click **Repair Disk** in the First Aid tab

5 When your disk reports no errors, click **Repair Disk Permissions**

6 **Reboot** your Mac without holding any keys during startup

Hot tip

Starting the Mac using the OS X installer DVD will allow you to boot up and use Disk Utility to repair the main hard drive.
When you insert the DVD, start the Mac up while holding down the C key to force it to boot up from the DVD.

Hot tip

Mountain Lion includes a Recovery Partition. To use this, start your Mac whilst holding down the Option key. Choose the Recovery Partition option to boot up and repair from that.

226

This Disk is Unreadable

This can be seen when using both USB drives and also CDs and DVDs. You will generally be told *"The disk you inserted was not readable by this computer"*.

- This is caused by not unmounting USB drives properly (unplugging without dragging to Trash icon first)

- It can also be caused by corruption of data structures, faulty libraries, or invalid file systems

The disk you inserted was not readable by this computer.

Initialize... Ignore Eject

Do not initialize!

1. You will lose your files on the disk. **Try plugging your USB drive into another Mac** if possible. It may mount on a second Mac and if it does, copy the files immediately to a safe place

2. Try using **Disk Utility** first to see if you can repair the USB drive

3. You can also use TechTool Pro 5 or Disk Warrior to analyze the drive, identify errors, and repair

4. If you have a backup of the files then you can reformat the faulty drive

App Crashes

Apps can crash while you are using them, for example, they unexpectedly quit, or they may fail to launch at all – simply bouncing on the dock before disappearing.

Solution

1 **Restart** the Mac

2 **Repair Permissions**

Remove the system preference .plist file for that app then try launching the app again

1 Go to **user/library/preferences**

2 Scroll through the list until you **find the .plist** file for your app

3 **Drag the .plist file to the Trash**

4 **Empty** Trash

5 **Restart** app

If all else fails

1 **Reinstall** the app

Duplicate Fonts

Many programs install their own fonts, e.g. Microsoft Office, Adobe Creative Suite, and many others. If they copy fonts you already have on your Mac you will end up with duplicates. These duplicated fonts can cause your Mac to misbehave, or programs to crash.

Deactivate duplicate fonts

1 **Open Font Book**

2 Look for a **yellow triangle** to the right of the font name (indicates multiple copies of font are installed)

3 **Select all fonts** (⌘ + A)

4 Go to **Edit > Look For Duplicates...**

5 When prompted click **Resolve Automatically**

6 This should solve your problem

Beware

Duplicate fonts may cause apps to crash. Check Font Book from time to time to see if you have any duplicate fonts.

Spinning Beachball

The *spinning beachball of death* has been present since the introduction of OS X. The spinning beachball is similar to the hourglass icon in Microsoft Windows.

When you see the beachball on the Mac it often hangs and there is little you can do while it spins.

Possible causes

1 Program is **busy**

2 You have **insufficient RAM**

3 The app is **frozen** or **hung**

4 You have **hardware problems**

Solution

1 Try being patient and **wait** to see if the beachball stops

2 Quit or **Force-Quit** the offending app (**Apple Menu > Force Quit** – look to see which app is not responding)

Force Quit Applications
If an application doesn't respond for a while, select its name and click Force Quit.
Expression Media
iCal
InDesign
iTunes
Mail
Microsoft Excel
Microsoft Word
Numbers
Pages
Photoshop
Preview (not responding)
Safari
Spotify
TextEdit
Finder
You can open this window by pressing Command-Option-Escape. Relaunch

3 **Restart Mac**

4 **Buy more RAM**

5 **Remove .plist file** from your user library

If all else fails...

If the Mac hangs and you cannot get it to do anything, hold down the power button until the Mac switches off. Wait one minute then restart the Mac.

Folder Moved to Wrong Place

Sometimes we drag files or folders to the wrong place. If you know where you dropped it, you can find it and drag it back out.

If you don't know where it went

1 Immediately after you dropped the file or folder into another location type ⌘ + Z (**Undo**)

2 This will undo your last action

3 However if you perform other actions *before* you try this manoeuvre then you won't be able to find the file other than by using **Spotlight** to search for the file by name

Undo Last Action

The ⌘ + Z command shortcut will get you out of all sorts of trouble, for example:

- You deleted text from a document in error

- You trashed a file or folder by mistake

- You made changes to text or a photo incorrectly

How to undo the last action

1 Click ⌘ + Z and your work will be restored

2 Many apps will let you undo several times allowing you to take several steps back rather than just one

231

Undo Scale Item	⌘Z
Redo	⇧⌘Z
Cut	⌘X
Copy	⌘C
Paste	**⌘V**
Paste without Formatting	⇧⌘V
Paste Into	⌥⌘V
Paste in Place	**⌥⇧⌘V**
Clear	⌫
Duplicate	⌥⇧⌘D
Step and Repeat...	⌥⌘U
Select All	**⌘A**
Deselect All	⇧⌘A
InCopy	▶
Edit Original	
Edit With	▶
Edit in Story Editor	⌘Y
Quick Apply...	**⌘↵**
Find/Change...	**⌘F**
Find Next	⌥⌘F
Spelling	▶
Transparency Blend Space	▶
Transparency Flattener Presets...	
Colour Settings...	
Assign Profiles...	
Convert to Profile...	
Keyboard Shortcuts...	
Menus...	

Can't Find Network Printer

Adding a printer in OS X is easy but sometimes the Mac can have trouble finding a printer, especially printers on a network.

If your documents fail to print or the Mac appears to be looking for the printer for a long time

1 Go to **Apple Menu > System Preferences > Print & Scan**

2 Select and **delete the printer** that has failed (click the – button)

3 Then **click the + button** and browse through the list of available printers

4 Click **Add**

5 The printer should now show in your list in the left pane

6 Try printing your document again

Safe Boot

If your Mac misbehaves, or fails to boot up normally, it could be due to hardware or software problems. System extensions added by third-party apps can cause problems. To determine whether this is the case you can do Safe Boot.

Safe Boot (Safe Mode)

- This forces the Mac to carry out a directory check

- The Mac loads only essential extensions

- The Mac disables fonts apart from the main fonts in /system/library/fonts

- It moves font caches to the Trash

- The Mac disables any start-up items

To start in Safe Mode

1. **Switch off the Mac**

2. Restart but **hold down the Shift key** as the Mac starts up

3. If the Mac starts you can then look for extension or font conflicts

Try logging in as another user

Programs may fail to work normally because of hardware (e.g. a USB device attached to the Mac) or because you have installed something which has created a conflict. To see if it's the Mac or just your account which has caused problems:

1. **Create a new account**, e.g. Guest, or named account and log in to the new account

2. Try running the program again

3. If the program still fails you know it's a Mac problem

4. If it *does* work then something in your account is stopping the program from working properly

Deleted File or Folder in Error

It happens to everyone – a crucial file or folder somehow gets deleted in error.

Don't empty the trash!
If the file or folder is still in the trash drag it out

The trash has been emptied

1 **Launch Time Machine**

2 **Locate the file** from an earlier time

3 **Restore** the file to the desktop or any folder

Time Machine cannot find the file

1 You may need to buy a recovery program such as Phoenix Mac Data Recovery (**stellarinfo.com**) or MacKeeper (**mackeeper.zerobit.com**)

Can't Eject a Disk

Sometimes when you want to remove a USB drive or CD by dragging to the trash you are notified that the drive is in use. You probably have a file open in Word or some other application and have not closed the file.

The fact that you are prevented from ejecting the disk safeguards you against failing to save the file.

The disk "INTEGRAL64G" couldn't be ejected because "Expression Media" and "InDesign" are using it.

Quit those applications and try to eject the disk again.

? OK

Solution

1 **Close any open documents** you're working on

2 If this fails, **close your apps** one at a time

3 Try to drag the USB drive to the trash to see if you can now safely eject it

4 If the notification tells you which app is in use quit that specific app

5 If all else fails – **restart the Mac** and that should solve the problem

Mountain Lion Recovery Disk

You can boot into the Recovery Partition on the Mac as outlined on page 226, or you can build a bootable USB drive which you can use to start up your Mac.

Create bootable recovery disk

 Download Mountain Lion Disk Maker (http:// blog.gete.net/Mountain Lion-diskmaker-us/)

Beware

You will probably need to re-download your Mountain Lion installer from the App Store since the installer is deleted after you install Mountain Lion.

Install and launch the app which will then look for a Mountain Lion installer on your hard drive

You will be prompted to create a DVD but you can use a USB drive (must be 8 GB minimum)

Index